GRONK

A VER: REVISIONING ART HISTORY

1. *Gronk*, by Max Benavidez (2007)

A Ver: Revisioning Art History stems from the conviction that individual artists and their coherent bodies of work are the foundation for a truly meaningful and diverse art history. This series explores the cultural, aesthetic, and historical contributions of Chicano, Puerto Rican, Cuban, Dominican, and other U.S. Latino artists. Related educational, archival, and media resources can be found at the series home page—www.chicano.ucla.edu/research/ArtHistory.html—including downloadable teacher's guides for each book. A ver…Let's see!

Series Editor
Chon A. Noriega, University of California, Los Angeles

National Advisory Board
Alejandro Anreus, William Patterson University
Gilberto Cárdenas, University of Notre Dame
Karen Mary Davalos, Loyola Marymount University
Henry C. Estrada, Smithsonian Center for Latino Initiatives
Jennifer A. González, University of California, Santa Cruz
Rita González, Los Angeles County Museum of Art
Kellie Jones, Yale University
Mari Carmen Ramírez, Museum of Fine Arts, Houston
Yasmin Ramírez, Hunter College
Terezita Romo, Mexican Museum, San Francisco

A VER: REVISIONING ART HISTORY

VOLUME 1

GRONK

MAX BENAVIDEZ

FOREWORD BY CHON A. NORIEGA

UCLA CHICANO STUDIES RESEARCH CENTER PRESS

LOS ANGELES

2007

CSRC Director: Chon A. Noriega
Press Manager: Wendy Belcher
Business Manager: Lisa Liang
Production Editor: Rebecca Frazier
Manuscript Editor: Catherine A. Sunshine
Production Assistant: Jessee Vidaurre
Developmental Editor: Colin Gunckel
Research Assistants: Linda Lara, Katie Mondloch, Beth Rosenblum, Jennifer Flores Sternad
Getty Intern: Nathalie Sanchez
Printed by ColorNet Press, Los Angeles. Bound by Roswell Book Binding, Phoenix

UCLA Chicano Studies Research Center
193 Haines Hall
Los Angeles, California, USA 90095-1544
press@chicano.ucla.edu
www.chicano.ucla.edu

Distributed by the University of Minnesota Press
111 Third Avenue South, Suite 290
Minneapolis, MN 55401-2520
www.upress.umn.edu

Library of Congress Cataloging-in-Publication Data
Benavidez, Max.
 Gronk / Max Benavidez.
 p. cm. – (A ver–revisioning art history ; 1)
 Includes bibliographical references and index.
 ISBN 978-0-89551-105-8 (cloth)
 ISBN 978-0-89551-101-0 (pbk)
 1. Gronk, 1954– 2. Mexican American artists–Biography. 3. Latino Art–Twentieth Century. 4. Chicano artists.
 5. Chicano art–California–Los Angeles. 6. Hispanic American Artists–Biography. 7. Hispanic American gays.
 I. Title. II. Series.
 N6537.G7195B46 2006
 709.2–dc22
 [B]
 2006017687

This book is printed on acid-free paper.

CONTENTS

SUPPORTING INSTITUTIONS

This book is sponsored by
La Plaza de Cultura y Arte
Los Angeles, California

A Ver: Revisioning Art History
is made possible through the generous support
of the following institutions:

The Getty Foundation
The Ford Foundation
The Andy Warhol Foundation for the Visual Arts
The JPMorgan Chase Foundation
The Rockefeller Foundation
UC MEXUS

AFFILIATED INSTITUTIONS

Archives of American Art, Smithsonian Institution • California Ethnic and Multicultural
Archives (CEMA), University of California, Santa Barbara • Centro de Estudios
Puertorriqueños, Hunter College, New York • Cuban Research Institute, Florida
International University • Hispanic Research Center, Arizona State University,
Phoenix • Inter-University Program for Latino Research (IUPLR) • Institute for Latino
Studies, University of Notre Dame • Jersey City Museum • La Plaza de Cultura y
Arte, Los Angeles • Latino Art Museum, Pomona • Latino Museum, Los Angeles •
Los Angeles County Museum of Art • Mexican Cultural Institute, Los Angeles •
Mexican Museum, San Francisco • El Museo del Barrio, New York • Museum of
Fine Arts, Houston • National Association of Latino Arts and Culture (NALAC)

ACKNOWLEDGMENTS

> The mythographer lives in a permanent state of chronological vertigo, which he pretends he wants to resolve. . . . No mythographer has ever managed to put his material together in a consistent sequence, yet all set out to impose order.
>
> —Roberto Calasso, *The Marriage of Cadmus and Harmony*

Imposing order on something as evanescent and mysterious as art can be a vertiginous process. One has to wonder whether illumination can emerge from such a method, and yet it does, because the story of true creativity has its own ineluctable compass. In the end, it can't be done in intellectual isolation. For this book on Gronk, I am indebted to the many artists and thinkers who have helped me understand how art is born— especially the art that emerges from a tumultuous social and cultural context.

While writing the heart of this book in 2004–2005, I had the good fortune to be a resident scholar at the UCLA Chicano Studies Research Center. The director of the center and editor of this unique series, Chon Noriega, generously and whole-heartedly supported this project. I am grateful to Chon's staff, including Wendy Belcher, Esther Buddenhagen, Rebecca Frazier, Jennifer Flores Sternad, Rita González, Colin Gunckel, Carlos Haro, Tere Romo, and Dianne Woo. Their intellectual, editorial, moral, and material support helped make this book possible.

I want to express my profound gratitude to Gronk. He opened his artistic life and shared his most private papers and personal ephemera, as well as books and films from his personal collection. Gronk also spent countless hours with me, discussing his work. We had many delightful conversations that opened new avenues of investigation and discovery for my research.

A number of people took the time to sit down with me or otherwise communicate with me about Gronk and his work. They include Sean Carrillo, Armando Durón, Camille Rose Garcia, Ramón García, Oscar Garza, Steve La Ponsie, Robert "Cyclona" Legorreta, Cheech Marin, Peter Martinez, Marisela Norte, Jeff Rangel, James Rojas, David Sandoval, Daniel Saxon, Patssi Valdez,

Jonathan Yorba, and many others too numerous to name here who shared their observations, memories, and experiences related to Gronk.

I also want to thank Harry Gamboa Jr. for sharing photographs of the early days of Asco from his vast collection. They provide a visual counterpoint to the text and help ensure that future generations will be able to see these striking images that document the genesis of an amazing group of artists.

Finally, I thank my wife, Katherine Del Monte, for her loving patience, understanding, and support that made my work on this book possible and worthwhile, and my daughters, Nora, Lola, and Daniela, for their understanding when I was away working on this book.

M. B.

Los Angeles

September 2006

The UCLA Chicano Studies Research Center gratefully acknowledges the vision and support of the following individuals in the development of A Ver: Revisioning Art History: Douglas Armato, Pamela Clapp, Deborah Marrow, Irma McClaurin, Claudia Mitchell-Kernan, Josephine Ramirez, Janet D. Rodriguez, Alexandra Seros, Walter Ulloa, Roberta Uno, Joan Weinstein, Tomás Ybarra-Frausto, and Jonathan Yorba.

FOREWORD

CHON A. NORIEGA

Gronk is easily one of the most recognized Chicano painters. And yet he remains a mysterious and mercurial figure, just as he was for those who first met him in the late 1960s and early 1970s. There is, first of all, the question of his name, its origin traced variously to a story about the Amazon in *National Geographic* or to a character in the short-lived CBS television series *It's About Time*. Indeed, Gronk has gone by many names since the 1950s, underscoring not only his artistic self-invention but also his underlying conceptual approach to art, identity, and politics. Rather than vesting himself in the object (both thing and goal), Gronk privileges the idea, because ideas can change and can bring change.

Growing up in East Los Angeles amid poverty and police riots, the recipient of a dead-end education in barrio schools, Gronk became an autodidact whose critical interests included art cinema, modernist theater, and campy B-movies, along with a wide array of philosophers, theorists, and writers. In this book, Max Benavidez, having immersed himself in Gronk's extensive library and film collection as part of his research, brings these influences to the foreground. In this way Benavidez gives us a different view of the "Chicano painter" from East Los Angeles. Here, we see an artist inventing himself within a global artistic frame of reference, even as his work intervened in volatile social conflicts in Los Angeles: homophobia in the Chicano community, police crackdowns on civil rights protests, racial biases in the print and electronic news media, and the exclusionary practices of the local arts institutions.

If Gronk remains a mysterious figure, that has largely to do with the fact that critics have recognized just the tip of the iceberg (a recurring image in Gronk's work). They often describe him as a painter and also as a co-founder of the Chicano conceptual art group Asco. But, as Benavidez notes, Gronk's is a "hybrid voice that speaks in many artistic tongues": painting, drawing, graphic arts, murals, performance art (street, stage, and video), photography, set design, ceramics, and computer-generated animation. While Gronk is most often associated with Asco, he has had other significant collaborators, before, during, and since Asco: Mundo

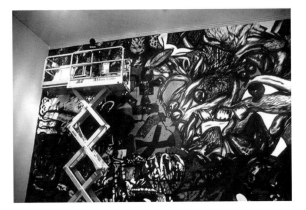

Gronk working on *Hit and Run*, an installation
at Cornell University, Ithaca, New York, in 1993.
Opposite: the finished work.

Meza and Robert "Cyclona" Legorreta (performance), Willie
Herrón III (murals), Jerry Dreva (mail art), the Kronos Quartet
(music and action painting), and Peter Sellars (set design),
among others. He staged the earliest gay-themed performance
in East Los Angeles, contributed to the emergence of gay,
punk, alternative, and Chicano art spaces, and—as a member of
Asco—developed and theorized the No Movie concurrent with
similar instances of conceptual or "expanded" cinema around
the world. In short, his work constitutes a nexus for several art
histories that have been seen as distinct.

Gronk's self-invention, hybrid voice, and conceptualism
pose a challenge to clear-cut categories, identities, and prac-
tices—including the gallery system, toward which he remains
ambivalent, but within which he has succeeded. "In the end,"
he explains, "I am not going to ask for permission to do
something."

In fall 1993, I commissioned Gronk to do an installation
painting in the Herbert F. Johnson Museum of Art at Cornell
University. The piece, *Hit and Run*, was part of a group show on
Latino site-specific installation art, called *Revelaciones/Revelations:
Hispanic Art of Evanescence*. After the exhibition the works were
disassembled, destroyed, or painted over. At the time, there were
no published books on installation art, but most critics dated
the genre to the 1970s. The exhibition brought together nine
Latino artists whose installation work spanned—and in a few
cases preceded—that historical framework, but who remained
outside the critical discourse. What if, we proposed, the history
of the genre could be told through these artists?

For two weeks, Gronk painted the far wall of the museum's main gallery, playing music, talking with passersby, and even stopping to give impromptu lectures to assembled students. As he applied layer upon layer of paint, using a power lift to reach the upper portions of the wall, familiar Gronkian shapes emerged, merged, and transformed, only to be covered over the next day. Each day, I would secretly will him to stop, since what he had painted seemed so beautiful, so compelling, and so complete. But he continued.

Meanwhile, another artist in the show was generating a great deal of notoriety for a series of black-tarred walls lining the walkways in the main quad. Eventually the piece would become the object of racist graffiti and vandalism and the catalyst for a student takeover of the administration building in protest of the hostile

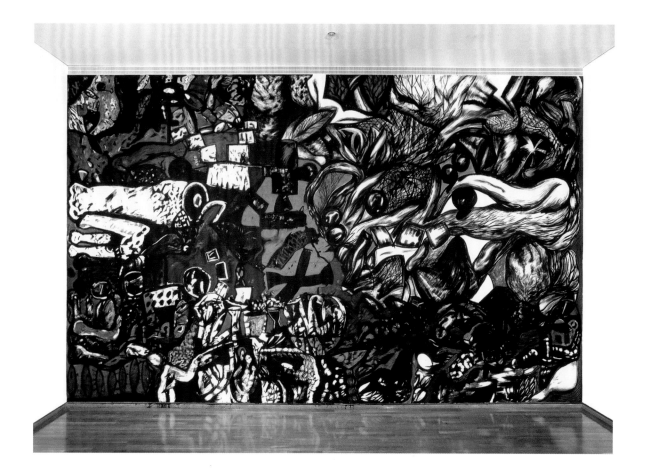

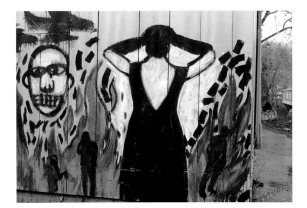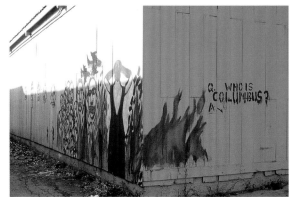

Gronk, detail of untitled mural, 1993. Ithaca, New York.

climate for Latino students. What few people appreciated at the time, however, was that the piece was the result of prolonged negotiation with the university, and that the artist, Daniel J. Martinez, had been given permission to construct the installation.

The night of the opening, the curators, artists, and assistants all boarded an old school bus and headed down the hill from campus to the town for a celebratory dinner. As the bus prepared to turn into the parking lot, we all noticed that the warehouse across the street from the restaurant had been tagged. In the midst of a series of red flames and floating heads stood none other than Tormenta, Gronk's most iconic image, the eternal enigma with her back to the viewer, on the city street and not in the campus gallery. Everyone moved to the left side of the bus to get a closer look. Around the corner from Tormenta, more flames and a stenciled question: "Who is Columbus?" For the answer, an arrow pointed downward, toward the ground (or perhaps the restaurant). Suddenly, Gronk called out in a lilting voice, "Danny . . ." We all looked to the back of the bus, where Gronk sat, and he proclaimed: "I didn't ask permission."

INTRODUCTION

Art attracts us only by what it reveals of our most secret self.
—Jean-Luc Godard, "What Is Cinema?"

The Santa Fe Opera theater sits in the desolate desert landscape of northern New Mexico, with the Sangre de Cristo (Blood of Christ) Mountains to the east and the volcanic field known as the Jemez Mountains to the west. In July 2005 a new version of the opera *Ainadamar*, based on the tragic death of the Spanish poet and playwright Federico García Lorca, premiered in the theater. Gronk, the Los Angeles–based multimedia artist, had painted a massive set covered with vibrant abstractions in earthen colorations: umber red, chalk white, ashen black, yellow ochre, and terra verte.

The set appeared to float like an ark in the black night of the desert. With the seed image as one of its central organizing motifs, the set evoked the hope that can emerge from tragedy and also symbolized Gronk's arrival at a new destination point in his career. Here was his work, familiar to those who know his paintings, sets, and murals, literally encasing the stage walls and floor for an opera about Lorca by the critically acclaimed Argentinean composer Osvaldo Golijov, directed by the peripatetic and inspirational Peter Sellars and sung by the great soprano Dawn Upshaw. Throughout the opera the set served as both character and essential environment. Coupled with Golijov's elegantly mournful music, the set helped carry along the sad story woven from the memories of Margarita Xirgu, the Spanish actress who often collaborated with Lorca.

In the month before the opera's opening night, Gronk worked twelve hours every day to create the set for *Ainadamar*. While painting, he was visited by schoolchildren, Girl Scouts, students from surrounding Indian pueblos, and a stream of curious spectators. He would work, stop, talk about the set, and then continue working again. In many ways this was his twenty-first-century interpretation of "action painting." While the abstract expressionists often worked in an unconscious mode, Gronk's version of action painting is more of an interactive effort. Both the process and the results constitute his creative endeavor.

Reviews of Gronk's set were generous. The *New York Times* said, "Energy runs like an underground stream beneath this piece, surfacing in the painted backdrops by the artist Gronk. Gronk's figures, crowded with color and hyperactivity, race back and forth across the walls of the stage and even cover the floor."[1] The *Washington Post* called Gronk's stage design reminiscent of Picasso's *Guernica*.[2] And the *Cincinnati Enquirer* announced that Gronk's set design was "nothing short of spectacular—Guernica-like painted mural covering three walls and the stage floor" (figs. 1, 2).[3]

Although clearly within his element, Gronk had journeyed far from the streets of East Los Angeles. At the end of the opera, he ran with the director to the front of the stage to receive a standing ovation. Gronk thus joined the ranks of international artists—David Hockney and William Kentridge, among others—who have created stage sets for plays and operas in the tradition of Salvador Dalí, Pablo Picasso, and Marc Chagall.[4]

The opera project, which marked a significant new phase in Gronk's career, was perhaps the ideal vehicle for his approach to creation. Like many of his previous projects, *Ainadamar* was a collaborative effort, involving fellow artists as well as the community. In this respect, the process was not unlike the one he used to paint murals on the streets of East Los Angeles in the 1970s or to create monumental wall works in museums in the 1980s and 1990s. The opera also reflected the performative dimension present in much of his work. Whether undermining the stability of gender and sexual identity through his Tormenta pieces, or participating in conceptual dramas, or completing controlled action-painting performances at museums, theaters, and universities, Gronk has shown that for him, to (de)construct identity through performance is to create.

The road from East Los Angeles to Santa Fe was anything but smooth. As an artist, Gronk emerged out of the Chicano art movement. And Chicano art, as a concept, has always been a moving target. Born around 1965, it was defined in the twentieth century as a proud emblem of marginality and political opposition, often populated by didactic images taken from religio-indigenous, pre-urban folklife and ancient Meso-American symbology.[5] In the twenty-first century Chicano art and its many offshoots, including the hybrid post-Chicano

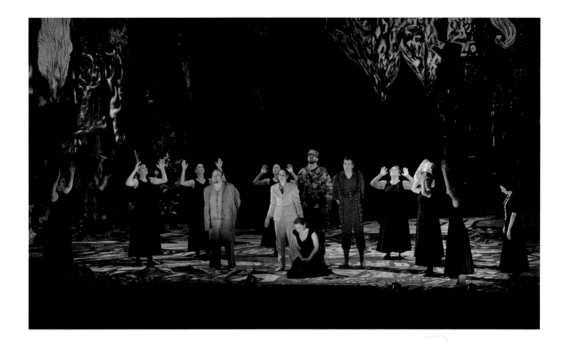

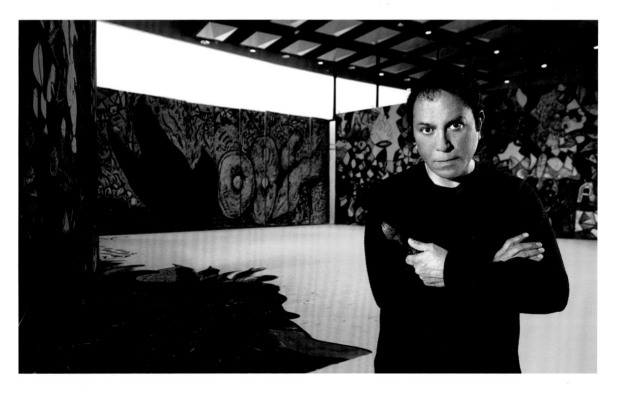

conceptual matrix, have become more of an allusive art, increasingly located outside the specific site of category.[6]

Gronk is one artist who typifies and embodies the shifts and transformations in Chicano art from the late twentieth century into the twenty-first. He is a cultural precursor who helped set the stage for an art that expresses the performative aspects of both gender and ethnic identity. In his early years, he seemed to understand that identity is, as Homi Bhabha notes, "always the production of an image of identity and the transformation of the subject in assuming that image."[7] Gronk also seemed to know that we live in a time of cynical simulated appropriation and unfettered pasticcio. In other words, his work indicates that he was aware from a relatively young age that we exist in a historical moment in which meaning has become unstable and malleable. Gronk manipulates this play of unhinged surfaces with irony and a critique of the status quo that has infused his perspective and his work since his early collaborative conceptual art.

For Gronk, art has been an evolutionary process, one that combines the autodidactic, guerrilla sensibilities of his earliest work with formal art school training. His life and work thus reflect his steady progression from a street artist who had to look up the word *mural* to know whether he could paint one, to an artist who creates sets for international operas and computerized animation for panoramic, 360-degree screens. Throughout, his work has remained steadfastly transgeneric, embracing painting, graphic art, drawing, photography, set design, performance art, and creation of computer-animated images. In this respect his career has also exemplified the formal diversity of Chicano art over time and witnessed, even propelled, historical shifts, consistently challenging fixed boundaries in the process. This tendency toward constant experimentation and his persistent refusal to dwell in arbitrary categories of any kind ultimately emanate from his particular perspective. "My view on things about life," he once said, "is a very hard existential sensibility. We're here for a moment, that's it, there's nothing beyond this. And that is what I deal with in my work."[8]

Life and work intersect for Gronk. His dedication to art with such a burning focus has created a certain personal isolation. And, he admits, he has always felt like an outsider: "I think I was pretty much a loner even as a kid."[9] While this sensibility may resonate with the collective experience of marginalization that

informs the work of many artists raised in East Los Angeles, it also suggests a position of self-imposed exile, a critical distance that has consistently allowed Gronk to transcend broader trends (and attract fellow outsiders) while pushing the concept of Chicano art in productive new directions.

Gronk's life has a classic arc, reminiscent of one of those Hollywood movies about a creative artist who emerges triumphant from hardscrabble origins and social chaos. As permanent outsiders, Gronk and Asco, the art collective he helped found, operated in the shadow of Hollywood's cultural-industrial complex. They responded to Hollywood's rejection of Chicanos not only by creating their counter-film series, the No Movie, but also by establishing a cinematic celebrity and aesthetic language that was all their own. The group even created the Aztlán Awards as a poke at the Oscars and Hollywood's self-congratulatory smugness. It was no accident that the Asco award was a cobra, a venomous gold-colored, bronze-eyed snake that flares its hood when angry. Unlike Hollywood filmmakers, whose creativity was tempered by bureaucratic and corporate control, Gronk delighted in the spontaneous and sought to puncture the notion that art is permanent. If Hollywood wouldn't tell his story, Gronk would do so through street performance, conceptual art, and painting.

Gronk was born in 1954 and started drawing when he was very young. He read everything and anything he could get his hands on. In fact, one of the earliest known photos of Gronk shows him as a boy reading a book in his backyard. He has often told friends that books transported him to other worlds and times. He found them full of the "beauty of words" and a way to fire his imagination.[10] As a child, he also loved comic books and cartoons. One can see this reflected in his art, particularly in the early murals such as the 1973 *Caras* in City Terrace Park and in the 2004 painting *History of Comics II* (fig. 3). Gronk's father had abandoned him and his mother, and young Gronk spent late afternoons and early evenings alone while his mother worked as a caregiver to the aged. He watched a lot of television: afternoon cartoon shows, classic sitcoms, and a parade of Hollywood movies. And he was drawing, always drawing.[11] He would draw as he spoke with other people, while in class at school, while on the bus. Over the course of his career, Gronk has continued

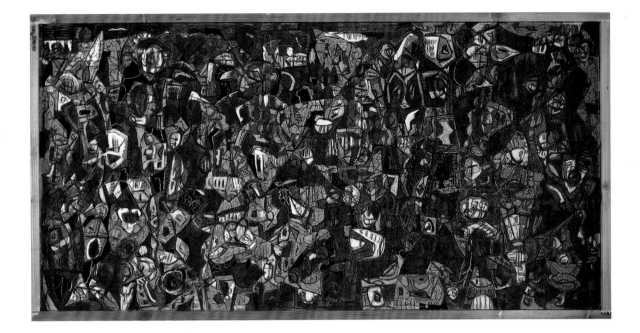

Figure 3. Gronk, *History of Comics II*, 2004. Acrylic, pastel, oil stick, and fine varnish on wood, 48 x 96 inches.

Photograph by Alan Schaeffer. Courtesy of Patricia Correia Gallery, Los Angeles. Reproduced by permission of the artist.

Figure 4. Gronk, *Rhino Boy*, 2000. Ink on paper napkin, 5 x 5 inches. Private collection.

Reproduced by permission of the artist.

Figure 5. Gronk, detail of *No Punctuation*, 1995. Mixed media triptych on wood, 8 x 8 feet. Private collection.

Photograph by Tony Cuñha, 2005. Reproduced by permission of the artist.

to fill volumes of notebooks with surrealistic ink drawings while sketching on any available material. In fact, napkin drawing has become almost a subgenre of Gronk's oeuvre, a marriage of black Rapidograph ink and white tissue texture (fig. 4).

By his adolescence in the 1960s he had discovered film, and it was to become his great artistic love. Whether it was art house classics such as Jean-Luc Godard's *Bande à part* (1964) or the delicious kitsch of B-movies from the 1950s and 1960s, Gronk found a creative wellspring of images and ideas that were to play a significant role in his own work. But it was the technical form of film that would stay with him: the shot, the jump cut, the close-up, the pan, the fade-out. He would later incorporate these cinematic techniques into his work, especially his paintings.

Perhaps drawing upon his own sexuality, Gronk's work from an early date openly engaged the construction of identity through what might be regarded as "the political performance of gender."[12] In *Gender Trouble*, Judith Butler offers insight into Gronk's stratagems as both a gay man and a Chicano artist. In Butler's view, the very nature of discourse is political and linguistic.[13] Claire Colebrook extrapolates from Butler's ideas

and notes that "for the most part we live our gender and social identity as the linguistic or social construction of our 'real' selves." But, more important for understanding Gronk and his work, people imagine "that there is a real sexual self somehow existing *before* cultural identity." Colebrook also asserts that "our gender identity is not expressed in language but created and performed through language," and Butler goes even further to say that language "creates the illusion of some subject or being that exists before language."[14]

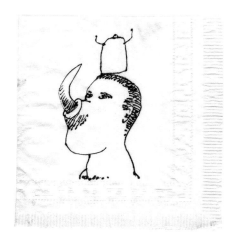

Whether that illusion is a painting or a theatrical presentation, identity within that construction is performative. Painting, or, for that matter, most art, is an illusion in nearly every sense. And then to add to the already conscious creation of illusion the additional creation of a sexual identity, which may or may not adhere to the "illusion" of a pre-linguistic male or female identity, is to double the pleasure. As Colebrook puts it, "The supposed pre-linguistic matter of the body that would issue in a secure male or female identity is thereby exposed as having potentials to act in multiple and incalculable ways." To act, then, in Butler's terms, produces "alternative imaginary schemas."[15]

It is these "alternative imaginary schemas" that limn the contours of Gronk's life. Gronk says he knew from a young age that he was gay. As far as his work is concerned, his homosexuality has had a nuanced manifestation. The sexualized queer aspect is there in many of his paintings such as *No Punctuation*, in which myriad phallic shapes, fisted forearms, and sheath-like spaces are meshed with graffiti scratchings, seed forms, and layers of acrylic paint on thin plywood. The effect is that of a homoerotic sexual awareness interacting with its environment in a dense interplay of sensuality, creativity, and urban intensity (fig. 5).

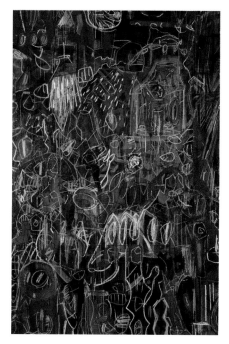

At the same time, and most notably in his glamorously stylish alter ego, La Tormenta, Gronk presents an image, central to his artistic arsenal, that serves as a symbolic counterpoint of an "authentic," stable sexual identity (fig. 6). In the case of La Tormenta, we may well have the expression of drag's double inversion. Or as Butler puts it, "Drag fully subverts the distinction between inner and outer psychic space and effectively mocks the expressive model of gender and the notion of a true gender identity."[16] From his very name, to his work, Gronk finds identity to be a site of conflicted and unresolved ambiguity. His work highlights the intersection of race, sexuality, and art, as

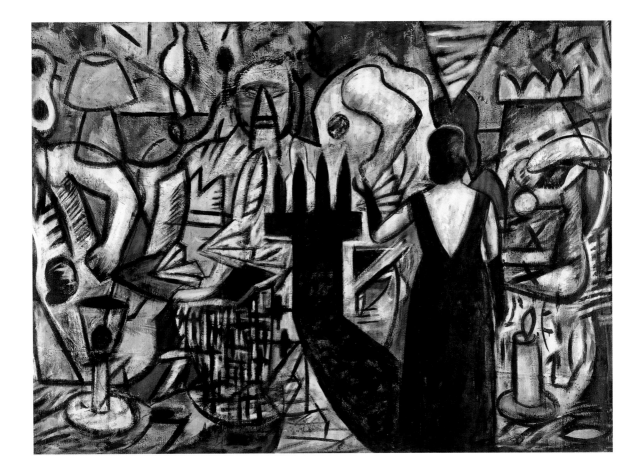

Figure 6. Gronk, *Post, Library: Muse,* 1995. Oil on canvas, 90 x 127 inches. Collection of the San Jose Museum of Art, gift of the artist.

Photograph by Douglas Sandberg, © San Jose Museum of Art. Courtesy of San Jose Museum of Art. Reproduced by permission of the artist.

well as the charged emotive contradictions that exist between and within classes, races, and genders. He is of Mexican descent. He is queer. He is an artist. And yet, despite those "facts" or the illusions of fact, he remains an enigma, or, at least, presents himself as one.

As a founding member of the Chicano art collective Asco, from 1972 through 1987, Gronk helped conceive the No Movie, the instant mural, the walking mural, and many other innovative conceptual stratagems. Asco—Spanish for nausea, as in "it makes me sick," *me da asco*—also included artists Harry Gamboa Jr., Willie Herrón III, and Patssi Valdez. The work that the group produced could be viewed as a rebirth of what is thought of as the avant-garde, with the caveat that this work emerged out of a

most unexpected place and time: the East Los Angeles barrios in the 1970s. Perhaps more important, the original members of Asco were unfamiliar, at least initially, with the very term *avant-garde* and with its prime aesthetic proponents in the United States and Europe. Asco's brand of urban street avant-gardism has to be seen as a unique and organic form of rebellious artistic production because it was an intuitive expression that flowed out of and reflected the personal, cultural, and social experiences of the group.

Chon A. Noriega comments on the group's negotiation of disparate spheres in his insightful introduction to *Urban Exile*, a collection of Harry Gamboa Jr.'s writings:

> Until recently, Gamboa and Asco have also been placed at the margins of Chicano art history, and their internal critique of Chicano art itself remains conveniently misunderstood. What is at stake in both instances is a historical question: What does the avant-garde look and sound like when it blooms outside the hothouse of the bourgeoisie? What does social protest against racism look and sound like when articulated outside a realist code? For a Chicano working-class avant-garde group raised in the barrio, assimilated to American mass culture, and making discourse the object of its social protest, the answer is simple: it looks like both and neither: and it sounds the same, but different.[17]

Asco's audacious achievement—both conscious and random at the same time—was to create two counternarratives. One was set against the emerging and "official" nationalistic rhetoric of Chicano art, and the other was set against the privileged status of the art world's avant-garde of the time.

By the 1970s, the Western European and U.S. avant-garde seemed to be more about passing trends than about social transformation. It was therefore almost logical that a true group of outsiders such as Asco could recalibrate the moribund energies and elements of the movement within the frame of the Chicano art movement, complicating the aesthetic and political commitments of both arenas in the process. Asco's work had an alluring duality, characterized by anger and a transgressive sense of humor, creating a space within which others might experiment artistically and launch a challenge to mainstream, avant-garde, and Chicano convention (fig. 7). There was consequently a level at which Asco built a critical awareness through its work. As noted

by Michelle Habell-Pallán, "Inventing hybrid forms . . . helps create the conditions for audiences to become cultural critics themselves."[18] However, this genuine and highly original renewal was little noticed or documented in the art historical record.

One simply has to look at the walking murals to see that Asco was saying in the most concrete terms that the murals on walls had to "walk" off the stucco and cement ramparts to remain relevant. They had to come alive, literally and figuratively. And Asco's edgy performances and events captured the attention of like-minded individuals. Sean Carrillo, a video artist and performer who worked with Asco in the 1980s, recalls that seeing an image of Valdez taped to a wall by Gronk, one of the famous Asco instant murals, sent a chill up his spine:

> One night we attended a gig in the basement of an apartment complex on Alvarado Street just south of Beverly Boulevard. The room was smoky, crowded and the bands played so close to the audience it was hard to tell who was actually playing. But the strangest thing about this gig was the slide show. Projected on a wall high above the audience were images of people in garish costumes as if performing some sort of bizarre street ritual. The images seemed strange and yet familiar. Then the slide came up which was a photograph of Patssi taped to the wall and I knew immediately what I was looking at. I can still feel the blood rush through me as I remember that evening.[19]

That sensibility, that way of seeing the world, was created, shared, and embodied by Gronk and the other members of Asco. In that way, it was reworking notions of what Chicano art was or could be. Asco was setting the stage for the post-Chicano conceptual matrix.

At the same time that he was working with Asco, Gronk was also painting murals throughout East Los Angeles. He was a significant force, along with his Asco cohort Willie Herrón, in moving Chicano muralism from a nationalist platform of self-glorification to a critical and expressive reinterpretation of his community and society. His artistic and personal partnership with the late artist and provocateur Jerry Dreva was another seminal element in his life and work. Dreva was Gronk's muse, sometime lover, and mail art collaborator. In a landmark show at Los Angeles Contemporary Exhibitions (LACE) and

Figure 7. Harry Gamboa Jr., *Asco 1980*, 1980. Black-and-white photograph. Left to right: Harry Gamboa Jr., Gronk, Patssi Valdez, and Willie Herrón III. Reproduced by permission of Harry Gamboa Jr.

through mail art, the two of them produced a record of a time and place that was imbued with drag and punk rock's cocky, incandescent fury against stale convention and mind-numbing bourgeois values.

Often seen primarily as a painter, Gronk also has worked extensively in theater, animation, music, conceptual art, mail art, graffiti, installation, muralism, graphic art, performance art, glass sculpture, video, and, of course, drawing. Above all, he is a conceptualist, someone who consistently reinvents the meaning and interrogates the value of art. One of his most conceptual acts has been to invent a profession: urban archeologist. He spends time excavating the remnants of urban life. There is a photo of him standing in front of the faded traces of an old sign that reads "Fascinating Slippers." Against the backdrop of the inner city, the juxtaposition of the pale words *fascinating* and *slippers* with Gronk's Chaplinesque persona frames Los Angeles as an unpredictable assemblage of semiotic fragments. This is what he looks for in the city and what feeds his creativity: the things

that once were and are gone but leave strange faint evocative traces in their wake.

The story of Gronk is a story of the will to create and the discovery of an artistic identity through trial and error. His work began on the streets and boulevards of the poverty-stricken East Los Angeles barrios, but it has extended all the way from those unforgiving streets to elite universities, museums, and even the rarefied stages of the Santa Fe Opera and New York's Lincoln Center. At the same time, he has lived the uneasy contradictions of being represented by a gallery, selling his art in the market, and becoming part of the culture industry, while still attempting to grow as an artist. It has been a balancing act. He has dedicated himself to his art, but he does not recommend art as a career: "It's a difficult decision to make, it's an impractical decision to make, and you have to be driven in order to want this and to be able to stay with this for the rest of your life, to do it. I wouldn't wish it on anybody."[20]

Gronk has applied his experience as an urban Chicano to combine and repurpose the Western creative tradition with a range of other influences including Cantinflas, the Mexican film comic; Yasujiro Ozu, the Japanese filmmaker; and Daffy Duck cartoons, among many other cultural touchstones. Anyone wishing to examine Gronk's work critically must take into account his origins in street culture as well as what bell hooks calls the "dynamism springing from the convergence, contact, and conflict of varied traditions."[21] This text, then, is a chronicle of a hybrid voice that speaks in many artistic tongues. This is the story of an artist of extraordinary contradictions and self-created transformations.

LIBRARY BOY
TRANSIT IN THE INSCRIBED CITY

All art is a game with and a fight against chaos.
 —Arnold Hauser, *The Social History of Art*

To grow up in East Los Angeles in the 1950s was to live in a place literally and figuratively outside the mainstream. Ever since the founding of Los Angeles in 1781 by a multiracial group of Mexican *pobladores* (settlers), the area immediately east of Olvera Street and the Los Angeles River, especially the Boyle Heights and Belvedere neighborhoods, has been a key destination for economic outcasts, refugees, and immigrants. For nearly a hundred years, from the 1920s to the present, Jews, Mexicans, Russians, Japanese, Armenians, Italians, and Chinese settled in this part of the city. Today it is primarily populated by Latinos of Mexican descent.

To understand Gronk and his work, one has to start in this eastern barrio, a place nothing like the artificial and glitzy media images of Hollywood, Malibu, and Orange County. In this Mexican ghetto, there was little that was magical or inspiring. Compared to schools in more affluent parts of Los Angeles, the schools in East Los Angeles bordered on institutionalized cruelty. A gradual process of deindustrialization had sucked the lifeblood out of the local economy. The whole east side, from Atlantic Boulevard on the east to Los Angeles City Hall on the west, was crisscrossed by freeways that slashed through the Mexican neighborhoods like concrete razor cuts. What's more, the east side sits in the center of a big, dusty basin where harsh sunlight creates a bright smoky glare and frequent temperature inversions, especially in the hot summer months, trapping pollution close to the ground. The children who grew up in East Los Angeles thus endured a toxic combination of atmospheric pollution, poverty, and social and educational exclusion.

The expressways that carved this area into odd-shaped pieces also carried motorists conveniently, if not always swiftly, past the barrio. You didn't have to stop in East Los Angeles, or even notice that it existed. The people living there remained

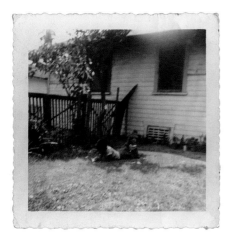

Figure 8. Gronk as a child in the late 1950s or early 1960s.

unknown and invisible to most Angelenos from other parts of the sprawling de-centered city. They became, in the words of Ascovite Harry Gamboa Jr., members of a "phantom culture . . . like a rumor," a culture that exists but is never perceived, like a ghost or wraith that remains intangible and therefore unreal.[1] Gronk thus spent his formative years in a time and place of great social, physical, and cultural alienation—what Richard Ingersoll calls the "monstrous incongruities" of sprawling cities such as Los Angeles.[2] Mexican Americans in East Los Angeles in the mid-twentieth century were caught in a world torn into haphazard parcels by massive cement formations and were ignored by their fellow Los Angeles residents, not to mention the rest of an American society informed by Hollywood and network news.

For Gronk, who grew up in the barrio on Gage Avenue near the Pomona Freeway, the magical had to be found somewhere else, someplace far away from gangs, drugs, poverty, and social and spatial estrangement. He had to go to a place that was utterly unlike the world he lived in as a child. As for many other artists, that world was his imagination. And his imagination was stretched by what he found in his local library, located down the street from where he lived (fig. 8).

Gronk rarely volunteers very much about his early home life. If asked, he will say that his mother's name was Elizabeth and that his father's name was Richard, and that they came from Mexico; neither is still living. He also has said that he was on his own from a young age. He recalls going home, when he was just seven or eight years old, and cooking his own dinner. "Who knows," he once said, "perhaps I envied other kids and their capacity to sit around a dinner table with a family."[3] He also recalls that he saw his father only on his birthdays. "I called him the watch man," Gronk said. "He always gave me a watch and we'd sit in his car in front of the house."[4]

These strained family relations ironically afforded Gronk the time and independence to pursue activities that fed his imagination, providing an avenue through which he escaped barrio realities.[5] Fascinated by books, he quickly discovered the nearby public library on Gage near Whittier Boulevard and began going there regularly, even obsessively. After a while, the librarian, a woman named Margaret, took an interest in him. His association with the librarian not only helped Gronk understand how he should approach the library's collection but also marked a

formative encounter with difference that exerted an effect on his personal development. He recalls that when he was young, probably in the early 1960s, he would go into the library

> and there was a woman who used to dress like a man. She looked like a farmer. She had overalls and a Pendleton shirt over that and she had short, cropped hair; and here were all these kids from East L.A. And she was white. She questioned me when I was just a kid: "Why are you reading everything from the As and the Bs and the Cs? You're going through the alphabet, aren't you?" I go, "Yeah," because I wanted to know everything. She shook her head and said, "That's not how you read books. Start with the Greeks and then work your way up to the present." She was just this strong woman in the library that was knowledgeable. She lived in a back house with her mother and all the parents in the neighborhood would say, "She dresses like that because she can't afford woman's clothing," and we would all roll our eyes like, "Yeah, sure." They were making an excuse because she was different, yet part of our community.[6]

Beyond his fascination with Margaret the librarian, Gronk came to regard the book itself as a symbol of something more:

> I got caught up in the world of books, and I think that was something that I still have to this day and it's something that has not left me. . . . Books were, for me, that escape, and carrying a book with me all the time was very important, because I could open it up and be transported.[7]

This librarian was to be the first of many mentors who influenced Gronk and served as guides as he navigated his desires and dreams of being an artist.

The writer Marisela Norte, a close friend whom Gronk calls his "soul mate" and who went to the same library, remembers Gronk surrounding himself with books. "Books and movies fed him," says Norte. "They were his escape and I guess they were for me, too. He knows so many authors and has read so much."[8] It was in reading books that he accessed other ways of life and dreamed about being part of them. Books about the lives of artists in particular offered him glimpses of the "glamorous" and "otherworldly," Gronk recalls, as he indulged in the "romantic notion of things taking place in far-off places."[9] Books were his ticket to the world of art in another sense: they provided a model for his earliest endeavors. He gravitated toward books illustrated by artists like George Grosz, finding them "inspiring, because it

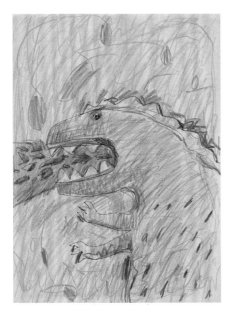

Figure 9. Gronk, *Godzilla*, ca. 1960. Crayon on paper, 11 x 9 inches. Private collection.

Reproduced by permission of the artist.

was the ability to make something with a simple medium: a pen, ink, and a sheet of paper."[10] As art supplies were scarce, Gronk began drawing obsessively with the materials at hand, filling his Pee-Chee folders, napkins, and the margins of his homework with endless sketches (fig. 9).

It is not surprising, given these proclivities, that Gronk soon realized that he wanted to be an artist by profession.

> I was thinking about being an artist at a very early age. I must have been six or so. I always enjoyed making things. I would use my imagination. I would use my hands to create something. Even today, in the same way, I am able to devote myself to be that maker of things . . . what really began to surprise me was that people were interested in what I was making.[11]

A few adults encouraged his efforts. For instance, he tells a story about his junior high school art teacher, the first "beatnik" he ever met. Her name was Patti La Duke and she always wore black. Once, she mentioned to him that she knew he was making wonderful ceramic masks with African motifs in school and that he took them home but never brought them back. She wanted to know what he did with them. Gronk's answer: "I'm burying them all around East L.A., and one day I hope an archeologist will find them and wonder what they are."[12] Another influence was a favorite uncle who drew cartoons.

Based on observations culled from these various sources, Gronk came to regard the artist's way of life as one of freedom. "A person who is an artist," Gronk once noted, "is someone who lives his life out the way they want to and in that way more worlds open up to you. In the end, I am not going to ask for permission to do something."[13]

The television and comic books that filled his empty hours also informed his earliest artistic efforts. Before long, however, Gronk became fascinated by cinema, and its influence on his work remains strong. As a teenager he would often take the bus across town to view the films of Federico Fellini, Ingmar Bergman, and Jean-Luc Godard, among others—works of aesthetic experimentation that he was unlikely to encounter in the theaters in his own neighborhood. The cinema was thus a conceptual and physical departure from his surroundings, and as he became increasingly aware of the creative labor behind each film, it fueled his own compulsion to create. While still enthralled by the low-budget

camp of B-movies, like *Devil Girl from Mars* (1954; fig. 10), Gronk developed an admiration for the Japanese filmmaker Yasujiro Ozu during this period. The combination of quiet elegance and layered density that characterizes films like *Tokyo Monogatari* (Tokyo Story) (1953; fig. 11), Gronk's favorite Ozu film, and *Early Summer* (1951) would later mark his own aesthetic aspirations.

Perhaps the most obvious manifestation of his willful self-construction as an artist is the invention of his name and the development of "Gronk" as a persona. His birth name is not definitely known, but at some point he took the name Glugio Gronk Nicandro, later shortened to Gronk. There are many stories circulating among his friends and acquaintances as to how and why he came up with that name, but the truth is that it fits him, even perhaps imbuing him with the enigmatic, other-worldly quality he once relished in artist biographies. According to one story, when he was a teenager he sometimes signed his drawings with the name Rob or Bob Gronk. In 1968 he signed "Grunk" to a black-and-white drawing of the performance artist Cyclona (Robert Legorreta). In his late teens, Gronk also went by the name of Otto Rieser. One source claims that his real name is Bob García.

In an essay titled "Groak at Mechicano," which was probably written around 1974, the late and highly accomplished painter Carlos Almaraz talks about meeting someone by the name of Lorenzo Groak Pedrigon. It is obviously Gronk. Almaraz writes: "Lorenzo Groak Pedrigon is small, thin and very delicate looking. He has the face of Buster Keaton and uses it in the same manner: hardly smiling and, in fact, hardly showing any expression. When he did smile, it made me feel strangely uncomfortable: I thought he was smiling at me." Almaraz goes on to make telling comments: "Groak is a man of costume and illusion; everything is part of his work in the same way that everything is part of his theatre. Like Duchamp, he selects work that he considers art. . . . His work is not pretty or arty but something a little more real. It's not beautiful in any bourgeois sense. It's certainly not a piece of property but very much like Groak himself: changing and alive, even very aggressive. He was wearing a tattered old leatherette jacket; the work has this kind of property" (fig. 12).[14]

Whatever his original name may have been, why did he change it to Glugio Gronk Nicandro? Could it be that he wanted

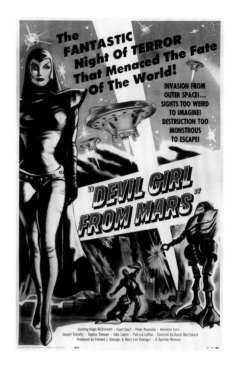

Figure 10. Promotional poster for *Devil Girl from Mars*, 1954. Directed by David MacDonald.
Reproduced by permission of Corinth Films, Inc.

Figure 11. Chishu Ryu and Chieko Higashiyama in *Tokyo Monogatari* (Tokyo Story), 1953. Directed by Yasujiro Ozu.

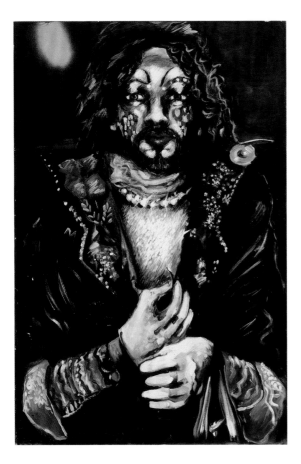

Figure 12. Gronk, self-portrait, ca. 1972. Acrylic on canvas, 36 x 24 inches. Private collection.

Photograph courtesy of Alan Schaeffer. Reproduced by permission of the artist.

to set himself apart from his Mexican American peers at elementary school, with their common Spanish surnames? Or was he simply constructing an identity that he would fill in as he lived the life that the name implied? What would Gronk's life be like, what kind of art would he create? This might be seen as one of his most challenging creative projects: the construction of his persona with name, career, product, and, above all, attitude.

Gronk himself has created an entertaining tale about how he received his curious name. As he tells it, his mother was reading a story in *National Geographic* about indigenous people in the Amazon as she went into labor. She saw the word *gronk*, which according to Gronk meant "to fly" in the Amazonian people's indigenous language, and chose that name for her son. This fanciful invention aside, Gronk's choice of pseudonym may have been at least partially inspired by the television show *It's About Time*, which ran for one season (1966–67) on CBS. In the show, two astronauts travel back in time to prehistoric days and meet a caveman named Gronk. Possibly it was the show's theme song, which evoked "strange people in the strangest place," that appealed to him. Gronk also once explained, "The kids used to call me Gronky. Gronkazoid. I went with the one that had the coolest sound."[15]

As someone who began his career as an artist in childhood—staging theatrical events in his backyard, constantly drawing with available materials—Gronk exemplifies the artist who starts from a point of "creative deployment," drawing on a set of improvised tools.[16] This approach later characterized his make-do theatrical stagings with Cyclona and his early work with Asco. His adoption of an enigmatic moniker involved the conception of his entire life as a work of art: "I think my life and the art that I create early on blended, from the performances, from the costumes, from the physical transformations. It was knowing that these things were like a live performance, that life itself was going to be this live performance, and that my cues came from the big range of people before me that utilized that same thing about costumes, about transformation, about change, about the body."[17]

Indeed, Gronk's outlandish appearance and self-conscious theatricality during his teenage years constituted an aesthetic rebellion, a response to and transformation of a potentially stifling environment. "Anarchy in East L.A." could well have been the title of Gronk's life and art in those early years. There was also something nomadic about him. During this period of his life he was living with his aunt on a sporadic basis and was even known to sometimes sleep on the roof of East Los Angeles College. It was precisely these qualities that attracted the admiration and curiosity of other outsiders in the neighborhood, some of whom would become collaborators. As Ascovite Patssi Valdez recalls, "He was walking around in sequined tops with fishnet stockings under jeans with holes all over them, this huge knotted hairdo. He'd have puppy dogs sewn on his pants, stones and jewels. I was fascinated by the fact that he could walk the streets and not get murdered looking that way, in East L.A."[18]

If there is a milestone that marks the beginning of Gronk's life as an artist in a public setting and the galvanizing of his earliest collaborations, it is probably November 1969, when he wrote and directed an obscure but nonetheless watershed artistic event in Chicano art: the protest farce *Caca-Roaches Have No Friends*. Not only did the performance prove an aggressively absurdist, even confrontational statement of purpose, it also marked perhaps the initial meeting of the individuals who would soon form Asco. Patssi Valdez eventually performed in the piece, while Willie Herrón and Harry Gamboa Jr. attended as spectators.

Gronk, then only fifteen years old, wrote the play as a protest against the government and convention in general. At the center of the tempestuous performance was Robert Legorreta as Cyclona, a drag queen sporting long sideburns and garishly garbed in a metallic bra, nightgown, and fur. Drawing on Legorreta's own excessive style and persona, Gronk modeled Cyclona's role on the character of La Saraghina in Fellini's *8½* (1963) (figs. 13, 14).

According to Cyclona, he and the late Mundo Meza, a subcultural star in the East Los Angeles pantheon of artistic characters, used to be followed by what they called a "barbarian/beatnik" as they took their daily stroll down Whittier Boulevard. They were usually dressed in drag and this "beatnik" would sneak up on them at the Goodwill outlet or would dart in and out of doorways as he followed them, clearly fascinated by the pair. "One day, he

Figure 13. Gronk, from *God Our Nurturin' Mother*, 1972. Color photograph. Shown: Cyclona. The Fire of Life: The Robert Legorreta/Cyclona Collection, CSRC Special Collections.
Reproduced by permission of the artist.

Figure 14. Marcello Mastroianni and Eddra Gale in *8½*, 1963. Directed by Federico Fellini.
Courtesy of Photofest.

approached us," said Cyclona, "and asked us if we wanted to put together a production. This person turned out to be Gronk!"[19] The production was *Caca-Roaches Have No Friends*. The fact that his first public artistic venture was a theatrical presentation underlines an orientation toward performance that has persisted throughout his career. The title of the work was an attempt at irony and foreshadowed the similar title of a future work, Oscar "Zeta" Acosta's 1973 novel, *The Revolt of the Cockroach People*.

There were three performances of *Caca-Roaches*. The first one took place on November 20, 1969, in Belvedere Park's Outdoor Theatre on the Lake. Cyclona recalls that the performances were raucous:

> The second performance was in the indoor gymnasium at Belvedere Park and the local paper advertised it as a play for the whole family. And, sure enough, whole families came to the theater of the absurd. However, when I got to the infamous cock scene the audience went berserk! They started throwing eggs at me and burning the giant indoor trashcans. The police rushed the stage and stopped the show. We ran for our lives.[20]

In the cock scene, a shirtless Mundo Meza wore a large balloon and two eggs in a grotesque parody of male genitalia. Kneeling in front of him, Cyclona caressed the balloon penis and then popped it before crushing the eggs and throwing them to the floor or into the audience. This shocking eruption of transgressive sexuality and aesthetic deviance in a public, family-oriented arena constituted a simultaneously satiric and angry gesture against an experience of alienation and disenfranchisement. Perhaps most significant was the fact that this performance also represented an assertion of sexual difference within a morally conservative and often hostile environment. While Asco took shape as a collective over the next few years, Gronk continued this line of collaboration with Meza and Legorreta—completing surreal series of photos and drawings, designing costumes, and staging performance pieces, including the 1972 *Cyclorama*.[21] Their stylish, spectacular subversion of gendered categories remained consistent throughout, with the ever-excessive Cyclona reigning as undisputed star.

Gronk grew up in an educational system that encouraged young Chicanos to train as mechanics or construction workers or, more insidiously, to participate in the escalating Vietnam

Figure 15. Cyclona, Gronk, and Patssi Valdez, 1987.
Photograph by Chavez Raving. Reproduced by permission.

War (he would later be drafted and quickly discharged). His flamboyant persona and stylish disruptions marked the vocation of artist as a refusal and reinvention of this environment. If Gronk would later characterize himself as an "urban archaeologist," these early years already suggested his ability to assemble the magical, the fantastic, and the defiant, including a cohort of like-minded collaborators, from an environment of scarcity and limited options (fig. 15).

PAINTING HISTORY
THE POST-CHICANO MURALS OF AZTLÁN

> We were the true representatives of the street, the real Chicanos who were taking it all the way. We weren't romanticizing or glorifying what the streets were like. . . . We wanted to reach inside and pull people's guts out.
> —Willie Herrón, interview with author

The term *Chicano*, originally a derogatory expression (as in *la chicanada*), refers to a politicized Mexican American. That is, a Chicano is someone who is critically aware of the systematic, institutionalized inequality to which Mexican Americans have historically been subjected in multiple arenas: education, economics, social status, urban geography, and civil power. The project of politicized identity formation and cultural affirmation that began in the 1960s was tightly intertwined with reconceptualized notions of geography and citizenship. Not only did Chicanos assert their historical presence in the Southwestern United States since the earliest days of Spanish exploration, but they reclaimed the region as Aztlán, the mythical homeland of the Aztecs.[1]

This empowering articulation of place and identity marked a significant break with the political orientation of previous generations. With Mexican Americans facing systemic discrimination as immigrants and racialized "others," the community's early leadership (in organizations such as the League of United Latin American Citizens, or LULAC) often attempted to strike an uncomfortable balance between cultural (including linguistic) pride and acculturation or "Americanization." Small pockets of radicalism and occasional episodes of cultural resistance in Mexican Los Angeles early in the twentieth century were precursors to the politics of the Chicano movement. But it was not until the 1960s that an entire generation was marshaled under the aegis of an oppositional identity. The broader social upheavals of the decade helped to propel this shift: cultural movements, civil rights activism, and generalized antiwar fervor all encouraged political awareness among young Chicanos and provided an incitement to action. Spurred on by the anti-authority zeitgeist of the time, Chicano youths walked out of their substandard schools (epitomized by the 1968 "blowouts" in

East Los Angeles), protested the unfairness of the Vietnam War, in which a disproportionate number of Chicanos were slaughtered, and began to find their social, political, and artistic voice.[2]

Chicanos were aware that the officially sanctioned narrative of the United States virtually excluded them from the story. As Edward Said has pointed out, "The United States, as an immigrant society composed of many cultures, has a public discourse more policed, more anxious to depict the country as free from taint, more unified around one iron-clad major narrative of innocent triumph" than one would expect given the national penchant for proclaiming faith in truth and justice.[3] Chicanos are absent from the official story because to include them would be to admit and accept a history of racism, illegal usurpation of territory, and injustice spanning generations.

Chicanos in the 1960s and 1970s were faced with a dilemma. They had a counternarrative to tell, but they owned no newspaper chains or broadcast outlets. The news about these emerging political beings, their beliefs, and their culture was spread by word of mouth, in alternative publications, and through murals. The previously blank walls in East Los Angeles and other urban barrios across the Southwest were soon covered with scenes of ancient Mexican life, farmworkers on strike, blue-cloaked Virgins of Guadalupe, Mexican revolutionaries, and other cultural images. The murals fed a deep hunger for cultural knowledge and positive self-imagery within an oppressive social and physical environment. They thus became a form of public theater and literature. The murals were the texts, the artists were the teachers, and the members of the community were the "readers" learning about a movement alternately ignored and vilified by the mass media. Some of the people painting stories on walls would become lifelong artists.

By the 1970s, the blank wall had become the preeminent space for Chicano art in Los Angeles. The murals became territorial markers and community billboards. With the support of grassroots organizations and collectives, many artists who eventually became well known, such as Carlos Almaraz, Judy Baca, John Valadez, and Wayne Alaniz Healy, started out as muralists. Another who did so was Gronk. Like many other Chicano artists, Gronk survived and flourished by acknowledging and juxtaposing images from two cultures. He and Willie Herrón were responsible for some of the most memorable murals created in Los Angeles during the Chicano mural movement of

the 1970s (fig. 16). The city offered two main artistic precursors and inspirations to guide and inspire them: Mexican muralism and Chicano graffiti. These antecedents influenced the wall works that were being painted in the urban barrios of East Los Angeles, each providing retrospective models of the intersection between political opposition, cultural affirmation, and aesthetic practice.[4] Thus Chicano muralism emerged as the culmination of a multigenerational legacy of art and resistance.

Perhaps most obviously, Chicano muralism owes a significant debt to the muralist movement of postrevolutionary Mexico. Along with Diego Rivera and José Clemente Orozco, David Alfaro Siqueiros was an important precursor, and the works he produced in Los Angeles during the early 1930s were particularly influential. He dedicated two controversial murals, *América Tropical* (1932) and *Street Meeting* (1932), to the working class of the city. If Mexican muralism provided a model of history and identity articulated as a visual lesson, these particular murals also intervened in the 1930s context of contentious labor activism, the deportation of much of the city's Mexican American population, and the general devaluation of anything Mexican.[5]

The massive *América Tropical*—it measured eighteen by eighty-two feet—was painted in Olvera Street, the city's founding place. It depicted a barefoot Mexican Indian strapped to a wooden cross, with an American eagle perched above his head, extending its rapacious talons. The mural's unmistakable condemnation of racism and exploitation caused an immediate backlash: the artwork was whitewashed by the city and, soon afterward, Siqueiros was expelled from the United States. The no less incendiary *Street Meeting*, which depicts a socialist activist lecturing a multi-ethnic group of attentive workers, was also eventually whitewashed. The fact that many Chicano murals suffered the same fate (including a work in El Monte by Gronk and Roberto Gil de Montes) only reinforces their connection to a history of socially engaged public art in Los Angeles.

For many Chicano artists, the legacy of Mexican muralism intersected with the long-established practice of graffiti. In East Los Angeles, graffiti started out sometime in the 1930s as scratchings and markings setting off the territories of different neighborhoods and rival gangs. In this respect, both aesthetic embellishment and assertions of identity and place had already become associated with neighborhood walls. As Marcos Sánchez-

Figure 16. Harry Gamboa Jr., *Black and White Mural/ Muralists*, 1979. Color photograph. From left: Willie Herrón III and Gronk.
Reproduced by permission of Harry Gamboa Jr.

Tranquilino argues, "For many muralists, the long established practice of *barrio* calligraphy, a highly developed system of artistic standards by which to properly create and appreciate neighborhood 'graffiti,' played a crucial role in preparing them to reattack the same walls with *movimiento* imagery."[6]

Gronk himself is explicit about the impact of graffiti on his formation. "I didn't go to galleries or museums. They weren't part of my childhood. But all I had to do was walk outside my front door to see visual images all around me. Graffiti was everywhere and it helped develop a sense for what I wanted to do."[7] In fact, Gronk likes to tell the story—it may be apocryphal—that after Herrón asked if he wanted to paint a mural together, he immediately ran home and looked up the word *mural*. And once he knew what it meant, he thought that he could do that. Then he ran back and said yes to Herrón.

In any case, the experience of living in Los Angeles had an effect on the development of Chicano artists. For one thing, there had always existed a paradoxical tension between the reality of a large, marginalized underclass and the media-constructed fantasy of a glamorous city. For many Chicano artists, a fragmented, decentered desert city dotted with innumerable strip malls and

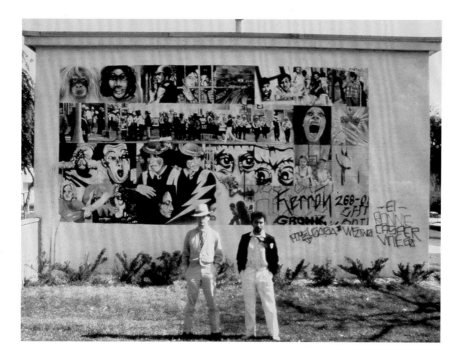

imported eucalyptus, palm, and jacaranda trees offered a strange type of absurdist inspiration. Given all these precedents and influences—the censored *América Tropical*, the encoded threatening language of urban graffiti, the dystopian subtext of Los Angeles—Chicano muralists of the period were able to draw on a considerable bank of intense visual imagery that helped produce powerful wall works, a repertoire of strategies articulating the nexus of aesthetics and identity.[8] One of those strategies involved a make-do aesthetic. Herrón describes the genesis of the first mural with Gronk:

> And so then I called Gronk and I just said, "Gronk, they'll give us all this paint. We'll split the paint fifty-fifty and let's just do it in black and white. This way you have all the colors to work on your paintings and I'll have colors to work on my paintings and we'll only use black and white. And that's what we'll be paid." That's like paying ourselves. We keep the colors for our paintings and we'll do the mural in black and white [*laughs*]. And I think we were conscious at that time that that would be unusual in the age of color televisions, in the age of color just being so powerful, super graphics and all that. We just said it would be cool to do the mural absent of all color.[9]

Tomás Ybarra-Frausto has defined this sensibility and approach as "rasquachismo."[10] He notes that "rasquachismo is an underdog perspective—*los de abajo* . . . it presupposes a world view of the have not, but it is a quality exemplified in objects and places and social comportment . . . it has evolved as a bicultural sensibility."[11] Later, in an essay in *Distant Relations*, Amalia Mesa-Bains elaborates on the concept: "In rasquachismo, the irreverent and spontaneous are employed to make the most from the least."[12] If to make something out of nothing became the *sine qua non* of early Chicano art, Gronk and Herrón did so in a way that gave full attention to the conceptual and political implications.

The mural they painted together was commissioned as part of a beautification project at the Estrada Courts housing project, for which eighty-two murals were painted between 1972 and 1978. It memorialized one of the most significant events in Chicano history: the national Chicano Moratorium, a massive protest by 30,000 Chicanos against the Vietnam War (fig. 17). The demonstration took place on the smoggy Saturday afternoon of August 29, 1970. In Michael Parrish's *For the People: Inside the Los Angeles County District Attorney's Office, 1850–2000*,

Figure 17. Willie Herrón III and Gronk, detail of *Black and White Mural*, 1973. Acrylic on concrete, 32 x 20 feet. Estrada Courts housing project, 3221 Olympic Boulevard, Boyle Heights, East Los Angeles. Photograph by Dieter Pinke. Reproduced by permission of the artists.

there is an account of the rally, the riot that took place, and the killing of journalist Rubén Salazar:

> During the riot, sheriff's deputies received a citizen's report that one or more armed men had entered the Silver Dollar Café, an East Los Angeles tavern near the center of the disturbance. Salazar and Restrepo [a KMEX-TV reporter] were inside at the time, among a dozen patrons, having stopped to use the restrooms and then lingering to drink a beer. Standing on the sidewalk, Sheriff's Deputy Thomas H. Wilson fired two heavy-duty Federal Flite-Rite tear gas projectiles through the curtained bar entrance. The high-velocity, pointed-tip, teargas shell, ten inches long and an inch and a half in diameter, is designed to penetrate walls in barricade situations. Its manufacturer specifically warned that it was "Not to be used in crowd control."[13]

Tear gas filled the place as people crawled out on their hands and knees. Restrepo wanted to go in for his boss, Salazar, but was held back by the police. As the district attorney's report noted, "Almost two hours passed because deputies had no gas masks that would allow them to reenter the bar. Salazar's body was eventually pulled out of the bar by a civilian. The first projectile fired had passed completely through his skull, killing him instantly."[14]

At the time of the killing, Salazar was a widely read columnist who wrote about Chicano issues for the *Los Angeles Times* and was also the news director of KMEX-TV, the main Spanish-language TV station. The killing of such a well-known figure on the day of the Moratorium, after what many in the Chicano community considered a police riot, sparked outrage throughout East Los Angeles. In the end, the district attorney refused to file murder charges against the police officer. Historian Mario T. García argues that for Chicanos, the Salazar murder and inquest "silenced an expression of hope that American society would keep its promises."[15] Salazar's death mirrored similar colonialist police actions taken throughout modern history in Algeria, Vietnam, Guatemala, India, and elsewhere. Just as the disproportionate Chicano death rate in Vietnam was a human as well as a Chicano tragedy, the Chicano Moratorium and the death of Salazar resonated with events throughout the world.

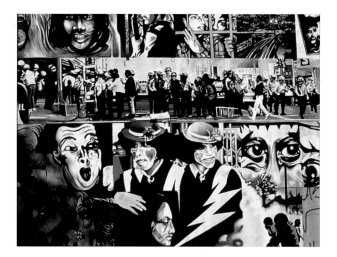

Figure 18. Willie Herrón III and Gronk, detail of *Black and White Mural*, 1973. Acrylic on concrete, 32 x 20 feet. Estrada Courts housing project, 3221 Olympic Boulevard, Boyle Heights, East Los Angeles. Photograph by Dieter Pinke. Reproduced by permission of the artists

The story of that day of antiwar protest and its aftermath is what makes *Black and White Mural* such a powerful piece (fig. 18). Although the mural is on a flat wall, the work conveys a sense of depth. The mural juxtaposes block images in black and white. They convey the illusion that you are looking at screens, as if several TVs were piled atop one another in four rows, broadcasting scenes or news reports from different places and times of the day. Each "screen" or image tells its own story, but the overall impact comes from their combined visual force. One of the centerpiece scenes shows the police, bystanders, and others outside the Silver Dollar Café. Another depicts a woman next to a religious image, screaming. Another presents young people behind bars as a policeman in riot gear stands guard. While this composition emerged in part from a collaboration undertaken in stages over nearly six years, it also self-reflexively exposes the grid structure used by muralists to transfer artwork to walls.[16] Furthermore, as Mario Ontiveros argues, the block structure "invites viewers to 'read' the scene as a progression of events—one frame after another. Yet small fissures continually clog the narrative flow."[17] Representations of the Moratorium and police repression are thus set next to cinematic references and depictions of Asco performances, avoiding the monolithic, "mytho-historical" narratives constructed by many Chicano muralists of the period.[18]

These types of conceptual installations have become familiar, as they have been presented in museums and galleries over and over again. But Gronk and Herrón's *Black and White Mural* was painted in 1973 and located in a housing project, not in a museum or gallery. In effect, the artists rewrote recent history using the visual style of the very media that had presented distorted images to the public—television and newspapers. And they did so using the community itself as their "canvas," rather than the usual sites for the news media (the home) and the art market (gallery space).[19]

Through this aesthetic approach, the pair created one of the first post-Chicano murals that would, in turn, lead to other forms of post-identity art. *Black and White Mural* can be placed alongside Asco's walking murals and Herrón's *The Wall That Cracked Open* (1972, between Carmenita and Miller Avenues, City Terrace, Los Angeles) as examples of a fresh style of muralism that created a new cultural space. In essence, the post-Chicano

aesthetic "implies a search for order on a vaster scale than is found in Chicano art. . . . Although Chicano art was a prerequisite for these artists, their work . . . attempted to grasp truths that are global in the truest sense."[20] Just as significantly, this sensibility also rejects (or makes ironic) the prevalent use of pre-Columbian imagery and reference to a pantheon of masculine heroes in favor of a more explicit engagement with the urban environment and contemporary events. Post-Chicano conceptions of identity complicate notions of a return to indigenous authenticity, instead acknowledging a diverse, fragmentary array of cross-cultural interfaces and pop culture influences.

In its earliest stages, Chicano muralism relied heavily upon images of cultural rejuvenation and glorified the past, whether they referenced Aztec ritual, religious symbols, or farmworker boycotts. Gronk and Herrón thus attempted to push Chicano muralism in new directions by consciously rejecting this already conventionalized vocabulary. Gronk explained: "I don't need that imagery in my work or to dwell on it so it's not going to be a part of my language." In his view, he could only depict what he knew: "I don't do Virgins of Guadalupe. I don't do corn goddesses. I can only do what I'm about, and I'm an urban Chicano living in a city. . . . I can be influenced by a war that's taking place, that's killing off people. . . . And now being tear-gassed in your own country. We do live in an absurd kind of world and things like this happen."[21]

When Gronk relates the genesis of *Black and White Mural*, he consequently draws a link between what was happening in East Los Angeles and what has happened in world history. He invokes the influence of 1960s political documentaries and *La battaglia di Algeri* (Battle of Algiers, directed by Gillo Pontecorvo, 1965), particularly their use of stark black-and-white photography. He makes a direct connection to the classic French film *Les enfants du paradis* (Children of Paradise, directed by Marcel Carné, 1945), comparing the conditions under which it was made with the situation in East Los Angeles at the time of the Moratorium:

> If you look at that piece, there is this character amongst all the images of East L.A., the riot that is taking place at that time, or the police coming in and hitting people with batons and tear-gassing them in the park, but in all of that there is an image of this mime. And the mime is Baptiste from *Children of Paradise*. . . . And the image of that is in there because

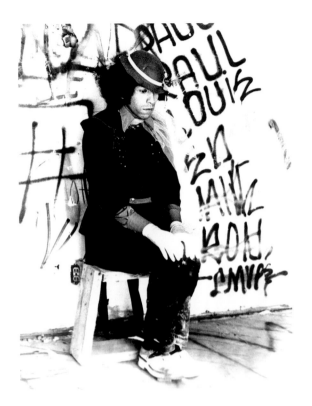

Figure 19. Gronk in performance, 1974. Gronk used the same character, Pontius Pilate (aka Popcorn), in *Stations of the Cross*, 1971, and *Black and White Mural*, 1973.

Photograph by Chavez Raving.

Figure 20. Jean-Louis Barrault in *Les enfants du paradis* (Children of Paradise), 1945. Directed by Marcel Carné.

Courtesy of Academy of Motion Picture Arts and Sciences.

that particular film was done during an occupation, when Germany was in France. . . . Well, it was the same thing; it's a feeling of occupation by the police in East Los Angeles.[22]

By placing the image of Baptiste (Jean-Louis Barrault), the mime, in the mural, Gronk conveys the pain of the event. Baptiste's face, expressing horrific shock, is set next to the bloody body of the assassinated Salazar. In the film, Baptiste is the sensitive artist. Gronk doesn't have to tell us how he himself felt about the murder; the artist figure, Baptiste, does this for him. In this mural and with the use of this film image, Gronk becomes both a Carné and a Barrault at the same time. With the silent mime set next to the dead Salazar, Gronk uses cinematic montage to suggest that there is no voice for the voiceless in East Los Angeles. In his horrified silence, the mime responds to the death of the person who spoke for the people of East Los Angeles. In his performance art, and in the mural itself, Gronk visualized this connection between himself as an artist and Baptiste-Barrault (figs. 19, 20).

In 1973 Gronk and Herrón completed *Caras*, a mural (no longer extant) in a pavilion at City Terrace Park in East Los Angeles. This mural again captures the poignant anger of their work during this period. It is helpful to think of the place where the mural existed for nearly twenty years: a recreation center that was often a nightly gathering spot for lost and searching youth. The faces in this mural are overlaid with graffiti, creating a rough-hewn texture of life without redemption or salvation. The eyes, in particular, seem to be staring at us, the viewers, with a defiant hurt that comes from having seen too much, too soon. The blood-red lips and shiny white teeth in stressful grimaces tell their own story. We see hope and fear, the violence of poverty, the injustice of miseducation, and the crowded conditions of urban life for poor people. The imagery shows us the madness, the turmoil, the chaos of life in the East Los Angeles barrio in 1973 (figs. 21, 22).

This style, which appears again, fully developed, in Gronk's set for *Ainadamar*, is faintly reminiscent of Picasso's *Weeping Woman* (1937) and of expressionism. It also calls to mind the muralism of David Alfaro Siqueiros and José Clemente Orozco. And, yet, the graffiti—the flat black and chalky white signatures of the young people, like El Smokey, who tagged the mural—along with the flesh colors and blood reds, the startled eyes and eyes of rage, define a Chicano art that is setting its own terms in its own space. Indeed, Gronk was already working with a certain palette, a certain style: a white chalkiness that would become La Tormenta's V-shaped back, the thick red lips that would later emblazon the 1989 canvas painting *Red Lips*, with their vaginal-anal shape. Above all, his effort to combine urban imagery, mass media, and artistic influences into a "language" to depict the violent absurdity facing Chicanos resulted in an utter density of color, composition, and form (figs. 23, 24).

Gronk returned to mural painting in 1981 for the *Murals of Aztlán* show at the Craft and Folk Art Museum in Los Angeles, working again in conjunction with Herrón.[23] Clearly evident are aspects that echo the *Caras* mural, along with elements on which Gronk would expand in his paintings. Taken together, *Caras* and the *Murals of Aztlán* piece point to elements that would emerge in Gronk's *Pérdida* (*ACCENT ON THE e*). This is a mature artist's rendering of what he had painted on a curving cement wall in a public space nearly thirty years before. In both instances, layered

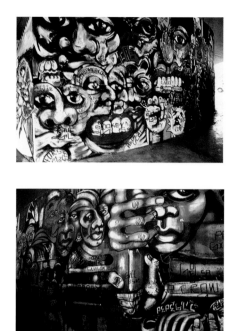

Figures 21, 22. Willie Herrón and Gronk, details of *Caras*, 1973. Acrylic on concrete, 57 x 13 feet. City Terrace Park, Los Angeles.

Photograph by Shifra Goldman. Reproduced by permission of the artists.

mixtures of paint and jagged scratchings create emotional density and make a statement on disillusion and glorious existential uncertainty (fig. 25).

With *Black and White Mural* and *Caras,* Gronk and Herrón created the raw apogee of muralism in Los Angeles. These images captured perfectly the furious sensibility of those times, not through a "return to origins" or gritty social realism, but by exploring tendencies and conceptual orientations that would occupy future generations of Chicano artists.

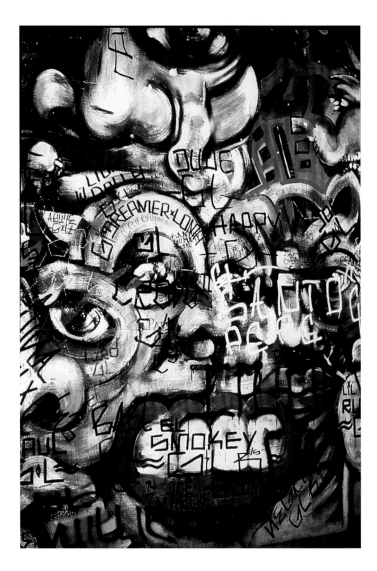

Figure 23. Willie Herrón and Gronk, detail of *Caras,* 1973. Acrylic on concrete, 57 x 13 feet. City Terrace Park, Los Angeles.

Photograph by Shifra Goldman. Reproduced by permission of the artists.

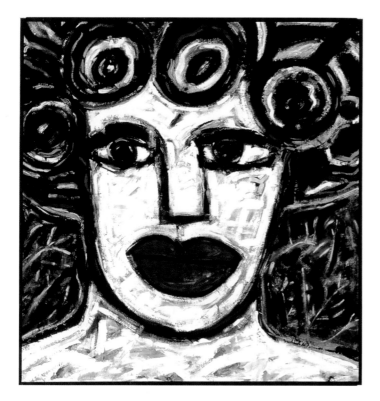

Figure 24. Gronk, *Red Lips*, 1989. Acrylic on canvas, 71½ x 68½ inches. Private collection.

Photograph by William Nettles. Courtesy of Daniel Saxon Gallery, Los Angeles. Reproduced by permission of the artist.

Figure 25. Gronk, *Pérdida (ACCENT ON THE e)*, 2000. Mixed media on handmade paper mounted on wood, 60 x 118 inches. Private collection.

Photograph by Peggy Tenison. Reproduced by permission of the artist.

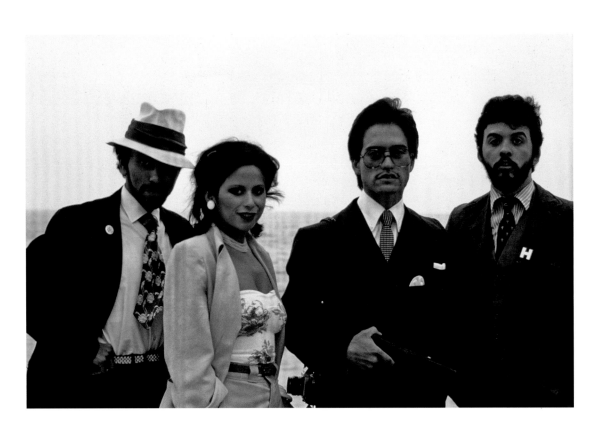

Figure 26. Harry Gamboa Jr., *Asco 1976*, 1976.
Color photograph. From left: Gronk,
Patssi Valdez, Willie Herrón III, and Harry Gamboa Jr.
Reproduced by permission of Harry Gamboa Jr.

Figure 27. Claude Brasseur, Sami Frey, and Anna Karina
in *Bande à part* (Band of Outsiders), 1964. Directed by
Jean-Luc Godard.

ASCO'S NO MANIFESTO
THE AVANT-GARDE IN EAST LOS ANGELES

"Why," said the Dodo, "the best way to explain it is to do it."
—Lewis Carroll, *Alice in Wonderland*

Asco was unlike anything ever seen in Los Angeles (fig. 26). The collective tapped into something deep in the psyche of young people in the 1970s and long after. Even today, many youths of different backgrounds are drawn to the group's singular and spectacular essence. Sean Carrillo perhaps put it best when he recalled his own experience:

> I remember being enthralled by the image of Patssi [Valdez] taped to the wall. But what was even more fascinating was the fact that the people creating them and I shared a culture. This was amazing. I don't mean Chicano culture or Latino culture. I could see these photos were more than the usual images found on walls all over the east side. These images went far beyond the usual corn, religious figures and the like. In fact these images had nothing to do with them and neither did I.
>
> Previously all the work I had seen and all the images produced by "Chicano Artists" were foreign to me. I had never been in prison. I felt no kinship to humor about marijuana or drug use. La Virgen de Guadalupe was an interesting legend but Our Lady of Fatima was far more compelling. As Marian apparitions go, Our Lady of Guadalupe is a "B" sighting with a minor miracle attached. Fatima was more recent and it involved children. It also carried the added mystery of the three secrets . . . but, who shared my sensibility?[1]

What Carrillo and others saw in Asco's post-Chicano sensibility was constant formal innovation that accompanied a reworking of contemporary urban identities. For Gronk, Asco was creative excitement. He has compared the experience to a famous scene in Jean-Luc Godard's film *Bande à part* (Band of Outsiders, 1964), where the three main characters race through the Louvre to see whether they can break the record for the fastest tour of the museum (fig. 27). Not coincidentally, the title of the film also provides an apt description of the group itself, in terms of both their relationship to place and their critical distance from more nationalist strains of Chicano art.

As a group of high school friends, Gamboa, Valdez, and Herrón had already begun experimenting with art and style as a response to an experience of marginalization. Regarding themselves as stylish, party-going "jetters," the students self-consciously exuded an "artistic" and intellectual air, choosing high fashion and cool detachment over the violence of the gang life that surrounded them. Given such a stance, it was perhaps only a matter of time before they crossed paths with Gronk. After their initial contact during the performances of *Caca-Roaches Have No Friends*, the four began meeting together and contributing artwork to *Regeneración* after the magazine hired Gamboa as editor. It was here that the group began collaborating in earnest, a period that Gronk regards as a turning point in his life:

> So we are in a garage together and we're talking and laughing, and all of a sudden I think, you know, "This is where I think I belong." And the drugs and the chaos of the other group [that included Cyclona and Mundo Meza], it just was not something that I thought I could stay with. So I think Cyclona thought that was a rejection and so did, perhaps, the other artists within that group. "Oh, look at it. He's going with those straight kids, and it's like he's denouncing us." And that's not the case. It was just maturing and growing and finding that here were three other people and that here was a familiarity and a camaraderie that I really enjoyed and a creative spark . . . that we knew that we were different and we also were learning from one another. . . . And we produced a body of work, but [with] Asco there were no bylaws, there were no fees, there were no discussions, manifestos, or anything like that. In my take on things, that was fine. Our manifestos came out of our No Movies. Our manifesto came out of like the critiques of our fellow artists at that particular moment in time. . . . It set a foundation for me.[2]

For a group of self-styled misfits and cultural radicals, Asco quickly became a surrogate family and refuge. In looking back at her time with the group, Valdez says, "They're related to me. Those friends were my art friends, productive, creative friends. . . . They're like my brothers" (fig. 27).[3]

Significantly, Asco afforded the four members the ability to explore individual interests through collaboration while also allowing each the autonomy to sustain a career beyond the group. Herrón honed his distinctive visual style and became the front man of the punk band Los Illegals (Gronk co-wrote the

group's first single, "El Lay"). Valdez cultivated her fashion and set design, also making forays into painting and photo collage. Gamboa pursued photography and writing and shared with Gronk a fascination with wordplay and a cinematic sensibility. Valdez recalls Gronk's particular influence upon the collective as art director and No Movie auteur:

> I used to call him my Mr. DeMille because when I was in front of that camera so much being photographed, Gronk was my director. Head up. Chin up. Stomach in. Shoulders back [*laughs*]. You know, for the Asco photos. And I wanted that because I couldn't see myself and I was posing. . . . So I [would] go, "Gronk, you need to help me." And he would give me signs of what to do so I could look right in front of the camera. So he became my mentor and my director in many ways.[4]

The classic Asco period, with the four original members, stretched roughly from the early 1970s to the early 1980s. Although now well known as Asco, the group worked together for at least three years before taking the name. Herrón explains that they first used the word for an exhibition at Self Help Graphics in 1974, agreeing to call the show "Asco, an Exhibition of Our Worst Work." Before 1974, he adds, "that word had never entered our vocabulary."[5] By appropriating and embracing the visceral, negative reactions to their work, members of the group affirmed their positions as outsiders. Eventually conceiving of Asco as the Chicano avant-garde, the collaborators consistently explored the productive tension between these two terms and inhabited the margins of both movements. They ultimately proposed a double-edged critique: while confronting an elitist, Eurocentric art world with an activist approach grounded in the Chicano movement, the group also maintained an often antagonistic relationship with the aesthetics and politics of fellow Chicano artists.

In 1972 Asco made one of its major marks, literally and figuratively, initiating in the process a critical dialogue with the art institutions of Los Angeles. Gronk, Gamboa, and Herrón paid an homage of sorts to Godard's films with a touch of *nouvelle vague* (new wave) Chicano rage by spray-painting their names gang-style on the outside of the Los Angeles County Museum of Art (LACMA). They then returned the next day to photograph their tags with Valdez, as she poses in profile above the names, looking slightly bored and weary, like Anna Karina in Godard's *Pierrot le fou* (1965). Known as *Spraypaint LACMA* or *Pie*

in Deface, this bold act of conceptual art has been immortalized in Chicano art lore and beyond (fig. 28).[6] The piece emerged from Gamboa's meeting with a LACMA curator, who told him that Chicanos were usually in gangs and that when they made art it was folk art, but certainly not fine art. Gamboa reported this back to his Asco cohorts, and they decided that if their work would not be exhibited, they would sign the museum and call *it*—the whole publicly funded museum, including bricks and mortar and everything inside—their artwork. As Karen Mary Davalos suggests, this gesture satirized the signature as a mark of authenticity, a guarantor of market value, and a construct of ethnocentric conceptions of artistic production.[7] At the same time, the act of tagging played upon prevalent "gangster" stereotypes and defiantly placed graffiti within the realm of "fine art," simultaneously branding the museum as an exclusionary and racist institution while claiming it as a work of Chicano art.[8]

It was a clever idea and perhaps the most audacious piece of conceptual art ever affiliated with LACMA. The idea to tag the building with their names and then document the act is a perfect example of the type of inspired conceptual impulse that set Asco apart from most Chicano artists of the period and potentially placed them in the same category as other conceptual art collectives of the time such as Fluxus. But unlike these latter groups, Asco embedded its protest and critique in the social realities of East Los Angeles in the 1970s, an orientation that perhaps accounts for the misinterpretation and dismissal of their work by art world gatekeepers. In a 1980 interview, Gronk summarized the situation:

> Because when someone does not belong to the dominant culture and yet comes up with concepts and/or theories that are equal to other ideas in the market, he is generally overlooked and not taken seriously by those who are in fact agents provocateurs of that culture, such as art critics, curators, and museum directors. . . . If a Third World artist creates a conceptual work, it is called folk art, but if Chris Burden, Alexis Smith, and others create a similar work, it is hailed as fine art.[9]

In a letter to the editor of *Neworld*, Los Angeles art critic Peter Plagens responded to Gronk's invective, ironically demonstrating the perspective the artist described in the interview. Rather than perceiving the relevance and specificity of social

Figure 28. Harry Gamboa Jr., *Spraypaint LACMA*, 1972. Color photograph. Shown: Patssi Valdez in the Asco performance piece.

Reproduced by permission of Harry Gamboa Jr.

critique, Plagens reduced Gronk's work to derivative imitation:

> What Gronk does—that all too common succotash of Andy Warhol camp, fragmented Berthold Brecht, and Sunset Strip runaway self-consciousness—has no special claim to being "the true avant-garde of Los Angeles," unless we're to believe that an artist who chooses a funny name and runs around doing funny things is automatically ahead of those who stay in the studio and make art objects.[10]

This debate aptly illustrates and explains Asco's and Gronk's systematic, ongoing exclusion from the avant-garde canon. Quite simply, they are largely excluded from the record. For example, in his landmark exegis of Los Angeles, *City of Quartz* (1990), Mike Davis, a self-styled progressive, fails to count Asco when he discusses the avant-garde waves of the city. He mentions the Black Arts Movement, the Ferus Gallery Group, and others from the 1960s and early 1970s, as well as later "fledgling attempts" to question the corporate takeover of the Los Angeles culture industry, including the "Los Angeles School" and "the community intellectuals of gangster rap."[11] There is no mention of any Chicano artistic or intellectual

avant-garde. In an interview with Jeffrey Rangel for the Smithsonian Institution, Gamboa notes, "And, of course, Asco's ignored. And even *Art in America* I think . . . commented, 'How can you forget Asco?' But it's not that they forget Asco. They know who Asco is. And they know who everyone who was in Asco was. It just doesn't fit."[12]

Asco's absence from prevalent histories of the avant-garde in the United States reflects the way art history is typically constructed. On the one hand, the "stereotypic vertigo" of the gatekeepers has historically relegated "ethnic art" to specific categories and concomitant aesthetic criteria.[13] On the other hand, Asco lacked the institutional ties and art world legitimacy that sustained other avant-garde art collectives and secured their legacy. By working from a culturally specific point of reference, Asco ensured that its interventions would remain illegible to an art world that summarily dismissed Chicano artists. Asco was thus not considered part of the art world's conversation, even when they engaged in debate over its direction. German artist Joseph Beuys used to refer to the "art world ghetto." Ironically, Asco was from a ghetto, but could not obtain entrance into the tightly restricted world of elite art. Asco was outside the outside. The group critically challenged the alternative sector and the mainstream as well as the political movement that helped give birth to Asco, constituting a parallel art movement alongside these other, more recognized approaches.

The group's engagement of Chicano art was perhaps even more scathing, as they consistently critiqued the limited visual vocabulary and didactic social realism that accompanied its more nationalist manifestations. Although Asco emerged from the political activism of the Chicano movement, Herrón remembers that the group wanted to say something new. They saw Chicano artists painting indigenous imagery, religious symbology, and Mexican revolutionary icons, for instance, while refusing to adapt their work to contemporary circumstance:

> They're not really re-creating it and they're not altering or they're not bending it and they're not including certain levels of their life that could possibly shed a new light on it, reuse it in a new way. And that's why . . . we were striving for that and trying to achieve that as a group, already representing something that was different, approaching art differently, not using those, but trying to come up with new symbols.[14]

Herrón's comment is another indicator of Asco's constant espousal of artistic and stylistic innovation as well as the group's insistence upon a critical engagement with the realities of contemporary urban existence. His assertion that Asco sought to re-create, bend, and reuse as well as to approach art "differently" and "to come up with new symbols" is probably the most explicit description of the group's working philosophy (they never issued a formal manifesto). His retrospective statement of the collective's desire and intent offers insight into their aesthetic assumptions and their aspirations to revise the artistic values of Chicano art and, by extension, all art.

In 1971, Asco created *Stations of the Cross*, an overtly agitprop act consciously designed to protest the continued high Chicano death rate in Vietnam. Gamboa describes the performance:

> On December 24, 1971, Herrón, Gronk, and Gamboa arrived unannounced on the corner of Eastern Avenue and Whittier Boulevard. Herrón was the representation of Christ/Death, dressed in a white robe that bore a brightly colored Sacred Heart, which he painted in acrylic. His face had been transformed by makeup into a stylized calavera. Gronk personified Pontius Pilate (aka Popcorn): he wore a green bowler hat, flaunted an excessively large beige fur purse, and carried a bag of unbuttered popcorn. Gamboa assumed the role of a zombie–altar boy and wore an animal skull headpiece to ward off unsolicited communion.[15]

The three carried a painted cardboard cross along Whittier Boulevard, which was packed with holiday shoppers. As Gamboa recalls, "The immediate reaction of the audience was primarily confusion laced with verbal hostility."[16] Pausing at several "stations" along the boulevard, they eventually deposited the cross at the Marine recruiting station, where they held a silent vigil, with Gronk scattering handfuls of popcorn. Combining the political and conceptual at a time when police surveillance and repression of Chicanos was rampant could be regarded as nothing less than heroic.

Asco's *Walking Mural* (1972), one of their most spectacular acts, commented on both the staleness of Chicano mural imagery and its static, inert nature (fig. 29). It was performed on Christmas Eve, after the city had canceled Christmas parades on Whittier Boulevard in an effort to prevent assemblies and protests. Like *Spraypaint LACMA*, performed a few

months earlier, *Walking Mural* was designed as a reclamation of public space. Images of the event show Herrón in the center, supporting three sculpted paper heads that are reminiscent of Mexican masks and the stone heads found at archeological sites in Mexico. Valdez is a postmodern, sexualized Virgen de Guadalupe with a see-through costume. Gronk is a blue-ornamented Christmas tree constructed from several chiffon dresses. By obviously commenting on and subverting the prevalent, gendered constructions of Mexican and Chicano identity evident in conventional mural vocabulary, the images tell the viewer that this work is alive, it walks, it can move. Beyond that, *Walking Mural* looked at the state of things around the artists while interrogating accepted notions of Chicano history and identity. Jacqueline Rose once wrote that people live with "consoling fictions," but that true hope in life comes only "in the death of such numbing and dangerous fantasies."[17] In that respect, Asco's performance questioned Chicano artists' dependence on glorifying cultural imagery that is not counterbalanced by the reality of war, economic inequity, and institutionalized discrimination.

With *Stations of the Cross, Walking Mural*, and, later, *Instant Mural* (1974), which took the walking mural concept one step further as an "instant," ephemeral (and very Gronk-like) art event, Asco had moved into the province of performance art. Although Gronk had done many performance art pieces before, including the pre-Asco piece *Caca-Roaches Have No Friends*, he says that the *Walking Mural* was the start of the collective's focus on a series of performance art events:

> One was a dinner party on a traffic island, traffic going in both directions, and we set up a dinner table and ate a meal [*First Supper After a Major Riot*, 1974]. I was interested in the temporal nature of things, so I wanted to do what I called the *Instant Mural*, which was to tape Patssi and Herb Sandoval to a wall on a city street. And I think one of the important things about our activities was the idea that we didn't ask for permission to do any of the work. (figs. 30, 31)[18]

This approach also informed the group's legendary performances presented during Self Help Graphics' Day of the Dead processions. Consciously reworking a celebration initially conceived as a recovery of indigenous tradition, Asco intervened with an elaborate theatricality that used the holiday to criticize the Vietnam War and urban violence. In 1974, for instance, the

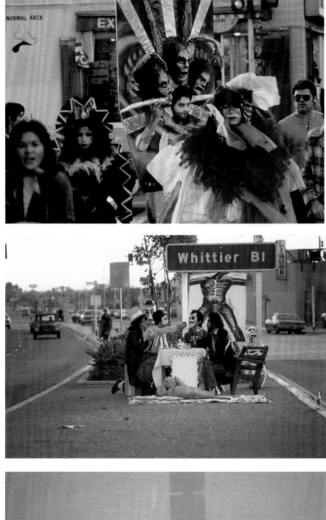

Figure 29. Harry Gamboa Jr., *Walking Mural*, 1972. Color photograph. From left: Patssi Valdez, Willie Herrón III, and Gronk in the Asco performance piece.

Reproduced by permission of Harry Gamboa Jr.

Figure 30. Harry Gamboa Jr. *First Supper After a Major Riot*, 1974. Color photograph. From left: Patssi Valdez, Humberto Sandoval, Willie Herrón III, and Gronk in the Asco performance piece.

Reproduced by permission of Harry Gamboa Jr.

Figure 31. Harry Gamboa Jr., *Instant Mural*, 1974. Color photograph. From left: Gronk and Patssi Valdez in the Asco performance piece.

Reproduced by permission of Harry Gamboa Jr.

group arrived at Evergreen Cemetery inside of a giant special-delivery envelope:

> Enclosed with postage due were Valdez as the Universe, dressed in a gold sequined formal gown, rainbow tissue paper halo, and an eight-foot span of clouds; Herrón as a Triplane, constructed of corrugated cardboard with wings that followed the winds of change and a pilot who was an extension of his weapon; Gamboa as the Archangel Blackcloud, wearing veiled threats and a bolt of intrusive lightning; Gronk as the Documenteur, carrying the official, oversized cardboard Asco-brand camera; Sandoval as the Asco Tank, with an operable gun turret, transported on a pair of formidable knee-high, leather platform boots.[19]

Asco thus contributed both aesthetic innovation and social critique to the celebration while also expanding and reworking the concept of death to encompass "the death of culture, death of fashion, death of dreams, and death of innocence."[20] As Kristen Guzmán argues, "Asco interjected its unique brand of street performance and cultural commentary" and thereby "challenged the boundaries of Self Help's interpretation of Day of the Dead."[21]

James Rojas contends that "the identity of place is not only created by physical forms but by the way inhabitants use exterior space around buildings. This environment is 'enacted.' Exterior space provides a background for people to manipulate as they please and to act in, much like a movie setting."[22] Asco, as individual artists and as a group, were from this "enacted environment." Rojas continues:

> A house in East Los Angeles generally resembles any other in Los Angeles. However, the tremendous difference in the appearance of the community is formed by the residents' use of space around the house. By working, playing, and "hanging out" in these outdoor spaces, their presence creates a spontaneous, dynamic, and animated urban landscape which is unlike any other in Los Angeles.[23]

In many ways, Asco's performative dimension emanated from this social dynamism of East Los Angeles street life. For the art collective, cultural spontaneity was the "texture" of their enacted urban environment.[24]

The group's performative dimension is perhaps most strikingly evident in the No Movie project, which was based on a

concept that initially evolved from the collaborative efforts of Gronk and Gamboa (fig. 32). Because Hollywood discriminated against Chicanos in terms of both industry access and representation, Asco reconceptualized and inverted the idea of the Hollywood movie. Often circulated by mail in a series of press kits and production stills, the No Movies' enigmatic imagery and evocative titles referred to nonexistent films while constructing the group as media celebrities. Commenting upon the contentious relationship between Chicanos and the mainstream media, the photographs simultaneously denied and affirmed the viability of an alternative cinema, satirizing emergent Chicano film practices that transferred the didactic nationalism of murals to a new medium. The images frequently use Los Angeles as a backdrop, and in their surrealistic, often campy theatricality, they reclaim a violent and alienating urban environment as a stage for subversive glamour. C. Ondine Chavoya argues that in this respect, the group "refused the interpellative address of this normative landscape and challenged its power to reconstitute its cognitive foundations and effects."[25] Likewise, David E. James regards the No Movie concept as one of the "profoundest negations" of Hollywood and the geographic inequality of Los Angeles.

The power of the No Movie is in the emotionally compressed synthesis of distress and rage documented in its single-frame images (fig. 33). James explains:

> For Asco, the premise of the entire No Movies project was . . . to link an infatuation with Hollywood, their pained awareness that it excluded them, and also a refusal of that exclusion. The construction of single-frame, idealized self-images in poses appropriated from daily life and from the movies dialectically articulates both the affection and the anger, the desire and the hatred. In this complexity, the No Movies both precede and exceed Cindy Sherman's film stills, for example, in which, by comparison, critical distance is dissolved into sentimental nostalgia—a fact that reflects the Asco members' reconstruction of a communal opposition to the political system that comes into focus as "Hollywood," rather than simply an individual narcissistic self-projection into it.[26]

Gronk, whose fascination with cinema and the performative shaped the No Movie enterprise, described the project accordingly:

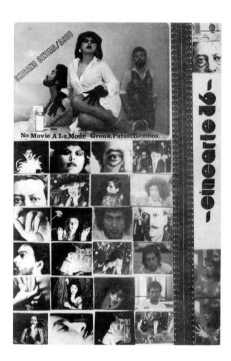

Figure 32. Gronk, *Cinearte 76*, 1976. Black-and-white photo collage. From *Chismearte* 1, no. 1 (1976): 30.

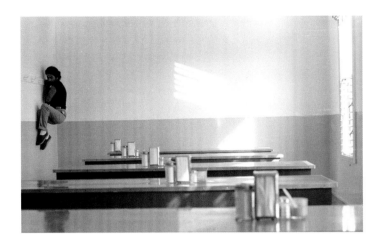

The No Movie was a concept that we came up with—making movies without the use of celluloid. And the idea was to reject the reel—r-e-e-l—by projecting the real—r-e-a-l . . . it was creating an image that looked as if there was a preceding image and an image that went after it, almost like a still that was taken from a film. . . . We wanted to do an alternative cinema and, coming out of no access, really, to Hollywood, the only way we could do that was to utilize ourselves and create many different characters for a camera. And we would think up a title. For instance, *A La Mode*. And it would be an image of Patssi sitting on a table but underneath her—which wasn't visible—was a piece of pie. So, in a sense, she became a scoop of ice cream sitting on a piece of pie. Hence, the title *A La Mode*. So it was ideas like that that we were playing with initially with the No Movie.[27]

After other mail artists began responding with their own No Movies, Asco initiated the annual No Movie (or Aztlán) Awards. In a critical parody of Hollywood's Academy Awards ceremony, the group awarded commemorative statues (a plaster cobra spray painted gold) for achievements in multiple categories that included performance, art direction, and, most improbably, sound and editing (fig. 34).

As Herrón and Valdez gradually drifted away from Asco in the early 1980s, Gamboa and Gronk began collaborating on theatrical works, making a transition from guerrilla street performance to theatrical stage. By this time the group had expanded to include new collaborators, including Diane Gamboa, Linda Gamboa,

Figure 33. Harry Gamboa Jr., *No Tip*, 1978. Shown: Gronk in the Asco No Movie.

Reproduced by permission of Harry Gamboa Jr.

Marisela Norte, Daniel J. Martínez, Juan Garza, Sean Carrillo, and Daniel Villareal, who contributed to these projects as both actors and crew (fig. 35). For such pieces, Harry Gamboa typically developed the text that Gronk would then shape through performance. Such was the case for *Jetter's Jinx*, a play written for Humberto Sandoval and Gronk (who also directed the piece) and staged at the Los Angeles Theatre Center in 1985. Conceived as a commentary on HIV/AIDS, the play centers on the archetypical, fast-living jetter (portrayed by Gronk), who is persuaded to commit suicide after his invited party guests fail to materialize.

During this period Gamboa also began producing video projects through Falcon Cable Television in Alhambra, California, extending the cinematic dimension of Asco's performance work to short films. Described by Chon A. Noriega as "conceptual dramas" or "experimental *telenovelas*," these works explored the dynamics of disintegrating romance and dysfunctional families through an absurdist, Brechtian performance style.[28] Gronk's paintings serve as set decoration in many of these productions, and he performs in several. In Gamboa's *Baby Kake* (1984), Gronk portrays an absent father, perhaps modeled on his own, who drops in momentarily to visit his overgrown child (Humberto Sandoval) and exhausted ex-wife (Barbara Carrasco) (fig. 36).[29]

These productions coincided with the gradual dissolution of Asco. While maintaining a critical distance from and marginal status within the art world, the individual members had gained a certain degree of legitimacy and professional stability that gradu-

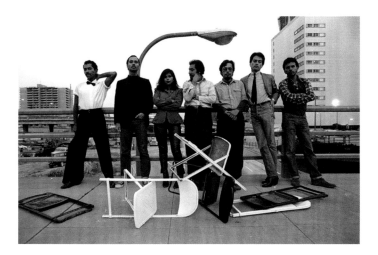

Figure 34. Nominations for Asco's No Movie Awards, 1978.

Figure 35. Harry Gamboa Jr., *Chic Año Seven*, 1980. Black-and-white photograph. From left: Gronk, Jerry Dreva, Patssi Valdez, Carlos Almaraz, John Valadez, Willie Herrón III, and Harry Gamboa Jr.
Reproduced by permission of Harry Gamboa Jr.

Figure 36. "And how's my baby boy?" Gronk and Humberto Sandoval in *Baby Kake*, 1984. Directed by Harry Gamboa Jr.

ally associated them (at least sporadically) with art institutions, galleries, theatrical venues, and, in the case of Herrón, a major record label. Although still contending with the lack of equality, access, and finances that inspired the No Movies, the artists now occupied a different position within a cultural environment whose terms had shifted. Whether because of the inevitable defusing or cooptation of subversive tendencies by the state and marketplace or the necessity of new responses to an emergent set of social relations, Asco's particular style of intervention no longer guaranteed the visceral impact of its earliest work. Gronk's work and that of his former cohorts, however, continued to register the tension generated by being both within and outside the art world and the Chicano arts movement—and the places where they intersect. Gronk later reflected on the irony of being the first Chicano artist to have a solo show at LACMA, *¡Gronk! A Living Survey, 1973–1993*, in which he echoed the original *Spray-paint LACMA*. He pointed out that in 1972 nobody really noticed Asco's audacious action:

> I think they just thought it was hoodlums that were out there doing that, and nobody ever said anything. Harry took photographs and recorded the visuals. But, no, we were never questioned about that action at all. I don't think they really realized who we were at the time. . . . That was 1972, so I don't think they were familiar with what we were, or what our activities were. And I think for me, I guess, the interesting thing is twenty years later to be on the inside of the L.A. County Museum and doing a piece, sort of a reference to it, called *Project Pie in Deface,* with using actually a defacement of a clay facial mask that's slapped onto a wall that I paint. It's sort of defacing on the inside of the museum, and I doubt very much if they understood or got it—or want to get it or understand it.[30]

The Asco years left a mark, like brilliant anonymous graffiti, on the history of art. The collective had dissolved by 1987, but there is no doubt that the group's anger still echoes through the streets of East Los Angeles. Perhaps it's no accident that a revitalized hardcore punk scene exploded on the east side in the early twenty-first century, with Latino immigrant groups giving themselves names such as Suburban Death Camp and Funeral Shock. Asco would be almost proud, as such new groups seem to draw on the alt-art sociopolitical heritage of Asco's own work as expressed in notorious pieces such as *Decoy Gang War Victim*

Figure 37. Harry Gamboa Jr., *Jetter's Jinx,* 1985. Black-and-white photograph. From left: Humberto Sandoval and Gronk in the play written by Harry Gamboa Jr., directed by Gronk, and performed at the Los Angeles Theatre Center.

Reproduced by permission of Harry Gamboa Jr.

(1974), in which Asco attracted media attention with a staged gang shooting.[31]

Years after the original Ascovites had gone their separate ways, Gamboa wrote a sardonic assessment:

> The cohesiveness of the art group as a collective was never fully realized by the individual members of Asco.... Although Asco members worked closely with each other, there was generally enough ego friction to maintain a sharp level of intra-group competitiveness. The connective tissue of the group had originally been the shared sense of otherness, past involvement with jetter or car club activities, an ongoing irrepressible creative drive, obscured Catholicism, near-lethal sarcasm, youth, ability to draw a straight line from psychosis to mundane reality, and a recurrent urge to connect the dots formed by politically motivated 16-gauge shotgun blasts.[32]

Performing as Jetter in 1985, Gronk delivered a line that not only conveys the tragedy of AIDS-related death in the early 1980s and the demise of the high-fashion jetter, but might also be read as a tribute to those collaborators who played integral roles in Gronk's development as an artist: "You don't see me complaining about my phantom-in-exile status. The fact that my guest list of family, friends, accomplices, companions, comrades, cohorts, escorts, rivals, those in essence who make up my past are not present, does not upset me, it erases me" (fig. 37).[33]

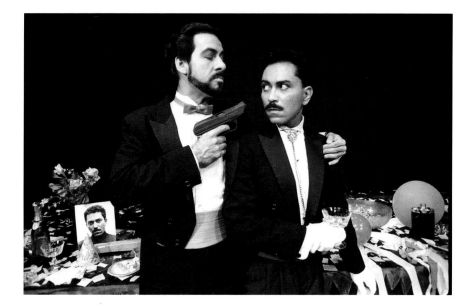

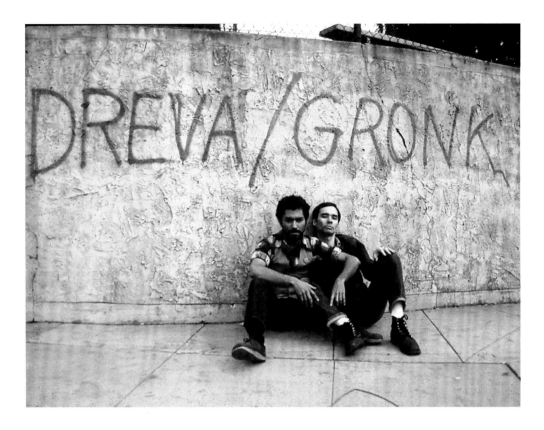

Figure 38. Teddy Sandoval, untitled portrait of Gronk and Jerry
Dreva, 1978. Color photograph. Private collection.

Photograph courtesy of Paul Polubinskas.

DREVA/GRONK
ART GANGSTERS

Dear Gronk—

Coldest winter in 100 years. Wish you were here to make history with me.

—Jerry Dreva, postcard to Gronk from Milwaukee, 1977

During Asco's early days, Gronk had what he considers a meeting with destiny in the form of an artist named Jerry Dreva, who would have a major influence on his art through the 1970s and beyond (fig. 38). Dreva was known for his work in mail art and as a member of Les BonBons, a conceptual drag rock group. He and Gronk first met in 1972 at a lecture at the Otis Art Institute. As he always did (and still does), Gronk took the bus to the lecture. He knew the person giving the lecture, Willoughby Sharp, who published a magazine called *Avalanche*, and Gronk attended hoping to learn about a new medium called videotape. He remembers seeing a man in a black leather jacket heckling Sharp and saying nasty things to him. "He was just very, very cocky," Gronk recalls. "I was like, 'Is that guy going to shut up?' It's like we're supposed to be here to learn, you know, and here's this guy who's ridiculing him."[1] That was Gronk's first encounter with Dreva. Later Gronk recalled the meeting:

> So afterwards, since I think I was probably the only brown person or person of color at the lecture, Jerry comes up to me and says, "Who are you?" I said, "My name's Gronk." He goes, "What do you do?" And at the time I was sending things out in the mail, so I was doing mail art at this time, and I did a lot of it, mailing things to people. And he goes, "Oh, I do the same thing. Can I have your address?" I said, "Yes, sure," so I gave him my address and we started to talk some more. He goes, "Oh yeah, I have a group, they're called the BonBons. We're a conceptual rock-and-roll group." I said, "Oh, I've got a group." "You do?" And so all of a sudden we just started to chat and talk. And then a couple of weeks had gone by and I had exchanged my number with him, and I run into him at this place called Butch Gardens.[2]

Located on Sunset Boulevard in Silver Lake, the Butch Gardens School of Fine Art was a gay bar and performance space operated by Teddy Sandoval, an artist whose own work encompassed performance, mail art, and ceramics. A number of emerging Chicano artists and musicians regularly congregated and collaborated at the space. In 1979 Gronk and Sandoval presented their piece *La historia de Frida Kahlo* there. As artist Lionel Biron remembers it, Gronk, as Diego Rivera, performed a musical number and danced with Sandoval, who was dressed as Kahlo in heels and a strapless gown (fig. 39).[3]

Gronk continued:

> So Jerry comes up to me, because he's there, and he goes, "I've been coming here because you mentioned this place." I said, "You know, I don't come here often, but—" He goes, "Well, can you give me your address and your number again?" I said, "What happened to the one I gave you?" "Oh, I masturbated on them and it just got all smeared all over the—"
>
> I'm like looking at this person, like, "Oh."
>
> He goes, "But it makes like a good piece, you know, and so I'm going to do a piece called *Wanks for the Memories*."[4]

Thus began the collaboration between Dreva and Gronk. Not coincidentally, the 1970s was a time of intense activity for gay artists and for expressive gender bending. Performers like Klaus Nomi, the New York Dolls, Lou Reed, and David Bowie's alter ego Ziggy Stardust shaped a cultural environment characterized by experimentation, posturing, glittered platform boots, smeared red lipstick, and a general breaking down of barriers between genders, genres, and guitars. Soon, Dreva was introducing Gronk to the Hollywood glam scene that had proved fertile ground for Les BonBons' exploration of style, gender, and celebrity (fig. 40).

Thematically, Dreva's performance-based work sought to undermine social facades and puncture holes in convention. Although his group didn't really play as a band, they were included in media stories and captured in photographs. By foregrounding the construction of stardom, they intended to expose and critique the media's superficiality. These tendencies clearly coincided with Gronk's own during that period, suggesting a particular affinity with the No Movie project. Both artists also

Figure 39. Gronk and Teddy Sandoval in *La historia de Frida Kahlo*, 1979.

Figure 40. Jerry Dreva, calendar for 1997. Photo collage and color photocopy, 8 ½ x 11 inches. Private collection. Counter-clockwise from upper left: Dreva with Lou Reed; Dreva; Dreva with Les BonBons, postcard of Los Angeles.

Figure 41. Postcard from Jerry Dreva to Gronk, 1977.

drew inspiration in particular from the work of Antonin Artaud, who is "associated with a fundamental revolt against insincerity," proposing a theater characterized "by freedom, the surreal, and by mystery" and an artistic practice informed by the "sacred" in some incantatory way.[5] Artists and thinkers such as Dreva, Artaud, and Alfred Jarry helped Gronk recognize that exploration for the sake of exploring is part of the creative process.

During this period, Dreva was also establishing his reputation as a preeminent mail artist. Started in the 1950s by the late Ray Johnson, mail art or correspondence art uses the postal system as its gallery. The amorphous international network of mail artists send postcards, letters, envelopes, three-dimensional pieces, and just about anything they can think of to one another. Mail art in the 1960s and 1970s often explored the emergent technology of Xerox photocopiers to fashion Dada-inspired collages. While not exclusively the domain of gay artists, the genre often provided a space for the expression of alternative sexualities. Seen by its practitioners as a form of democratic art, mail art was also viewed as a way of subverting the gallery and museum system and the elitism of art in general. At one point, Dreva even influenced David Bowie. In August 1980, Bowie released his album *Ashes to Ashes* in three editions with different jackets, with the first 100,000 copies covered with stamps that Bowie designed based on an idea from Dreva. In tribute to Dreva, Bowie included "Bon Bon" on each of the stamps.[6]

After an initial period of friendship and collaboration with Gronk in Los Angeles, Dreva departed for Wisconsin. Perhaps appropriately for two dedicated mail artists, distance only increased the intensity of their work together. "After he left, we were together for a moment in time there when he was here in Los Angeles, then he ends up in Wisconsin and we started to correspond over the next several years, and we kept all the correspondence" (fig. 41).[7] In addition to being a mail artist, Dreva was an inveterate letter writer. He sent suggestions about what to read and what to think. In one letter sent to Gronk, Dreva included a suggested reading list that included Artaud's *The Theater and Its Double*, John Cage's *Silence*, Herbert Marcuse's *Eros and Civilization*, and Susan Sontag's *Against Interpretation*. But perhaps more interesting in relation to the historical record on Gronk were Dreva's own thoughts on the events and currents of his time and place.

His letters, in this pre-computer age, were usually composed on a manual typewriter. In a letter that has no date but seems to be from the mid-1970s, Dreva discusses his views about being gay in America and lays out the BonBons' philosophy of genital sex:

> If straight men finally wake up and see that it is in their own best interest to come out and develop their own latent Gayness, they should make love with each other and not expect Gay people to expend time and energy bringing them out. Finally, BonBons don't put too much stock in genital sex—period. Just what the actual consequences of that position are remain to be seen. Personally I tend to see genital-orgasmic sex as an outrageous sublimation of erotic energies. Sure, I still enjoy "sex" once in a while, but I find myself moving more and more away from worrying if/how i can get my rocks off and toward an experience of highly eroticized existence—a 24 hr a day life of love, play, whole body eroticism (why shd it all be confined to the cock?) and polymorphous perverse sensuality. "making love with the rain outside my window" to me is more than a poetic metaphor."[8]

An excerpt from another typewritten letter from Dreva to Gronk further suggests the sensibility they shared:

> may 28 En route to New York. After telephone farewells and brunch on Yonge Street the tour reluctantly departs from Toronto. all agree to do intensive research here prior to the Apocalypse. Bonbons meet Mystic Maid of Niagara Falls & leave their mark in the men's room. Les Bons Bons on the Borderline, dozen pigs with dog ransack Vega & tear thru luggage. The Hand of the Spirit is abused by U$ Border Patrol. handcuffs in triplicate for Gay Insiders evoke snickers from Gestapo. Amerikan Bonbons stripped & searched up the ass for drugs. finding none, police confiscate pipe ("Residue," the Man said.) & papers, adding data to International Bonbon File. Back in the Fatherland mobile emergency conference debates alternatives to U$ fascism with no hard results. the Tore arrives in Nude York City after a Hard Daze Nite and checks in at the Chelsea Hotel at 8 AM on may 29 in The Apple. sleep most of drizzly day in Room 117 of Historic Chelsea (Thomas Wolfe Slept Here. Brendan Behan Too. Also Dylan Thomas, Virgil Thompson & Viva. Linda Merinoff Fucked Brian Jones Here.)[9]

Through their constant correspondence, Dreva and Gronk validated each other's work. Like explorers in a brave new world, they fed each other's desire for more: more art, more sexual

freedom, more experimentation. In an undated, handwritten letter that seems to be from the BonBons period of the mid-1970s, Dreva writes to Gronk:

> nice to see your mural in The Times and Hurrah for Harry, too . . . Hatched so many schemes for projects while on the road i hardly know where to begin. if I realize 10% of them i'll be happy (no i won't)—But you know what i mean. i wish i had an army of assistants like Leonardo—then i cd farm out my projects & they's all get done. & the world would be inundated with useless shit—i'd be the Warhol of the Seventies with a Factory to turn out the "art"—what a horrid thought. Being a cultural machine. ick! This isn't really a letter 'cause i don't feel like writing. i just wanted to let you know that i've received all yr mailings & love them.[10]

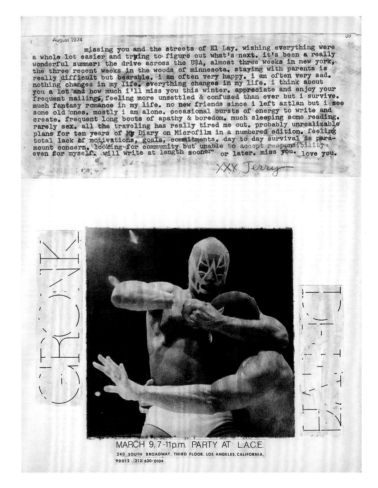

Figure 42. Promotional flyer for *Dreva/Gronk 1968–1978: Ten Years of Art/Life*, Los Angeles Contemporary Exhibitions, 1978. With typewritten message from Jerry Dreva to Gronk.

The culmination of their artistic relationship (Gronk has called it an "exclamation point") was a landmark show held at LACE in 1978 (fig. 42). By this point the two had been exchanging correspondence for several years. As founding members of LACE, Gronk and Gamboa had been instrumental in formulating its mission. Established with funding from the Carter administration's Comprehensive Employment and Training Act, the nonprofit not only was committed to the exploration and promotion of formal experimentation (installation, performance art, and video) outside the economic imperatives of the art market but also strove to incorporate the surrounding communities into its operations and exhibitions.[11] As Claudine Isé argues, the emergence of LACE and similar venues "shifted the locus of creative activity from the lone artist to a shared creative and interpretive process between artist and audience."[12] Gronk's own working philosophy and his multimedia production during the period contributed to this shift in the Los Angeles art scene.

Eventually establishing itself in an abandoned space above the old Victor Clothing store on Broadway, LACE became an important element of an energetic downtown cultural scene that included Al's Bar and the Women's Building. This explosion of alternative art spaces also coincided with the emergence of a nascent anarchic sensibility. By the late 1970s, the remnants of the glam scene had given way to a vibrant punk culture that consciously placed itself in opposition to an already co-opted and ostensibly elitist New York scene. This meant not only the momentary confluence of the marginalized (queers, people of color, working-class youth) but also an environment that fostered fluidity, rebellion, and experimentation while contributing to a flourishing of musical and artistic activity in East Los Angeles and Hollywood as well as downtown.

The LACE show was a major event, drawing spectators from the realms of drag rock, glam rock, punk rock, and Chicano art, as well as an assortment of onlookers and curiosity seekers (including gang members) who were looking for thrills, inspiration, or simply a warm body (fig. 43). Gronk recalled the events that led to the show:

> Dreva and I corresponded a lot about the show and we wanted it to be "art meets punk," and have punk bands play for the opening night. We weren't quite sure what was going to happen, but we knew, "Okay, if we're going to do this, that

ART MEETS PUNK

You're invited to get down with the artists (or get trampled by the crowd) at a special opening night preview of 'DREVA/GRONK 1968 - 1978: TEN YEARS OF ART/LIFE.' The preview and party will take place Thursday, March 9, from 7 to 11 p.m. at Los Angeles Contemporary Exhibitions, located at 240 S. Broadway (Third floor), in downtown Los Angeles.

Be a part of this anti-historic occasion celebrating the return of Jerry X. Bonbon to Hollywood. Make headlines with Dreva and Gronk as they tear down the gallery walls and take art to the streets. Be on hand when Art meets Punk at the opening of this important exhibition of new art.

It wouldn't be the same without you.

Figure 43. Announcement for *Dreva/Gronk 1968–1978: Ten Years of Art/Life*, Los Angeles Contemporary Exhibitions, 1978. Printed in *Slash* newspaper, February 1978.

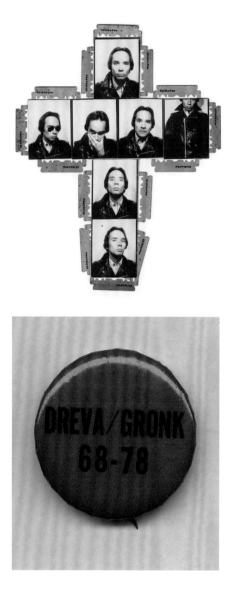

means the work might not survive and that will be it." And so we were both in agreement that "Yeah, it's worth it, so we'll just put all the correspondence that we did back and forth into these black books. I'll get tables." I went out and bought these tables, placed the black books on the tables, filled the walls with a lot of other work. He had one room. I had another room inside the gallery space, and then we had a bar that set up inside, and an area where the bands would be performing. It was a big chaotic mess of activities, extremes, and people just going wild in the place. By the end of the evening, people were actually grabbing at things, and Jerry had his razorblade crosses and people would just like grab at them and tear them off, and people were like putting the "Dreva and Gronk" buttons into their ears, or just like sticking themselves with it. So it was really wild.[13] (fig. 44)

As only the second show organized by LACE, the controversial event generated invaluable press coverage for the new organization. The volatility of the show, however, troubled other members of LACE, catalyzing differences centered on a reluctance to regularly exhibit Chicano artists and a movement toward more "conventional" programming. These tensions culminated in the eventual departure of both Gronk and Gamboa. The show also marked the end of the productive relationship between Gronk and Dreva.

So '78, and Jerry came for the opening and stayed for a while. We stopped our correspondence after that by mutual agreement. "We did it and so now let's move on." And he went on doing other things in other countries and doing different activities and occasionally I would get something from him, but it was not that intense kind of relationship. So we both moved on to do other things. So that was the end of that particular chapter of my work.[14]

Biron, a gay San Francisco–based artist who corresponded and exchanged mail art with both Gronk and Dreva, remembers the 1978 LACE show and a gift from Gronk. "I still have a Dreva/Gronk 68–78 commemorative button created for that exhibition. Gronk sent me—folded neatly in an envelope—an extremely fine pen and ink drawing on a plain white cotton handkerchief. Now those Gronk handkerchiefs are sold in art galleries for $1,000" (fig. 45).[15]

Dreva moved on to other things. He did reappear in Los Angeles one last time in early 1997, when he promised to once again work with Gronk. But he died soon after, in March 1997, at the age of 52.

Figure 44. Jerry Dreva, razorblade cross, ca. 1978. Razorblades and photo collage on matte board, 9 x 7 ½ inches. Private collection.

Figure 45. Pin from *Dreva/Gronk 1968–1978: Ten Years of Art/Life*, Los Angeles Contemporary Exhibitions, 1978.

Figure 46. Tomata DuPlenty and Gronk, 1984.
Photograph by Fayette Hauser.

Figure 47. Promotional flyer for the closing party for
Gronk/Tomata, 1984. Drawing by Tomata DuPlenty.

Whether it was following Cyclona and Mundo Meza down Whittier Boulevard or sending postcards to Dreva in Milwaukee, Gronk drew from and inspired others who were also positioned as outsiders, artists who tested the boundaries of formal and conceptual categories, challenging the limits of sexuality, gender norms, taste, and convention. In the late 1970s and early 1980s a number of creative collaborations emerged from Gronk's romantic relationships. In addition to Dreva, Gronk worked closely with the late Tomata DuPlenty, a former member of the Cockettes revue and leader of the influential Los Angeles punk group The Screamers (figs. 46, 47). Together they appeared in various theatrical pieces written by Tomata, including *The Royal Family* (1985–86; fig. 48), which also starred Fayette Hauser of the Cockettes, and *The Loves of Edgar Allen Poe* (1988). Their

Figure 48. Promotional flyer for *The Royal Family*, 1985. Written by Tomata DuPlenty.

Figure 49. The Score Bar, 1984. Reception for *Gronk/Tomata*.

Photograph by Gronk.

collaboration extended to the visual arts, and in 1984 they presented *Gronk/Tomata*, a joint exhibition of paintings at the Score Bar, a popular gay bar in downtown Los Angeles (fig. 49). The show marked a transition to painting that would occupy their respective careers in the decades to come, and it was the first exhibition in which all Gronk's paintings sold. During this period Gronk also worked with James Bucalo, an artist and bartender at Anti-Club, a punk bar on Melrose. Together, they staged a piece titled *Morning Becomes Electricity* (1986), which incorporated live performance with the creative destruction of Gronk's installation painting at MOCA.

A postcard from Dreva in Gronk's collection, postmarked "September 30, 1976, Milwaukee, Wisconsin," may help to explain what Gronk was looking for in these relationships. The front of the card has a torn plastic pocket with stamps from different African countries. The message on the other side, in Dreva's flowing stream-of-consciousness style, reads:

Nothing new all fine here as autumn dazzles with colors galore and crunching leaves underfoot running thru the woods early september mornings chasing squirrels + rabbits playing with chipmunks + robins flying south for winter boys play football + girls cheer with red + white pompoms U rah rah South Mil-wau-kee riding my tricycle thru Grant Park till the sun sets forever

—jerry
30 Sept 76

LA TORMENTA

THE ETERNAL ENIGMA

> The human is understood differently depending on its race, the legibility of that race, its morphology, the recognizability of that morphology, its sex, the perceptual verifiability of that sex, its ethnicity, the categorical understanding of that ethnicity.
>
> —Judith Butler, *Undoing Gender*

The early 1980s were a transformative period for Gronk. A fellowship from the National Endowment for the Arts, intended to support his performance and conceptual art, allowed Gronk to focus more resolutely on painting (fig. 50). As he explains, the funding offered an unprecedented opportunity: "I didn't have to worry about supplies, I didn't have to worry about materials, and I could just do as much as I wanted to."[1] This intense period of work and development culminated in the invitation to participate, along with Herrón, in a group show at the Los Angeles Museum of Contemporary Art (MOCA) in 1985. Gronk used the occasion to execute an installation painting of monumental dimensions, approximately 30 by 300 feet, which attracted positive reviews and the attention of art dealers. Daniel Saxon, at that time the co-owner of the Saxon-Lee Gallery, was impressed by the massive work and eventually became Gronk's art dealer, a relationship that would last nearly twenty years. Saxon introduced a larger, more affluent audience to Gronk's work. Through many gallery shows and other exhibitions at his renamed Daniel Saxon Gallery, Saxon helped place Gronk on the map with collectors, museum curators, and university art programs.

Gronk's formal entrance into the art market came amid a growing recognition of Chicano art by mainstream institutions, a trend "fueled by the market's co-optation of multiculturalism."[2] Gronk's work thus contributed to and benefited from the broader legitimization of Chicano art while it also reflected an increasing emphasis on individual aesthetics. For instance, as Tere Romo points out, Gronk's series of limited-edition serigraphs printed at Self Help Graphics in 1982 provided a financial boost to the organization's fledgling atelier program,

NEA 2 (Rev.)

A-81-183566

OMB-128-

Individual Grant Application
National Endowment for the Arts

Applications must be submitted in triplicate and mailed with other required materials to the address indicated under "Application procedures" for your category.

Visual Arts Program

Category under which support is requested:

FEB 9 1981

Name (last, first, middle initial)	U.S. Citizenship		
NICANDRO, GLUGIO, GRONK	Yes X No	Visa Number	

Present mailing address/phone	Professional field or discipline
370 S. GAGE AVENUE LOS ANGELES, CALIFORNIA 90023 213/268-6916	ARTIST

Birth Date APRIL 29, 1954 **Place of Birth** LOS ANGELES, CA.

Permanent mailing address/phone	Period of support requested

370 S. GAGE AVENUE
LOS ANGELES, CALIFORNIA 90023
213/268-6916

Starting 10 2 1
 month day year

Ending 4 1 82
 month day year

Career summary or background

Gronk (Brazilian dialect for "to fly")
 In 1954, a young pregnant woman from East L.A. was looking at a copy of the National Geographic between labor pains. She became so completely involved in reading an article on South American birds that she continued to flip thru the pages becoming oblivious to the fact of the birth of her son. It was a 50's version of the "Immaculate Deception". No one brought gifts but at least I had a beginning. From then on it was a matter of developing and refining my own a areness of the context in which others base their perceptions. Los Angeles is a complex example of urban diffusion. Cultures and ways of life crisscross one another like a maddened freeway system that has artificial exits. By 1960, I found myself goin in the wrong direction on the cultural fast lane. It was during a drop drill in elementary school that I was struck with the realization that the dominant society relegated the influence by Chicanos on Los Angeles to that of a phantom culture. By 1970, I had become an adept organizer of obscure barrio talents that would act in concert to convey a sense of social alienation (cultural resistance via performance). During 70-71, I produced a series of performances e.g. "Cockroaches Have No Friends" that featured Cyclona who was the epitome of the collision in values, attitudes, and images between cultures. My involvement with Willie Herrón, Patssi Valdez, and Harry Gamboa Jr. as co-member of the Asco art group allowed me to participate in cooperative expressions which led to the development of my "Instant Murals" and "Photo Sentences". Many of the Asco performances took place on the streets of Los Angeles and were marked by an attitude of perceptual estrangement. We developed the "No Movie" concept which allows us to present life within a cinemagraphic context via still-photography and printed matter. During 1978, I established myself as host to two major mass performances, the Dreva/Gronk exhibition and the Miss Galery Pageant. With a combined downtown attendance of nearly 3,000 participants from different cultures and ways of life, I was able to coordinate the effective application of cultural shock treatment. In early 1981, I will erase the U.S./Mexico border with a large eraser. Throughout the years I have presented my work to thousands of public school/university students as well as thousands of gallery and televison viewers. I have exhibited my works in the United States, Latin America, and Europe.

Amount requested from National Endowment for the Arts $ $5,000.00

Figure 50. Gronk's application for a grant from the National Endowment for the Arts, 1981.

which was then moving toward the production of collectable "fine art" prints.[3] During this period, however, Gronk continued to focus primarily on large-scale painting, both for sale to collectors and as temporary installations. He also worked to refine an identifiable style and visual vocabulary.

There is perhaps no more riveting or dreamlike persona to emerge from Gronk's oeuvre during this period than La Tormenta, the elegant enigma who has her back to the spectator. Tormenta is a Gronk creation par excellence, translating his earlier preoccupations into a new medium. His work has always been about the self-reflexive construction of personas and all the games associated with the wearing of masks, whether emotional, sexual, or ethnic. With Tormenta, Gronk created a powerful archetype that has served him well for over two decades. By using basic forms to create the image, Gronk imbued it with a power that comes from the fundamental shapes of nature, thus making her more real than real. This is an image that declares, "The reality of my reality will become your reality."[4] Gronk describes her invention:

> She's strong and holds her own cocktail glass, and that was a choice I wanted in that image. I wanted something simple, the elimination of a lot: the circle for the head, the back is almost triangular, encased in a square. . . . I want something to cross over time, that I can utilize over and over and over again to give it a mythological character. . . . I wanted to create my own American mythological character and give her a name that has several layers of meaning.[5]

Gronk has said that he wanted to create a mythic figure along the lines of ancient mythic women such as Medea and Electra.[6] He succeeded by combining mythology with several real-life and cinematic sources: his friend Patssi Valdez, a painter and fellow Ascovite; writer Marisela Norte, his soul mate from East Los Angeles and frequent Asco collaborator; Ingrid Bergman from Hitchcock's *Notorious* (1946); Anita Ekberg, frolicking in the Trevi Fountain in *La dolce vita* (1960); and the beautiful women in black cocktail dresses walking through Michelangelo Antonioni's black-and-white films, especially Jeanne Moreau in *La notte* (1961). Tormenta also finds a key source in a touchstone of cinematic modernism, Alain Resnais's *L' année dernière à Marienbad* (Last Year at Marienbad, 1961) (figs. 51, 52). From the perspective of basic pictorial grammar, the aesthetic influence of Ozu is also clearly evident in the use of fundamental forms: the

Figure 51. *L' année dernière à Marienbad* (Last Year at Marienbad, 1961). Directed by Alain Resnais.
Courtesy of Academy of Motion Picture Arts and Sciences.

Figure 52. Gronk, drawing of Tormenta, 2005. Ink on paper napkin, 5 x 5 inches. Private collection.
Image courtesy of Carnegie Art Museum, Oxnard, California. Reproduced by permission of the artist.

circle, the triangle, and the square. Writing about Ozu's use of circularity, for example, Donald Richie notes, "The circle, after all, is a balanced, continuous, geometrical form congenial to the human mind. . . . The circular form presupposes a return. The idea of the return, like the idea of the circle, is something we find emotionally compelling."[7] Gronk has inked a thick black line of emphasis at this point in his copy of the Ozu book. Tormenta is "emotionally compelling" because her building blocks are the basic forms we encounter all around us every day.

Beyond the use of familiar shapes and forms, Tormenta, the image, speaks to us in deeper codes. To see her from behind, her plunging black gown creating a chalk-white V, is to see shape and color united to convey the everlasting shadow, that hidden side of ourselves. Is she the fluid sexuality that may well exist in us all? Or, given the logic of Gronk's worldview, is she a visual pun about the eternal flux of identity itself? In response to these questions, Claire Colebrook's lucid unwinding of Judith Butler's theorization of sexual identity and performativity is revealing and uncovers what may well be Gronk's subtle use of the aesthetic form and content of Tormenta to unravel the nature of sexual identity:

> The person who labels the homosexual as "queer" has an allegorical notion of language: that there *are* homosexual identities that can be labeled and discovered. But the homosexual who, in a gay Mardi Gras, presents himself explicitly as an amalgam of performances, as nothing more than a series of camp gestures, allows the performance of identity to be presented *as performance:* "the parodic repetition of 'the original' . . . reveals the original to be nothing other than a parody of the *idea* of the natural and original."[8]

This is the "alternative imaginary schema" referred to earlier in this book. Speaking about sexual identity means, as Colebrook notes, that we all have the potential to act in "multiple and incalculable ways. . . . By performing differently, by acting in ways that are not recognized as reducible to heterosexual norms, the illusion of matter as having a natural sex is undone."[9] Tormenta is that paradox of a classic image that is also a destabilizing image. This paradox is underlined by the very notion that gender is performance. As Colebrook explains, "We cannot escape the systems of identity, or the illusion that there is a subject *who speaks.* But we can perform, repeat, or parody all those gestures that create this subject."[10]

There are further layers to the Tormenta image beyond its unmasking of the illusion of meaning and its challenging of the notion of a self endowed with a defined sexual identity. We never see her face. Is this denial a further extension of her tormenting ways? Isn't it enough that she strips us bare of the idea of our prelinguistic sexual identity? And, yet, at the same time, this faceless icon provides us with a certain freedom, at least as far as she is concerned. We are free to imagine her lips, her eyes, her nose, her brow, any way we want. We can fantasize about her and conjure images of her hidden features. Perhaps this is her narcissism. As Gronk has said, "In the end, she still has mystery to her."[11] Whether we are looking at various images of La Tormenta, such as the early *Slice of Life* (1984, fig. 53), or the luminescent *She's Scared* (1988, private collection), or *St. Rose of Lima* (1991, Museum of Contemporary Art, Los Angeles), or more recent permutations such as the *Tormenta Suite in 12 Movements* (2001, serigraph edition of 75, printed at Tandem Press, Madison, Wisconsin), we have to ask: Is not Tormenta a metaphor for life's unfathomable enigmas? Is not sexual identity an enigma itself?

Enter Tormenta, Gronk's 2001 masterwork, gives us one of the most haunting, beguiling, and vulnerable Tormentas (fig. 54). She grips billowy blood-red curtains with a black-gloved hand, and her grip betrays a sense of nervous anticipation. It is with this image of Tormenta that we again see Ozu's influence on Gronk. They both create stages upon which they place their artistic expression. For Ozu, it was the Japanese home. For Gronk, it is the stage itself, and in *Enter Tormenta* the theater is presented: stage, curtain, audience, and, finally, Tormenta, the star performer.

Another Tormenta image that exemplifies Gronk's skillful use of staging and form is *Puta's Cave* (1988), yet another Gronkian pun (fig. 55). The "cave" is the cosmic vagina or vulva, the opening to the womb. The painting is also a sly play on Plato's cave: Tormenta literally creates a shadow puppet with her hands, one that is not unlike the horned figure shadow she throws in *Enter Tormenta* or the thick penile shadow she casts in Gronk's 1995 *Post, Library: Muse* (see fig. 6). Tormenta may be Gronk's visual marionette, but she, too, can play the puppet master. She is laughing at us and with us. Like a monologue by Samuel Beckett or a novel by José Saramago, Gronk's Tormenta stops us for a brief moment to consider our futile human condition.[12]

Figure 53. Gronk, *Slice of Life*, 1984. Acrylic on canvas, 75½ x 50½ inches. Private collection.

Photograph by William Nettles. Courtesy of Daniel Saxon Gallery, Los Angeles. Reproduced by permission of the artist.

Figure 54. Gronk, *Enter Tormenta*, 2001. Acrylic on canvas, 84 x 96 inches. Carnegie Art Museum, Oxnard, California.

Photograph courtesy of Carnegie Art Museum. Reproduced by permission of the artist.

Life is at once laughable and deadly serious. We are here and then we're gone, just like that. Gronk underlined this passage in *Ozu*: "the eternal is contained within the transient."[13] The impermanent is both impertinent and important. Evoking a dreamlike (perhaps nightmarish) image of hell, limbo, or Hades, the piece derives much of its conceptual strength as a creative reworking of Plato's cave. Inside this allegorical cave, a group of prisoners are chained, unable to turn their heads. All they can see is the wall of the cave. Behind them burns a fire. Between the fire and the prisoners there is a catwalk and puppeteers walk along it,

Figure 55. Gronk, *Puta's Cave*, 1988. Acrylic on canvas, 72 x 48 inches. Private collection.

Photograph by William Nettles. Courtesy of Daniel Saxon Gallery, Los Angeles. Reproduced by permission of the artist.

casting shadows on the wall of the cave. Their vision restricted, the prisoners mistake the appearance of shadows for reality. In other words, they would know nothing of unmediated reality.[14] They are in darkness, and Plato is implying that they need to "see the light"—and that, ultimately, our perception of reality is always imperfect and partial.

Here, Tormenta is casting a shadow of a masculine energy form: horns or antlers that symbolize fertility. The erect male protrusion, the horn (as in horny), is the phallus as shadow, and it is being "thrown" on the wall, controlled by her gloved hand. In calling Tormenta a *puta*, which means "whore" or "slut" in Spanish, Gronk adds a playful dimension to Plato's allegory of representation, suggesting that sexuality, prostitution, and even his own art have a place in the dark cave. What we are seeing, then, is a highly stylized performance of gender in which the masculine and the feminine are manipulated and inverted on several levels with several connotations and permutations. This shadow play also effects a challenge to moral and gendered hierarchies that structure our reality: often hurled as a playground insult suggesting the lowest form of debasement, *puta* in this instance embodies identity as enigma, simultaneously controlling and undermining access to "truth."

The use of this Spanish term, along with the connotations of darkness and shadow, also suggests the work's racialized dimension. Evoking the degraded, violated indigenous mother central to historical conceptions of Mexican mestizaje (the legacy excavated in Octavio Paz's *Labyrinth of Solitude*), the *puta* casts a dark shadow over a collective sense of (gendered) identity. Gronk recovers this "fallen woman," perhaps a figure of repressed shame, as a knowing, omnipotent, and, above all, glamorously ambiguous presence that unmasks both masculinity and femininity as fanciful constructions. Such a vision provocatively reworks traditional, essentializing formulations of Mexican and Chicano identity. If many Chicana artists have creatively re-imagined the Virgin of Guadalupe (traditionally positioned as the embodiment of ideal femininity), Gronk conjures and interrogates the other term in this dichotomy. Resonating with the archetypal in a more universal sense—the caped, horned figure, devil, vampire, primal symbol of Eros and of the dark aspect of ourselves—the artist also suggests that mythical convergences of darkness and fear inform attitudes toward the racialized and gendered subject.

In this respect, the power of Gronk's work lies in its provocative mobilization of the culturally specific, yet it also transcends those roots through recourse to the mythological and a sly inversion of sexual identity. Gronk demonstrates his artistry: he can handle larger-than-life mythic themes with deftness and razor-sharp wit while linking them to a specific sense of time and place. He can draw on an ancient Greek philosopher for inspiration, filtering it through the theatric and cinematic, and apply his own experience to create something altogether new and revealing.

Gronk has extended Tormenta beyond the canvas and into other media, constantly experimenting with painting as a performative, ephemeral creation. Over the years, Gronk has worked with composer Joseph Julián González on *Tormenta Cantata.* Drawing from a scene in Hitchcock's *The Man Who Knew Too Much* (1956) titled "Storm Cantata," the innovative performance foregrounds the operatic and cinematic provenance of the now-legendary Tormenta character. The piece has been performed in several venues, including UCLA, the Smithsonian Institution in Washington, D.C., and the National Hispanic Cultural Center in Albuquerque.

It is during this piece that Gronk engages in his particular form of action painting. When Jackson Pollock practiced the method, often working in an almost trancelike emotional state, he produced accidental and random abstract effects. Then, based on the unexpected patterns, he would move toward a more consciously created piece. Often regarded as a subgenre of abstract expressionism, action painting was popular in the 1950s. Gronk's version of action painting, especially during the *Cantata* sessions, is more purposeful and less indulgent than the Pollock method. Gronk knows that he has to have the Tormenta image in the work. He then adds more elements from his pictorial repertoire. Rather than being merely accidental and mood-induced, the images that he creates in real time during the performance constitute wholly completed paintings. He may do some touch-up afterward, but the final work is quite close to what he has painted on stage. *Tormenta Cantata I* is a good example (fig. 56). What you see is what he painted during the performance. And as he says, "You also have to learn the music. You have to follow a metronome to learn how to paint. There's a structure there. It is not just like, 'Okay, I'm just going to ad

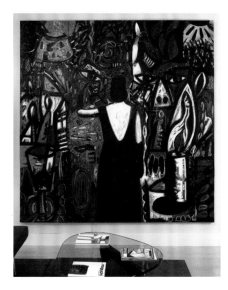

Figure 56. Gronk, *Tormenta Cantata I,* 1995. Mixed media on treated wood, 8 x 8 feet. Private collection. Photograph by Tony Cuñha, 2005. Reproduced by permission of the artist.

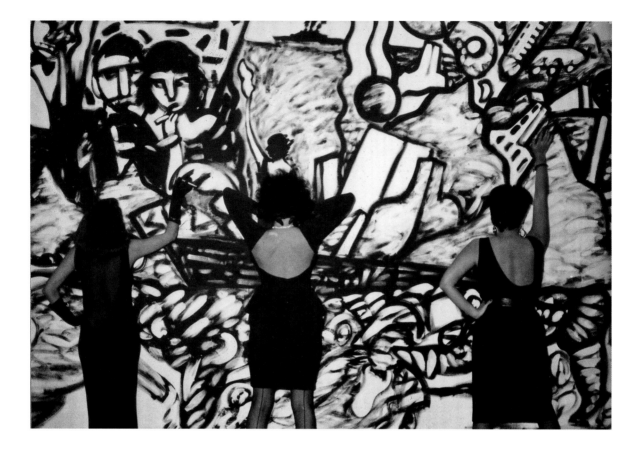

Figure 57. Lindsey Haley, Sylvia Delgado, and Marisela Norte posing as La Tormenta for the exhibition *The Titanic and Other Tragedies at Sea*, Galería Ocaso, Los Angeles, 1985.

Photograph courtesy of Juan Garza.

lib and improvise it.' It's not improvised. There's a structure and you have to memorize certain things or else it's just not going to work."[15] During these performances the Kronos Quartet often plays the music. At least a half-dozen new *Tormenta Cantatas* have been created this way (fig. 57).

As a classic image, La Tormenta is one of the enduring symbols of the performative nature of sexual identity. In that sense, she is a political performance. She tells us that sexual identity (and for that matter cultural or racial identity) has an element of illusion in its social construction. The nature of self is something we create because in creating it we produce the self that is there to be identified. In the end, Tormenta, the black-and-white enigmatic creature, is a cipher made of signs pointing toward meaning (fig. 58). Ultimately, she is liminality in all its transformative possibilities.

Figure 58. Gronk, notebook drawing, 1989. Ink on
paper, 8¼ x 5¼ inches. Private collection.

Reproduced by permission of the artist.

HOTEL SENATOR
PORTAL TO THE UNDERWORLD

Deep, deep, and still deeper must we go,
if we would find out the heart of a man;
descending into which is as descending
a spiral stair in a shaft, without any end,
and where that endlessness is only
concealed by the spiralness of the stair,
and the blackness of the shaft.

—Herman Melville
Pierre or The Ambiguities

Throughout the 1980s Gronk continued his explorations of the Tormenta character, often placing her within gallery installations and conjuring her presence through both painted works and live performances. This also intersected with a recurring fascination with the temporality of space, with the notion of sinking ships and dingy hotel rooms as momentary vessels of human tragedy (fig. 59). His Grand Hotel series of exhibitions, including *Hotel Zombie* (1991) and *Hotel Tormenta* (1992), combined painting, installation, and performance, melding a personal vocabulary grounded in cinematic and literary references with his ongoing engagement of urban space (fig. 60). Each of the shows was installed in a different city—Paris, Los Angeles, and San Francisco—an itinerary itself evoking the cosmopolitan glamour of the bygone Grand Hotel chain. The works in each of these shows, like the earlier *Titanic and Other Tragedies at Sea* (1985), imbued these luxurious spaces with a sense of dread and ephemerality. The paintings in the 1989 *Grand Hotel* exhibition, including *The Man Without Desire* (fig. 61), reveal hotel rooms fraught with existential anguish and isolation. In 1990, as a high point of this series, Gronk painted a group of works on wooden doors, calling it *Hotel Senator*. This took him to a new level as a painter and sharp-eyed observer of life, cleverly integrating media, form, and content.

In many respects, *Hotel Senator* was a culmination of Gronk's art and worldview up to that time. In this show, he transformed thirteen wooden panels into a succinct meditation on life in perpetual

Figure 59. Gronk, notebook drawing, 1990. Ink on paper, 8¼ x 5¼ inches. Private collection.

Reproduced by permission of the artist.

Figure 60. *Grand Hotel*, an exhibition of Gronk's works at Daniel Saxon Gallery, 1989. From left: *House Dick* (1988), *Conquest* (1988), *Bellhop* (1988), *The High Society Skirt, Marie Chandelier* (1988).

Photograph by William Nettles.

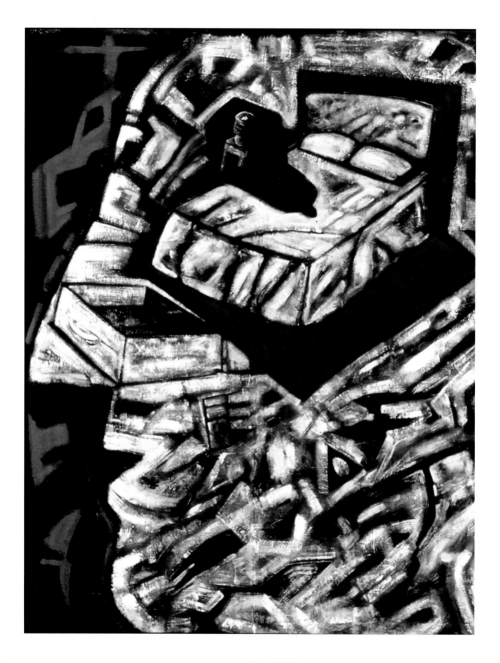

Figure 61. Gronk, *The Man Without Desire*, 1988.
Acrylic on canvas, 73¼ x 61½ inches, framed. Private
collection.

Photograph by William Nettles. Courtesy of Daniel Saxon
Gallery, Los Angeles. Reproduced by permission of the artist.

and painful passage. Moving from more mythical or abstract spatial references in earlier works, the works in this particular show evolved from years of observation of a hotel across the street from his studio loft on Spring Street in downtown Los Angeles. Gronk used to sit on the fire escape of his place and watch the people go in and out of the cheap Senator Hotel (fig. 62). Prostitutes, druggies, the homeless, and other desperate souls went there to anesthetize themselves in one way or another. Gronk chronicled it in a way that "set fire" to the life he portrayed in the series. He recalled the inspiration for the *Hotel Senator* show:

> The Hotel Senator was a building again close to my neighborhood or my archaeological dig—or site as I called it—Los Angeles, and across the street from where I live. . . . It's this building that housed a house of prostitution and drugs. I like the fact that it was called "Senator" . . . and it was like this house of prostitution.
>
> It had the ugliest-looking sign leaning up against this building announcing what that place was. And I thought, "This is like so ugly. It's like that sign is just like a beat-up looking piece of wood." And I asked one of my neighbors, Steve La Ponsie, to go up on top of the building to yell to me, "Go!" when he sees nobody around, so that I can run across the street and steal the sign. So I ran across the street when he said, "Go," brought the sign back up into my studio, and, again, being that archaeologist who finds the chip, "This is my fragment. Now what does this beat-up sign mean to me?" Well, it's really decrepit. It's like the veneer of a door is the door's skin. It's taking the whole thing apart and trying to piece it back together again, and taking a little fragment and basing my scenario of this next body of work that I'm going to create from this particular sign. And I thought it was done so crudely that I said, "Well, I really don't paint that well with my left hand. I'm really right-handed. So I'm going to create this body of work with my left hand and not use my right hand." So the work was even more chaotic, in a way, painterly-wise. I did the series and I thought, "Well, a prostitute is usually associated with this particular place. But I don't want to do the conventional woman standing under a street lamp selling herself in this particular piece. I want it to be told from the point of view of vessels, because a woman is referred to as a vessel because she carries life." And I thought, "I sort of want to do it with a Styrofoam cup, because a Styrofoam cup is something that you utilize once

Figure 62. Edmund Barr, untitled portrait of Gronk with the Senator Hotel sign, 1991. Black-and-white photograph. Private collection. Reproduced by permission.

and once you've used it it's damaged goods and you throw it away." . . . What is inhabiting this particular place is society's throwaways. So it was like taking the Styrofoam cup and it become[s] an important element—or a cocktail glass, a martini glass. But a lot of the vessels were drained and sort of empty and ugly looking in a way.

So that was the *Hotel Senator* series. One of the last acts was to place that particular sign in front of my gallery, so that for me in a sense the gallery becomes a house of prostitution—which happens to artists along the way as well. So there was that performance/conceptual element to the painting.[1]

With *Hotel Senator*, Gronk went in a new direction. As he once put it, "I think I learned from '85 through the nineties how to paint. I mean, it was just like driving myself to use a medium and develop the language that I was using. So, of course, the work is in flux, in change. I was doing big pop figures, grinning teeth, faces and stuff. And it was like, you know, it wore thin. . . . I wanted to shift and change a particular way of doing something. . . . But it means like certain breaks and certain changes in you, with society and things, your outlook on things."[2] Even before *Hotel Senator*, he had used hotels (and their luxury ocean liner kin) as thematic constructs. But in this earlier work, hotels were glittery settings where he pilloried the pretensions of ruling elites even as he seemed to relish, in a vicarious way, the opulent decadence of the upper-crust life. With him, we spun and danced in grand ballrooms that were bejeweled with crystal chandeliers. We followed bellhops and others into the alluring make-believe of high society. We rubbed shoulders with La Tormenta and her bewitching sorority—sequined women, wigged drag queens, and cross-dressers—in their exquisite evening gowns. Hard-jawed, black-tied Reaganesque power mongers prowled paintings such as *Cabin Fever*, glaring like hungry panthers searching for their next prey (fig. 63). We knew we were surrounded by the lost and loathsome. But they had the means to disguise the truth, at least up to a point. By shifting his focus from the facile posturing of glamorous power and dissolution that typified the 1980s, he stripped away the facade. He simultaneously moved from the hotel as concept or abstraction to a commentary on his own surroundings. He was now documenting underclass life in his art. The paintings in *Hotel Senator* revealed a new sensibility. He had pared things down to the bare essentials. He was Ozu as the painter.

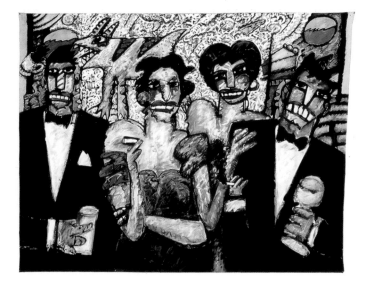

Jean Genet once wrote that there is an "absolute solitude of object as painting":

> So it is at once the image that is on the canvas—and the actual object it represents that I want to grasp in their solitude. So I must first try to isolate in its significance the painting as material object (canvas, frame, etc.), so that it stops belonging to the immense family of painting . . . but so that the image on the canvas becomes linked to my experiences of space, to my knowledge of the solitude of objects, beings, or events. . . . Whoever has never been filled with wonder at this solitude will not know the beauty of painting. If he claims to, he is lying.[3]

In the *Hotel Senator* paintings Gronk conveys this solitude. In fact, the series is about solitude as a concept. The paintings in this series are divested of human vestiges. In their place we find only a few artifacts of civilization and portraits of post-mortals. Those portrayed here are like zombies: breathing, but so violated as to be emotionally lobotomized. They are alone as image and object. In painting after painting in this series, we see bestial souls with their raw nerves exposed. This is an exhibition, but it is one of our inner selves, in which our insides are completely exposed to the world and on display for all to see.[4]

By taking the dirty discarded sign that once leaned outside the hotel's entrance as his point of departure, Gronk was working

Figure 63. Gronk, *Cabin Fever*, 1984. Acrylic on canvas, 72 x 95 inches (unstretched). Private collection.

Photograph by William Nettles. Courtesy of Daniel Saxon Gallery, Los Angeles. Reproduced by permission of the artist.

toward an extraction of the dark impressions entombed within its tortured memory. Although an inert sign, it "witnessed" and "chronicled" everything that passed by it and into the Senator Hotel. This show was the result of that fixation: a series of barely opened doors inviting us to glimpse the dreary monstrosity of life.

On door after door, Gronk painted a statement on the moral perversity of both inflicted and self-imposed estrangement. The grainy texture of the wooden doors combines with the thickly layered surfaces of acrylic paint to convey a primal, troubling disquiet. Again, the influence of Ozu is felt. Richie explains that Ozu's films "share the assumption that it is through the everyday, the mundane, the common—and only through them—that the transcendent can be expressed."[5] What is more everyday and common than a door? The doors add a striking metaphoric value to the images. Doors are thresholds, portals through which we pass into other worlds. Here at the Senator Hotel, the *locus spiritus* of sleaze, each door leads into some private hell brought on by the brutal indifference of our consumer society. People become disposable when nothing is worth keeping.

At the same time, doors are barriers, impenetrable guardians of privacy. Behind closed doors, life and its emotional entanglements can be avoided. Doors mark off spaces in which to indulge secret desires. For a cerebral artist such as Gronk, the doors provide the perfect basis for a structured exploration of opposing but strangely complementary principles. Gronk subsumes straightforward commentaries within these self-contained intellectual constructs, on these doors and with the imagery of these entrances and exits. Implication is the rule.

Unlike much of his previous work, *Hotel Senator* made little room for linear three-part storytelling. This new, indirect approach is signaled by his left-handed painting and therefore becomes manifested in the pictorial style itself. The resulting narrative is more subtle, told through the imagery combined with the medium and the form. Taken together, then, these elements are what create the narrative, the story of *Hotel Senator*. The fleshless figure in *Doorman with Key* (fig. 64) and the bulky pitiful wench in *Attack from Both Sides* (1990, private collection) are featureless. Their blank faces suggest generality and abstraction. Gronk seems less concerned with the specific outright expressions of inhumanity and more preoccupied with the

feelings left behind. This is about the imperceptible on one level, but about the palpable on a completely different level.

Although he created a new visual terrain in *Hotel Senator*, Gronk retained elements of earlier imagery. For example, *Foreign Soldiers* (1990, private collection) and *Simon on Fire* (1990, private collection) echo previous works. However, where once these entities were trapped within themselves, they are now vaporized into the fiery night. The smoke in the images could very well be their spirits or souls dissipating into the ether. Bondage has given way to some final, solitary escape not unlike death. Here we encounter the funereal aftermath of betrayal and deceit. These pieces give off an emotional incense of tragic finality, providing us with further evidence of the artist's intersecting themes and concerns. The burning, smoking bed in *Foreign Soldiers* and the shadowy figure standing on the promontory can be read to indicate a spurned lover who destroys the evidence of a love lost but who is terribly saddened by that loss. This could be a mourning scene. The figure looks almost as if it has turned into a black stone statue like Lot's wife in the Bible. To see the ghostly black apparition in the form of smoke hovering over the dark figure is to realize that no matter how much we may want to put something out of our minds, we may not be able to erase the memory. Our traumas haunt us whether we want them or not.

Like the rest of the paintings in this series, *Baghdad Cocktail*, with its single glass, was completed just as Iraq was marching into Kuwait in August 1990, just before the Desert Storm war (fig. 65). In that sense, then, the series was prescient in the way that only art can be. *Baghdad Cocktail* has touches of the extravagance found in Gronk's previous works. There is an almost soothing quality here. But closer inspection reveals that the cocktail glass is an empty container. Accented, as it is, by lightning-like white strokes, it possesses an elegance and nobility in its eerie

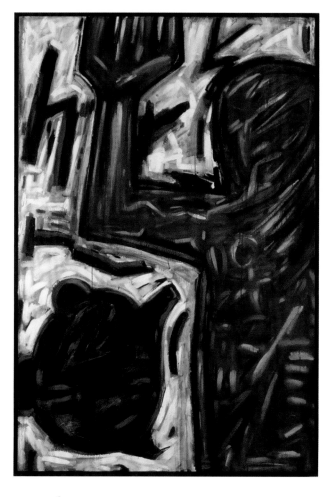

Figure 64. Gronk, *Doorman with Key*, 1990. Acrylic on wood, 73¼ x 49¼ inches, framed. Private collection. Photograph by Tony Cuñha. Courtesy of Daniel Saxon Gallery, Los Angeles. Reproduced by permission of the artist.

Figure 65. Gronk, *Baghdad Cocktail*, 1990. Acrylic on wood, 73¼ x 49¼ inches, framed. Collection of the Denver Museum.

Photograph by William Nettles. Courtesy of Daniel Saxon Gallery, Los Angeles. Reproduced by permission of the artist.

coloration and utter isolation. But like so many vessels at the Senator Hotel, it is depleted, empty and spent. As if to exorcise the demons of our collective past, Gronk has turned to some of the imagery for which he is best known—party glasses and white Styrofoam coffee cups—and has drained them dry. What are left are only the vessels, beautiful in their simplicity but devoid of anything other than the traces of vice.

It is no accident that Gronk works here in a dark palette. The creations have a delirious and aphotic sheen, produced by the use of acrylic on wood. Acrylic is a synthetic (and toxic) resin that has a translucent visual quality. On the treated wood, acrylic acquires a burnished patina, and that resinoid feel works well with the recurrent themes of horror and contamination in the series. For example, *Natural Vessel,* anchored by the solitary confinement of an empty cup, radiates a mood of certainty and technical deftness (fig. 66). The polished effect is beautiful. A viewer may have mercy on the ethereal floating cup, shimmering in its whiteness and suspended in a blue-black eternal vacuum. It is like a soul suspended infinitely in space or in some purgatory.

The signature piece of the series is perhaps the most compelling and repellant. The blue creature, *Hotel Senator,* functions as the horrific yet pitied signifier for the show (fig. 67). The toothy grins of bellhops in earlier works have been transformed into a grimace of deep psychic pain. This is an ecorché taken to the extreme. The ecorché, also known as the flayed figure (Xipe Totec in Aztec mythology was the flayed god who wore a mantle of human skin), is an anatomical painting or sculpture that shows the musculature of the human body. Gronk's blue flaming ecorché is a portrayal of the inner self, scorched by its wounds. This thing has intuited the ghastly acts of our age—not by reading newspapers or watching the news, but by experiencing life's relentless brutality. This also may be the portrait of an artist who has sold his soul. After all, the Senator Hotel was a house of prostitution, and Gronk equates that with the art gallery, using the actual hotel sign to connect these two arenas. If the hotel is his inspiration and his home-studio is where he produces a body of work, then the gallery is where the artist prostitutes himself. This series expresses Gronk's continuing ambivalence about the gallery system while retaining the conceptual edge that undergirds his art. We may wonder, then, about the meaning of this sad blue spent creature. Perhaps this figure is none other than

Figure 66. Gronk, *Natural Vessel,* 1990. Acrylic on wood, 73¼ x 49¼ inches, framed. Private collection. Photograph by Tony Cuñha. Courtesy of Daniel Saxon Gallery, Los Angeles. Reproduced by permission of the artist.

Figure 67. Gronk, *Hotel Senator*, 1990. Acrylic on wood, 73¼ x 49 ¼ inches, framed. Private collection.

Photograph by William Nettles. Courtesy of Daniel Saxon Gallery, Los Angeles. Reproduced by permission of the artist.

Gronk, running back to his studio with the Senator Hotel sign, his mind on fire with a burning concept, yet knowing that no matter what he creates, it is still being produced within the binding constraints of the gallery system.

Whereas the imagery of other pieces in this series is overtly violent, the blue being in *Hotel Senator* has been deadened by incremental violations of the spirit. The expression, what there is of one, suggests disbelieving shock. It is reminiscent of the shock that people sometimes show on their faces when they encounter life not as they thought it would be but as it really is. The shock reverberates through the whole being; the head is on fire. Or perhaps the head is aflame with too many ideas, concepts, machinations. Simultaneously, this blue figure suggests the crucified soul and a Christ-like martyrdom. Those who stay at the Senator Hotel are the tortured victims of the world, but they self-inflict their pain. They suffer for the rest of us or, perhaps, because of us.

From one panel to the next, Gronk subverted conventional assumptions and created new meanings. By using images of receptacles on doors, the exhibition resonated with its own purpose. The doors became receptacles for paint and image just as prostitutes are receptacles for bodily fluids. When you take account of the empty vessels and the impermanence of disposability, you come to transience. And that equals the throwaway residents and migratory victims of the hotel: the whores, losers, and addicts of life. The total effect takes on the contours of a profound riddle.

There is a hopeful sign: the doorman with the key. He is pointing upward, perhaps gesturing toward heaven or simply seeking some type of solace for his deformed limb. He may be pointing toward some salvation and away from the ghostly hallucinatory world around him. A silent messenger of hope, he is surrounded by a quivering chalky whiteness. He echoes the haloed figure in *Electricity and Water* (1990, private collection), who, like the doorman, is not human but is offering something other than violence, violation, or futility.

The ahistoric limbo of *Hotel Senator*'s narrative lent it an anti-mythic, perhaps even postmythic, edge. There are no heroes here. No Gilgamesh. No Hercules. No Achilles. Not even a Cuauhtémoc having his feet burned by Cortés. There are only vestiges, fragments, discards, and the forgotten human flotsam floating from one loathsome assignation to another behind the doors of the Senator Hotel. To be heroic is to be fearless and bold, but the one emotion that comes through in Gronk's *Hotel Senator* is *fear*, the terror of life and the panic that more terror could be just around the corner.

In *Hotel Senator* Gronk elevated transience and horror to the level of the supernatural, where they became that thing that only art can be: the witness to our own being. For one transcendent moment within the confines of our brief existence we are totally transfixed by our own reflection. With *Hotel Senator*, Gronk achieved transcendence and allowed us to experience the "ecstasy of catastrophe."[6] We realize that the depravity and ungraspable forces we see in the series are frightening, not because they existed in some sorry hotel in downtown Los Angeles but because all that potential for terror, fear, and pain exists within us.

Through form, color, and the most elemental types of representation, Gronk formulated a symbolic discourse that demonstrated that a painter could be profound, and that his art could instill awe, reaching so deeply into the human psyche as to trump the cold irony of the 1990s. The show's lasting value is partly found in the paintings' raw compositional strength. The paintings are powerful in and of themselves. Each one has a unity of form, color, and space. Technically, there are two or three paintings that have the feel of being "throwaways," quickly completed paintings—but then the show is about disposability.

Hotel Senator will continue to have an impact after Gronk is gone. With the exhibition, he demonstrated that he not only was attuned to the mass disillusionment of our time but also could portray it in a way that was necessarily at odds with the art market and gallery system. Indeed, this show did not sell well when it first opened. Collectors were not enamored of the imagery's darkness and social premise. He depicted the nightmare of life by painting the unholy apparitions that surround us. And in making the gallery and transient hotel isomorphic, he paid homage to the travails of the lonely residents at the Senator Hotel and to the "beauty of painting."

URBAN NARRATIVE
A WORLD OF SECRET AFFINITIES

Beauty has no other origin than a wound, unique, different for each person, hidden or visible, that everyone keeps in himself, that he preserves and to which he withdraws when he wants to leave the world for a temporary, but profound solitude.

—Jean Genet, *Fragments of the Artwork*

With *Hotel Senator* and its brutal inscription of urban life, Gronk reached a new level as an interpretive artist. After all, at his essence he is a constant explorer, a postmodern urban Ulysses. The world he traverses is the city in all its layered and secret permutations. He crosses urban landscapes in different guises: a nomad in search of a sign open to interpretation, an archeologist digging for clues to a primeval past, an explorer in the fields of the imagination. The outcome of his urban transmigrations is his work.

Looking backward and forward in time, we can see that a line—curved, not straight, but not crooked either—can be drawn from Gronk's work with Asco (such as the conceptual No Movie) to his collaboration with Dreva to his mainstream art world coming-out party at MOCA's Temporary Contemporary space in 1985. The line continues to his private diaries and journals and, ultimately, to his computer animation work in *Gronk's BrainFlame* and his set for the opera *Ainadamar*. While aesthetic and conceptual continuity might therefore be somewhat apparent across his career, these milestones also mark a steady trajectory toward international recognition. Daniel Saxon's efforts on Gronk's behalf have been instrumental in this regard, ultimately affecting the way Chicano artists are perceived in the art world. Saxon was a determined promoter of Gronk and his work, marketing his shows and the artist on a continual basis. Access to a gallery and creative management placed Gronk on a more professional level. Although Gronk often says that La Tormenta has turned her back on the art world, the truth is more complex.

Saxon played an instrumental role in arranging for Gronk's first comprehensive museum survey show, which was presented

at LACMA. The show originated at the Mexican Museum in San Francisco in the fall of 1993, and it took a good amount of lobbying to persuade LACMA to accept it. After all, the museum had never held an exhibition on an individual Chicano artist. Finally, in March 1994, *¡Gronk! A Living Survey, 1973–1993* opened at LACMA to respectful if somewhat mixed reviews.

The Saxon-Gronk working relationship had a father-son aspect and was quite beneficial for both. In the course of their time together as dealer and artist, Gronk became a main point person for the introduction of Chicano art into the commercial art market. The irony here, of course, is that Gronk's roots as a street artist and his later work with Asco, Dreva, and others were often in opposition to the concerns of the commercial art market. Gronk has navigated this tension through participation in projects that maintain some level of experimentation, such as his work in the 1990s with Peter Sellars on *Los Biombos/The Screens*, an adaptation of Jean Genet's *Les paravents* (1961), which was presented at the East Los Angeles Skills Center, a cavernous space in a former warehouse. As such opportunities continue to arise, Gronk has increasingly gravitated toward collaborations in institutional settings, placing less emphasis on painting for the market.

Perhaps representative of his move away from art as commodity, the pieces completed for *Los Biombos/The Screens* later made up part of *Urban Narrative: Works by Gronk*, an exhibition that in many ways served as a counterpoint to or expansion of the LACMA survey. Gronk reconstructed the narrative of his own career for the occasion, conducting a self-reflexive analysis through art and his personal archive. The show, curated by James Rojas and staged in 2005 at Gallery 727, featured raw canvas paintings, displays, and installations. The downtown gallery where it opened was next door to his loft on Spring Street. The postcard announcing the show featured *The Boo Report*, one of his No Movies, a set of three photos from 1974 (fig. 68). In the first photo, under a hand-painted butcher paper sign advertising a store's sale of Pepsi-Cola six-packs, a drunk is trying to hold up another drunk. In the next shot, the first drunk is limp and the second drunk now holds him up. The final photo shows the two drunks holding on to each other, either to keep themselves from falling or perhaps from a primal, shared compassion. This No Movie depicts a world that Gronk inhabits every day. He sees the derelicts, the lost, and the hopeless right outside his door.

The No Movie concept and Gronk's approach in general is about implicit knowledge. The meaning of something is not obvious but obtuse, and therein lies its power. In contemplating a still photo from Sergei Eisenstein's *Ivan the Terrible* (1944), Roland Barthes, in *Image, Music, Text*, writes the following, which could just as easily apply to a No Movie still or to urban narrative as seen, composed, and presented by Gronk:

> Greater than the pure, upright, secant, legal perpendicular of the narrative, it seems to open the field of meaning totally, that is infinitely. . . . The obtuse meaning appears to extend outside culture, knowledge, information; analytically it has something derisory about it: opening out into the infinity of language, it can come through as limited in the eyes of analytical reason; it belongs to the family of the pun, buffoonery, useless expenditure. Indifferent to moral or aesthetic categories (the trivial, the futile, the false, the pastiche), it is on the side of carnival.[1]

Gronk is interested in creating a counternarrative that derides the received tenets of art or culture. It's not that his work is without organizing principles. But, as Herrón said about Asco, it is "different," and in that difference is a distinctive and asymmetric concept of art as seen from within an oppositional perspective that exposes and explores the webs of hypocrisies around us.

In *Urban Narrative*, Gronk arranged two large glass display cases with personal memorabilia and ephemera. Within each case were photographs from all the periods of his life, drawings from his personal collection, flyers, mail art, bus and train tickets, and the like. The artist presented the images and allowed the viewer to make the connections. For the uninitiated, it was an introduction to a life steeped in art. As the viewer walked alongside the display cases, viewing the paraphernalia and pieces of a life, it began to make sense. There were photos of Gronk's early days with Cyclona. The time with Asco was represented with an image of a No Movie. La Tormenta was there. Gronk's friendship with Marisela Norte, "the poet laureate of Boyle Heights," was captured in a photo that could be from a family reunion, showing Norte leaning her head on his shoulder. A card announced "The Royal Family," with Tomata DuPlenty. Dreva and some unnamed lovers were present as well.

In addition to the display cases and a large installation for the show, Gronk hung several of the raw canvasses that he had

Figure 68. Gronk, *The Boo Report* (No Movie), 1974. Black-and-white 35 mm photographs.
Reproduced by permission of the artist.

painted for *Los Biombos/The Screens*. The adaptation of Genet's play dealt with the issues of conflict in oblique ways. While Genet's version was set during the Franco-Algerian War, the Sellars version was a subtle recounting of another state of emergency: the lives of people in poor urban enclaves.

Gronk's screens for the production, which included *Doggone Chicken*, *New World*, and *Sisyphus Brain*, are black-on-white works that were hung throughout the giant warehouse where the performance took place. These screens told the story about what life is like during wartime. One screen, *Doggone Chicken*, depicts a dog within a dog, with a skull inside the mouth of the inner dog (fig. 69). A chicken head comes out of an arm as if the head were a hand. The toothy snarl on the larger dog reminds one of Mario Bava's *Rabid Dogs*, a 1970s Italian film about a cynical society where trust is in short supply. The imagery in these "screens" is about struggle and the need for freedom in the midst of chaos.

Gronk created an installation especially for *Urban Narrative* called *Cheap Construction* (fig. 70). A corner wall was covered in Gronk's recognizable blacks, reds, and chalky whites, similar to the colors in *The Man Without Desire*. The walls met a riser on the floor made of drywall, also colored in black, red, and white. Glass brains lit from within sat on the drywall risers. Deep in the far left corner was a pair of little girl's silver sandals. These sandals completed the "narrative" (fig. 71).

As part of an autobiographical framework, *Cheap Construction* is about the destruction of the downtown that Gronk has consistently engaged in his work. Writing in the *L.A. Weekly*, Gloria Ohland noted that Gronk "is an existential detective who plumbs the ephemeral, protean landscape of L.A.'s beleaguered urban core for clues to the real, unreal, and surreal narratives that tell our collective story as a city."[2] Gentrification and "urban renewal" constitute perhaps the most recent chapter of this story, the newest layers of this tattered palimpsest. As more people move into converted lofts, Gronk has noticed that many new occupants use drywall to build little rooms, boxes of privacy and isolation. This private renovation may predict the alteration of public space, the transformation of a bustling Latino shopping district into a sanitized open-air mall. The silver sandals in his installation not only evoked a little girl lost in the city but also called forth memories of a time and perhaps an innocence that is slipping away. The sandals were a gift from Norte. She remembers the day they first saw them:

We were walking down Spring Street and we saw a mother with a baby in the stroller. She also had a little boy and a little girl. The family was at a bus stop waiting for the next bus to

Figure 69. Gronk, *Doggone Chicken*, 1998. Acrylic on canvas, 6¼ x 10 feet. Set for *Los Biombos/The Screens*. Adapted by Gloria Alvarez, directed by Peter Sellars. Photograph by Tony Cuñha, 2005. Reproduced by permission of the artist.

Figure 70. Gronk, *Cheap Construction*, 2005. Mixed media installation at Gallery 727, Los Angeles. Photograph by Tony Cuñha, 2005. Reproduced by permission of the artist.

Figure 71. Gronk, detail of *Cheap Construction*, 2005. Mixed media installation at Gallery 727, Los Angeles. Photograph by Tony Cuñha, 2005. Reproduced by permission of the artist.

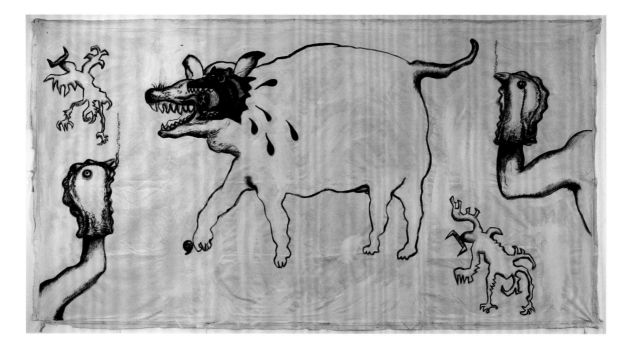

somewhere. People were walking up and down the street and in the middle of all this in the window of a store there was a pair of silver sandals that caught our eyes. I bought them and gave them to Gronk as a gift. They sat on top of his computer for years. For us, silver was the space age. When we were little kids anything that was silver was space age.[3]

Using the sandals as both an evocation of childhood and a reference to downtown as a shopping destination for working-class Latinos, Gronk offered a subtle commentary upon the ongoing transformation of urban space. As suburbanites move in and re-create the little boxes of suburbia, other segments of the population (like the family at the bus stop) will inevitably be displaced. This process also threatens to alter the tumultuous unpredictability of a downtown that has remained a constant inspiration for Gronk's work. The sandals thus functioned as an archaeological artifact and a trace of an urban environment that may soon vanish, conjuring the phantom of a little girl on a

weekend shopping excursion with her mother. Thus the installation approached the politics of space through personal memory and lived experience. It was also an homage to Gronk's friend Marisela Norte and their experiences downtown. It's interesting that at the end of the show's run, Gronk had the piece painted over, as he often does with his wall works at museums and universities. One might assume that the sandals are back on top of Gronk's computer. As Norte likes to imagine, "when the little girl in the installation goes to sleep at night she dreams of her silver space age sandals."[4]

The glass brains in *Cheap Construction* were from a series of Gronk's glass sculptures that influenced a computer animation that premiered in the summer of 2005 at the planetarium in Albuquerque. *Gronk's BrainFlame* is a 5,000-square-foot digitally animated depiction of what happens during a creative epiphany (figs. 72–74). The work was completed through the ARTS Lab of the University of New Mexico. The fourteen-minute piece was created specifically for the LodeStar Dome Theater and took two years to develop. Gronk was the director; his longtime collaborator, Steve La Ponsie, composed the delicately haunting score; animator Hue Walker oversaw the complex and time-demanding animation; and a number of students also worked on the animation through the Digital Pueblo Project.

It begins inside a piece of floating matter. Crisscrossing lines appear little by little, and suddenly we see a lone figure. It appears that we are witnessing the creation of a world or the genesis of an idea. It might also be seen as a post-apocalyptic vision as more figures appear in the landscape, where they plant seeds and strange pink flowers. We still see the world half-open, as if our planet or another one has been blown apart, with half of it drifting off into space. Could this be the aftermath of an environmental collapse, or is it the seeding of an idea, electrical impulses creating imagery in the artist's mind?

The animation has the intense feel of the collaborative process, the artist's mode of creation, while giving a sense of movement through an inner space. At one point, familiar Gronkian shapes float alongside fluttering pale fire-colored butterfly shapes that might have held the rapt attention of the lepidopterist side of Vladimir Nabokov. As the butterfly shapes begin to coalesce, a misty ether becomes animated, and it's as if Gronk's *No Punctuation* has splintered into organic breathing shapes. Finally, at the

Figures 72–74. Gronk, images from *Gronk's BrainFlame,* 2005. Digital animation. Score by Steve La Ponsie, animation supervised by Hue Walker. Produced at the Digital Pueblo Project with support from the National Science Foundation at University of New Mexico, Albuquerque.

Reproduced by permission.

end, we see a golden seed—the idea, the new world, the potential—floating in black space. *Gronk's BrainFlame* is the animated version and a visual interpretation of what he sees as the creative process, as well as an inventory of his imagery to this point in his career. His abstract works from the late 1990s and the early twenty-first century and the figures and landscapes from his diaries join together in one massive visualization of what it means to create. There is a scientific air to the piece, as if it were a series of images transmitted back from one of NASA's distant voyages to deep outer space. At one point in the animation the worldlike globular structure is a luminous gold, like the ink found in old books or the funerary designs of ancient Egyptian pharaohs.

BrainFlame captures the existential quality of Gronk's journal drawings, which, as Gronk points out, have a bleak quality (figs. 75–78). While there is an element of bleakness in the animation as well, there's also living color in motion, and La Ponsie's score adds an uplifting, expansive quality. The journals are themselves an entire body of work. Gronk has shown them publicly from time to time, and at the Carnegie Art Museum's *Tormenta* show in 2003. The journals and the countless pages of drawings and watercolors are the places where Gronk works out his shapes, forms, and themes. To look at them closely is to see a world where the sky is king and a raw landscape with boulders, rocks, stones, hills, mountains, and dried shrub takes shape. These Gronkian landscapes are the very place where one could imagine the gods nailing Prometheus to a rock as we all watch the vultures claw out his eyes. Cautioning against any overly linear interpretation of life, Albert Camus, apropos the return of Prometheus to our contemporary time, wrote, "History is a sterile earth where heather does not grow. Yet men today have chosen history, and they neither could nor should turn away from it."[5] Prometheus tried to save us, but as the myth tells us, we saw without seeing, heard without listening, like figures in a dream. In this respect, Gronk's journals are dreamlike, ahistorical, and mythic, offering a pointed contrast not only to the sterility of history but also to his more overtly historical and political work. Perhaps, like the lost little girl evoked by the silver sandals in *Cheap Construction*, we, too, have lost our way while searching for myths to believe in. The message of *Gronk's BrainFlame* and Gronk's journals may be that we need to go back to the source for the seed that will grow into some kind of hope, no matter how faint.

Figures 75–78. Gronk, untitled notebook drawings,
2000. Ink and watercolor on paper, 11 x 8½ inches.
Private collection.

Reproduced by permission of the artist.

Gronk's large sets for the first fully staged production of *Aina-damar* represent another career milestone. Taking the source of his imagery from one word, *seed,* Gronk painted the walls and floor of the set in a palette that he had been gestating for several years. If the scenes from *Gronk's BrainFlame* were blown up to a monumental proportion, if the golden-hued *History of Comics II* and works such as *No Punctuation* with their rust-bloods and greens were extended far beyond the limits of the canvas, and if his classic colors—the reds, blacks, and textured chalky whites—were added to the mix, the combined effect might approach the earth-toned richness of Gronk's *Ainadamar* sets (fig. 79).

Ainadamar, Arabic for "fountain of tears," is located on the road between Víznar and Alfacer in Granada, Spain. This is where a Spanish death squad killed Federico García Lorca because the fascists hated his work and the fact that he was a homosexual, a *maricón.* Gronk captured the visual feel of the region where Lorca grew up and was murdered, and where the play takes place. Like Claude Debussy, who composed a dreamy tonal portrait of Granada in *Iberia* (1909) without ever visiting the country, Gronk, who has never been to Granada, re-created the warm palette of the landscape for his stage set. Lorca wrote that Debussy reached "his highest creative pitch" in *Iberia,* a work in which "Andulasian perfumes and essences dreamily float," through a serious study of the region's songs.[6] Gronk, too, seriously studied the colors, emotional tones, and sexual-political landscape of Granada.

Writing in the *New Yorker,* Alex Ross explains the opera's premise:

> The libretto, by the playwright David Henry Hwang, places us in a theatre in Uruguay, in the nineteen-sixties, where a venerable actress is about to step onstage for what will turn out to be her last performance. As she waits in the wings, she is overcome by a surge of memories, both happy and harrowing. The character is based on a real figure: Margarita Xirgu, the great Catalan tragedian, who, in the 1920s and 1930s collaborated with Federico García Lorca on several of his most famous plays. Joining her, in a series of dreamlike flashbacks, is Lorca himself, whose high ideals and dark passions dictate the opera's tone.[7] (fig. 80)

Xirgu worked with Lorca on his first play, *Mariana Pineda.* Interestingly, the sets for the 1927 production of that play were

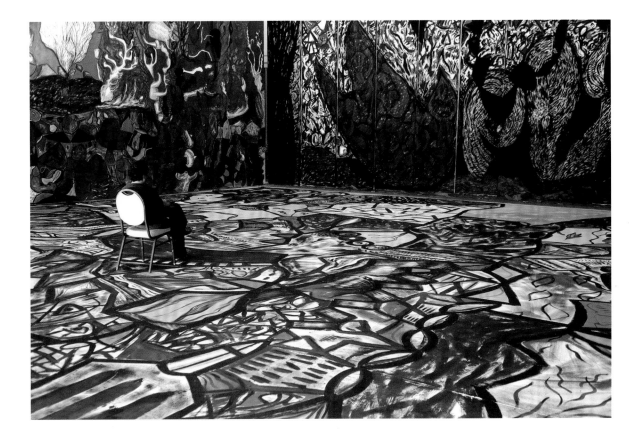

Figure 79. Gronk on the set for *Ainadamar*, 2005.
Photograph by Bob Godwin. Reproduced by permission of
Santa Fe Opera.

by Salvador Dalí, like Gronk an artist with a distinct memorable style of painting and a life lived to his tastes as a supreme individualist. *Mariana Pineda* is about a woman in nineteenth-century Granada, Lorca's birthplace, who was killed for her liberal ideals. In that sense, Lorca was prescient as he, too, was killed for his leftist sympathies as well as for being an outspoken homosexual artist. In the play, Lorca writes about Pineda's death but he could just as well have been writing about his own end: "How sad it was in Granada. The stones began to cry."

One of Lorca's most famous poems is "Lament for Ignacio Sánchez Mejías," about a beautiful bullfighter killed in the arena. At one point in the poem Lorca writes that nature brings forth flowers from the dead bullfighter's skull. That image is curiously echoed in *BrainFlame*, when one of the figures in the animated film begins creating flowers of the imagination. In the poem, Lorca writes:

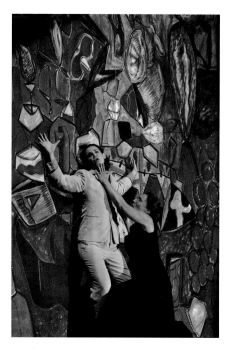

Figure 80. Kelley O'Connor as Federico García Lorca and Dawn Upshaw as Margarita Xirgu in *Ainadamar,* 2005.

Photograph by Ken Howard. Reproduced by permission of Santa Fe Opera.

But now he sleeps without end.
Now the moss and the grass
open with sure fingers
the flower of his skull . . .

Now, Ignacio the well born lies on the stone.
All is finished. What is happening! Contemplate his face:
death has covered him with pale sulphur
and placed on him the head of a dark minotaur.[8]

Gronk's work is "the flower of his skull," the art that comes from within and is set free into the world where it can be interpreted, admired, critiqued, or hung on a wall—or disappear under a whitewash or simply cover a page in one of his diaries. Gronk is like the "dark minotaur," a hybrid being, working, painting, drawing, on and on into the next project, the next show, the next performance.

The sweep of Gronk's life and career as an artist has comprised a series of transcending events. One could say that he has transcended his origins, but not by forgetting them. He has transcended categories, in large part by claiming so many. More than anything, he is the artist as the anti-artist in all his jagged contradictions and negations. Not unlike the potent dialectic of the No Movie concept, Gronk is both "the desire and the hatred." Looking back over the course of his work, we realize that he is Puta, Tormenta, Jetter, Lorenzo Groak Pedrigon, the Man Without Desire, a doomed passenger on the *Titanic,* a bellhop, *and* an artist named Gronk.

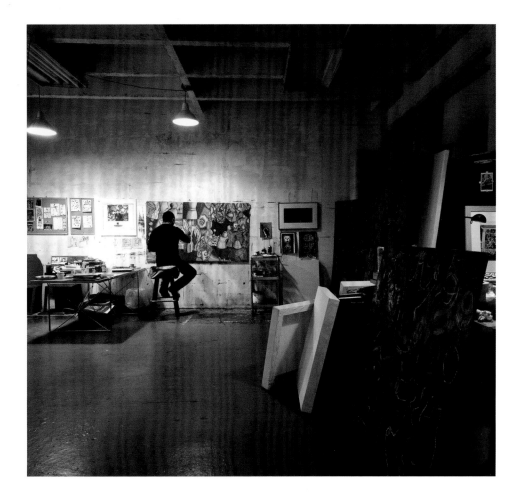

Gronk working in his studio, 2000.

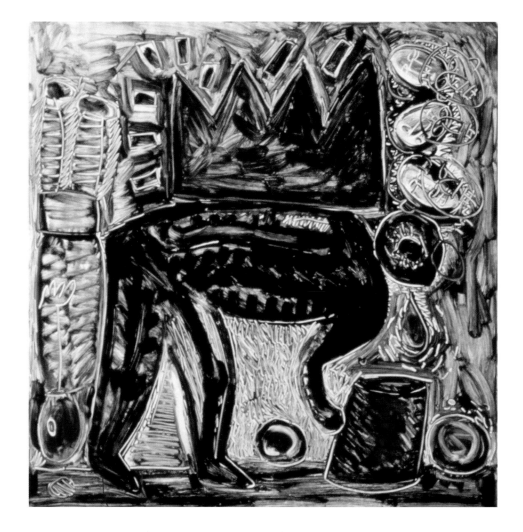

Gronk, *The Kingdom,* 1995. Paint on Plexiglas,
30 x 30 inches.

Photograph courtesy of Tandem Press.
Reproduced by permission of the artist.

NOTES

INTRODUCTION

1. Bernard Holland, "Haunted by the Deaths of Martyrs, a Century Apart," *New York Times*, August 1, 2005, E5.

2. Philip Kennicott, "'Ainadamar': Agony and Ecstasy in Santa Fe," *Washington Post*, August 15, 2005, C1.

3. Janelle Gelfand, "Cincinnati Opera Could Learn from Successful Risk Takers," *Cincinnati Enquirer*, August 7, 2005, 8D.

4. Robert Ayers, "Artists Take Center Stage at the Opera with Innovative Set and Costume Designs," *ARTNews*, Summer 2005.

5. See Shifra M. Goldman and Tomás Ybarra-Frausto, "The Political and Social Contexts of Chicano Art," in *Chicano Art: Resistance and Affirmation, 1965–1985*, ed. Richard Griswold del Castillo, Teresa McKenna, and Yvonne Yarbro-Bejarano (Los Angeles: University of California, Wight Art Gallery, 1991), 83–95.

6. For a discussion of current trends in Chicano art, including the post-Chicano sensibility, see Josh Kun, "The New Chicano Movement," *Los Angeles Times Magazine*, January 9, 2005, 1.

7. Homi K. Bhabha, *The Location of Culture* (New York: Routledge, 1994), 64. See also Bhabha's essay "Remembering Fanon: Self, Psyche, and the Colonial Condition," in *Rethinking Fanon: The Continuing Dialogue*, ed. Nigel C. Gibson (Amherst, NY: Humanity Books, 1999), 179–96.

8. Gronk, interview by Rita González and Jennifer Flores Sternad, Los Angeles, August 31, 2004, transcript, UCLA Chicano Studies Research Center Library and Archive. Gronk mentioned to this author that he touched on subjects in this interview that he had never discussed before, including his relationship with Jerry Dreva (see chapter 4, "Dreva/Gronk: Art Gangsters").

9. Ibid.

10. Ibid.

11. Gronk, interview by author, Los Angeles, May 18, 2004.

12. Claire Colebrook, *Irony* (New York: Routledge, 2004), 126.

13. Judith Butler, *Gender Trouble: Feminism and the Subversion of Identity* (New York: Routledge, 1999).

14. Colebrook, *Irony*, 126–27. Italics added.

15. Ibid., 128.

16. Butler, *Gender Trouble*, 174.

17. Chon A. Noriega, "No Introduction," in Harry Gamboa Jr., *Urban Exile: Collected Writings of Harry Gamboa, Jr.*, ed. Chon A. Noriega (Minneapolis: University of Minnesota Press, 1998), 2–3.

18. Michelle Habell-Pallán, *Loca Motion: The Travels of Chicana and Latina Popular Culture* (New York: New York University Press, 2005), 5. Interestingly, this book captures the sensibility first piloted by Asco and its cohorts. One chapter highlights Marisela Norte, Gronk's "soul mate" and a former collaborator of Harry Gamboa Jr. Habell-Pallán refers to Norte as the "poet laureate of Boyle Heights" and cultural ambassador of East Los Angeles.

19. Sean Carrillo, e-mail to author, May 10, 2005.

20. Gronk, interview by González and Flores Sternad.

21. bell hooks, "Altars of Sacrifice: Re-Membering Basquiat," in *Art on My Mind: Visual Politics* (New York: New Press, 1995), 36. Although hooks is writing about Basquiat's blackness in this essay, it bears noting that his mother was Puerto Rican and that his status as an Afro-Latino is rarely commented upon in the black-white battle over who and what he was. He evoked great admiration, as demonstrated here by hooks, as well as great anger, as demonstrated by Robert Hughes in *American Visions: The Epic History of Art in America* (New York: Alfred A. Knopf, 1997), when he condescendingly refers to Basquiat as having been turned into "the Little Black Rimbaud of American painting" by the PC crowd (602).

LIBRARY BOY

1. Max Benavidez, "Latino Dada: Savage Satire from Harry Gamboa, Jr.," *L.A. Weekly*, May 16–22, 1986, 43.

2. Richard Ingersoll, *Sprawltown: Looking for the City on Its Edges* (New York: Princeton Architectural Press, 2006), 89.

3. Gronk, interview by author, Los Angeles, September 11, 2004.

4. Elston Carr, "Just Another Painter from East L.A.," *L.A. Weekly*, March 18–24, 1998, 16.

5. Gronk, interview by González and Flores Sternad.

6. Ibid.

7. Ibid.

8. Marisela Norte, interview by author, Los Angeles, May 19, 2005.

9. Gronk, interview by González and Flores Sternad.

10. Ibid.

11. Ibid.

12. Gronk, interview by Jeffrey Rangel, Los Angeles, January 20 and 23, 1997, transcript, Archives of American Art, Smithsonian Institution.

13. Gronk, interview by author, September 11, 2004.

14. Carlos Almaraz, "Groak at Mechicano," 1974, class paper in Gronk's personal collection. Almaraz was a member of the art group Los Four, which also included Frank Romero, Beto de la Rocha, and Gilbert "Magú" Luján. See *Los Four* (1974), dir. James Tartan, on the DVD *Early Chicano Art Documentaries*, Chicano Cinema and Media Arts Series, vol. 1 (Los Angeles: UCLA Chicano Studies Research Center Press, 2004). Almaraz himself used different versions of his name at different points in his life; he signed the Groak essay as Charles David Almaraz.

15. *Santa Fe Opera Crescendo*, "The Opera Gets Gronked," Spring 2005, 2.

16. Michael Taussig, *Shamanism, Colonialism, and the Wild Man: A Study in Terror and Healing* (Chicago: University of Chicago Press, 1987), 465.

17. Gronk, interview by González and Flores Sternad.

18. Quoted in Linda Frye Burnham, "Asco: Camus, Daffy Duck and Devil Girls from East L.A.," *L.A. Style*, February 1987, 58.

19. Cyclona (Robert Legorreta), untitled and unpublished memoirs, "The Fire of Life: The Robert Legorreta/Cyclona Collection," UCLA Chicano Studies Research Center Library and Archive, Special Collections.

20. Ibid.

21. Robb Hernandez, *Robert "Cyclona" Legorreta: The Fire of Life/El Fuego de la Vida Collection* (Los Angeles: UCLA Chicano Studies Research Center Press, forthcoming).

PAINTING HISTORY

1. See Rudolfo A. Anaya and Francisco A. Lomelí, eds., *Aztlán: Essays on the Chicano Homeland* (Albuquerque: Academia/El Norte Publications, 1989).

2. See Carlos Muñoz, *Youth, Identity, Power: The Chicano Movement* (New York: Verso, 1989).

3. Edward W. Said, *Culture and Imperialism* (New York: Alfred A. Knopf, 1993), 314–15.

4. Max Benavidez and Kate Vozoff, "The Wall: Image and Boundary, Chicano Art in the 1970s," in *Mexican Art of the 1970s: Images of Displacement*, ed. Leonard Folgarait (Nashville: Vanderbilt University, 1984), 45–54.

5. The history of both of Siqueiros's Los Angeles murals, and the efforts to restore them, will figure prominently in the major exhibition *Legacy and Legend: Siqueiros and América Tropical—Censorship Defied*, scheduled for 2007. See also Jesús Salvador Treviño's 1971 documentary production *América Tropical*.

6. Marcos Sánchez-Tranquilino, "Murales del Movimiento: Chicano Murals and the Discourses of Art and Americanization," in *Signs from the Heart: California Chicano Murals*, ed. Eva Sperling Cockcroft and Holly Barnet-Sánchez (Venice, CA: Social and Public Art Resource Center; Albuquerque: University of New Mexico Press, 1990), 94–95.

7. Benavidez and Vozoff, "The Wall."

8. Max Benavidez, "Chicano Art: Culture, Myth and Sensibility," in *Chicano Visions: American Painters on the Verge* (New York: Little, Brown, 2002).

9. Willie Herrón, interview by Jeffrey Rangel, Los Angeles, February 5, 2000, transcript, Archives of American Art, Smithsonian Institution.

10. Tomás Ybarra-Frausto, *Rasquache: A Chicano Sensibility* (Phoenix: MARS Artspace, 1988). Also see Ybarra-Frausto's essay "Rasquachismo: A Chicano Sensibility," in *Chicano Art: Resistance and Affirmation, 1965–1985*, ed. Richard Griswold del Castillo, Teresa McKenna, and Yvonne Yarbro-Bejarano (Los Angeles: University of California, Wight Art Gallery, 1991), 155–62.

11. Ybarra-Frausto, *Rasquache*.

12. Amalia Mesa-Bains, "Domesticana: The Sensibility of Chicana Rasquache," in *Distant Relations/Cercanías Distantes/Clann I Gcein: Chicano, Irish, Mexican Art and Critical Writing*, ed. Trisha Ziff (Santa Monica, CA: Smart Art Press, 1996), 156–58.

13. Michael Parrish, *For the People: Inside the Los Angeles County District Attorney's Office, 1850–2000* (Los Angeles: Angel City Press, 2001), 117.

14. Ibid.

15. Mario T. García, "Introduction," in Rubén Salazar, *Border Correspondent: Selected Writings, 1955–1970* (Berkeley: University of California Press, 1995), 35.

16. Mario Ontiveros, "Reconfiguring Activism: Inquiries into Obligation, Responsibility, and Social Relations in Post-1960s Art Practices in the United States" (PhD diss., University of California at Los Angeles, 2005), 76–77.

17. Ibid., 77.

18. Ibid., 75.

19. For a discussion of the Chicano Moratorium and the distinct response on the part of Chicano filmmakers, see Chon A. Noriega, "The Requiem for Our Beginnings," *Aztlán: A Journal of Chicano Studies* 25, no. 2 (2000): 1–10.

20. Max Benavidez, "The Post-Chicano Aesthetic: Making Sense of the World," in *Post-Chicano Generation in Art: Breaking Boundaries*, exhibition catalog (Phoenix: MARS Artspace, 1990).

21. Gronk, interview by Rangel.

22. Ibid.

23. See *Murals of Aztlán: The Street Painters of East Los Angeles* (1981), dir. James Tartan, on the DVD *Early Chicano Art Documentaries*, Chicano Cinema and Media Arts Series, vol. 1 (UCLA Chicano Studies Research Center Press, 2004).

ASCO'S NO MANIFESTO

1. Sean Carrillo, e-mail to author, May 10, 2005.

2. Gronk, interview by González and Flores Sternad.

3. Patssi Valdez, interview by Jeffrey Rangel, Los Angeles, May 26, 1999, transcript, Archives of American Art, Smithsonian Institution.

4. Ibid.

5. Herrón, interview by Rangel.

6. Howard N. Fox, "Tremors in Paradise, 1960–1980," in *Made in California: Art, Image, and Identity, 1900–2000*, ed. Stephanie Barron, Sheri Bernstein, and Ilene Susan Fort (Los Angeles: Los Angeles County Museum of Art; Berkeley: University of California Press, 2000), 226–27; Chon A. Noriega, "From Beats to Borders: An Alternative History of Chicano Art in California," in *Reading California: Art, Image, and Identity, 1900–2000*, ed. Stephanie Barron, Sheri Bernstein, and Ilene Susan Fort (Los Angeles: Los Angeles County Museum of Art; Berkeley: University of California Press, 2000), 361–65.

7. Karen Mary Davalos, *Exhibiting Mestizaje: Mexican (American) Museums in the Diaspora* (Albuquerque: University of New Mexico Press, 2001), 95–96.

8. Noriega, "From Beats to Borders"; C. Ondine Chavoya, "Internal Exiles: The Interventionist Public and Performance Art of Asco," in *Space, Site, Intervention: Situating Installation Art*, ed. Erika Suderburg (Minneapolis: University of Minnesota Press, 2000), 198–208.

9. Harry Gamboa Jr., "Gronk: Off-the-Wall Artist," *Neworld* 4 (July/August 1980): 33. Reprinted in Harry Gamboa Jr., *Urban Exile: Collected Writings of Harry Gamboa, Jr.*, ed. Chon A. Noriega (Minneapolis: University of Minnesota Press, 1998), 50.

10. Peter Plagens, letter to the editor, *Neworld* 5 (September/October 1980): 9.

11. Mike Davis, *City of Quartz: Excavating the Future in Los Angeles* (London: Verso, 1990), 24. Beyond Asco's exclusion from books such as Davis's progressively oriented text, its greater omission from the art historical record reminds one of Sigmund Freud's fascinating observation in *Moses and Monotheism*, trans. Katherine Jones (New York: Vintage Books, 1967): "The distortion of a text is not unlike a murder. The difficulty lies not in the execution of the deed, but in doing away with the traces." Freud explains that "distortion" once had two meanings: to change the nature of the thing and "to wrench apart" or "to put in another place." He also notes that "is why in so many textual distortions we may count on finding the suppressed and abnegated material hidden away somewhere, though in an altered shape and torn out of its original connection" (52).

12. Harry Gamboa Jr., interview by Jeffrey Rangel, Los Angeles, April 1 and 16, 1999, transcript, Archives of American Art, Smithsonian Institution.

13. Roland Barthes, *S/Z: An Essay*, trans. Richard Miller (New York: Hill and Wang, 1974), 98. For Barthes, "stereotypic vertigo" is a condition that infects language. Of course, the source of the infection is found in its original source: thought or conventional thought patterns. The cultural arbiters exhibit this stereotypic vertigo when looking, or not looking at all, at an art group such

as Asco. As Barthes notes, "Like didactic language and political language, which also never question the repetition of their utterances (their stereotypic essence), the cultural proverb vexes, provokes an intolerant reading" (98).

14. Herrón, interview by Rangel.

15. Harry Gamboa Jr., "In the City of Angels, Chameleons, and Phantoms: Asco, a Case Study of Chicano Art in Urban Tones (or, Asco Was a Four-Member Word)," in *Urban Exile: Collected Writings of Harry Gamboa, Jr.*, ed. Chon A. Noriega (Minneapolis: University of Minnesota Press, 1998), 76.

16. Ibid., 77.

17. Jacqueline Rose, "Response to Edward Said," in *Freud and the Non-European*, by Edward W. Said (London: Verso, 2003), 68.

18. Gronk, interview by González and Flores Sternad.

19. Gamboa, "In the City of Angels," 80.

20. Ibid.

21. Kristen Guzmán, *Self Help Graphics and Art: Art in the Heart of East Los Angeles* (Los Angeles: UCLA Chicano Studies Research Center Press, 2005), 13.

22. James Rojas, "The Enacted Environment: The Creation of 'Place' by Mexicans and Mexican Americans in East Los Angeles" (master's thesis, Massachusetts Institute of Technology, 1991), 14.

23. Ibid.

24. Ibid., 15.

25. Chavoya, "Internal Exiles," 201.

26. David E. James, "Hollywood Extras: One Tradition of 'Avant-Garde' Film in Los Angeles," *October* 90 (1999): 3–24.

27. Gronk, interview by Rangel.

28. Chon A. Noriega, "Talking Heads, Body Politic: The Plural Self of Chicano Experimental Video," in *Resolutions: Contemporary Video Practices*, ed. Michael Renov and Erika Suderburg (Minneapolis: University of Minnesota Press, 1996), 215.

29. See *Harry Gamboa Jr.: 1980s Video Art*, Chicano Cinema and Media Arts Series, vol. 2, DVD (Los Angeles: UCLA Chicano Studies Research Center Press, 2004).

30. Gronk, interview by Rangel.

31. Ryan Furtado, "East Los with the Death Camp," *YO! Youth Outlook*, Pacific News Service, March 10, 2006, http://www.youthoutlook.org/news/view_article.

html?article_id=899f78e73aa9f0103865dfd1bf2d44d2.

32. Gamboa, "In the City of Angels," 82.

33. Harry Gamboa Jr., "Jetter's Jinx: A Conceptual Drama," in *Urban Exile: Collected Writings of Harry Gamboa, Jr.*, ed. Chon A. Noriega (Minneapolis: University of Minnesota Press, 1998), 229.

DREVA/GRONK

1. Gronk, interview by González and Flores Sternad.

2. Ibid.

3. Lionel Biron, interview by Philip Vincent, "Part II: The 1970s Revisited," www.photos-biron.com/words/interv01b.htm.

4. Gronk, interview by González and Flores Sternad.

5. Wallace Fowlie, *Dionysus in Paris: A Guide to Contemporary French Theater* (New York: Meridian Books, 1960), 203–9.

6. See the Bowie Wonderworld website, http://www.bowiewonderworld.com/art/art1.htm; and the Bowie Golden Years website, http://members.ol.com.au/rgriffin/GoldenYears/1980.html.

7. Gronk, interview by González and Flores Sternad.

8. Jerry Dreva to Gronk, mid-1970s, letter in Gronk's personal collection.

9. Jerry Dreva to Gronk, May 17, 1974, letter in Gronk's personal collection.

10. Jerry Dreva to Gronk, mid-1970s, letter in Gronk's personal collection.

11. For more information about the CETA program and minority artists, see Mirasol Riojas, *The Accidental Arts Supporter: An Assessment of the Comprehensive Employment and Training Act (CETA)*, Research Report No. 8 (Los Angeles: UCLA Chicano Studies Research Center Press, 2006), http://www.chicano.ucla.edu/press/reports/archive.asp.

12. Claudine Isé, "Considering the Art World Alternatives: LACE and Community Formation in Los Angeles," in *The Sons and Daughters of Los: Culture and Community in L.A.*, ed. David E. James (Philadelphia: Temple University Press, 2003), 86–87.

13. Gronk, interview by González and Flores Sternad.

14. Ibid.

15. See Lionel Biron, interviews, http://www.photos-biron.com/words/interv01b.htm.

LA TORMENTA

1. Gronk, interview by Rangel.

2. Tere Romo, "Points of Convergence: The Iconography of the Chicano Poster," in *Just Another Poster? Chicano Graphic Arts in California*, ed. Chon A. Noriega (Santa Barbara: University of California, University Art Museum, 2001), 109.

3. Ibid.

4. Blakeslee Stevens's text in *Humanesque*, spoken-word performance, Los Angeles, 1986.

5. Gronk, "Painting Stages/Performing Life: Gronk" (interview by Jennifer Flores Sternad), *Contemporary Theater Review* 15, no. 3 (2005): 343. The Tormenta image also reminds one of René Grau's famous 1956 image created for Dior, in which a woman in a black backless gown has her head turned away from the viewer. Grau created the image for the fragrance Diorissimo.

6. Gronk, "Painting Stages," 342.

7. Donald Richie, *Ozu* (Berkeley: University of California Press, 1974), 162.

8. Colebrook, *Irony*, 128.

9. Ibid.

10. Ibid.

11. Gronk, "Painting Stages," 343.

12. See Christopher Rollason, "Globalization and Particularism in the Work of Jose Saramago: The Symbolism of the Shopping Mall in *A Caverna*," paper presented at Globalization and Nationalisms: Second International Conference on Postcolonial Studies, University of Vigo, Galicia, Spain, October 24–26, 2001.

13. Richie, *Ozu*, 187. At another point in this book, which seems to serve as Gronk's aesthetic bible, Richie notes that Ozu believed that "you are a transient in a transitory world." This applied to Gronk's worldview as well. Later, Richie states, per Ozu, "You are what you do, and nothing more nor less; the sum total of your choices, your actions, is the sum total of yourself. In choosing, you not only create self, you transcend it" (71–72). This also echoes Gronk's perspective, and these lines were underlined in Gronk's hand.

14. Plato, "The Allegory of the Cave," in *The Republic*, trans. G. M. A. Grube, rev. C. D. C. Reeve (Indianapolis: Hackett, 1992).

15. Gronk, interview by González and Flores Sternad.

HOTEL SENATOR

1. Gronk, interview by Rangel.

2. Ibid.

3. Jean Genet, "The Studio of Alberto Giacometti," in *Fragments of the Artwork*, trans. Charlotte Mandell (Stanford: Stanford University Press, 2003), 47.

4. For further discussion, see Max Benavidez, *Gronk: Hotel Senator* (Los Angeles: Daniel Saxon Gallery, 1990).

5. Richie, *Ozu*, 188. In the sense that the everyday is transcendent, it is worth noting that the Japanese have an aesthetic category called *wabi*. Richie explains: "The more ordinary, even poorer, the container, the stronger the (properly displayed) effect. The plain, the rough, the common—these are the best conduits for the aesthetic spirit. . . . *Wabi* as a spiritual tool suggests that the eternal is contained in the transient" (187).

6. My use of this concept draws from Howard V. Hendrix, *The Ecstasy of Catastrophe: A Study of Apocalyptic Narrative from Langland to Milton* (New York: P. Lang, 1990).

URBAN NARRATIVE

1. Roland Barthes, "The Third Meaning: Research Notes on Some Eisenstein Stills," in *Image, Music, Text*, trans. Stephen Heath (New York: Hill and Wang, 1977), 52–68.

2. Gloria Ohland, "Urban Narrative," *L.A. Weekly*, March 3–10, 2005.

3. Norte, interview by author.

4. Ibid.

5. Albert Camus, "Prometheus in the Underworld," in *Lyrical and Critical Essays* (New York: Vintage, 1968), 138–42.

6. Federico García Lorca, "Deep Song," trans. Christopher Maurer, in *In Search of Duende* (New York: New Directions, 1998), 9.

7. Alex Ross, "Deep Song: Ainadamar," *New Yorker*, September 1, 2003, 128.

8. Federico García Lorca, "Lament for Ignacio Sánchez Mejías," trans. Stephen Spender, in *In Search of Duende* (New York: New Directions, 1998), 67–81. According to Christopher Maurer, who edited and translated the prose portions of *In Search of Duende*, Lorca once told a friend that Sánchez Mejías's death was like "an apprenticeship for my own." Lorca died two years after making this comment.

EXHIBITION HISTORY

EDUCATION

BFA, East Los Angeles College, 1975
MFA, California State University, Los Angeles, 1978

AWARDS

2002 Artist in Residence, University of New Mexico, Albuquerque
1996 Artist in Residence, Villa Montalvo, Saratoga, CA
1993 Artist in Residence, Tandem Press, University of Wisconsin, Madison
Artist in Residence, Cornell University, Ithaca, NY
1983 Visual Artist Fellowship, National Endowment for the Arts
1977 Artist of the Year, Mexican-American Fine Art Association, Los Angeles, CA

MUSEUM COLLECTIONS

Denver Art Museum, Denver, CO
Museum of Contemporary Art, Los Angeles, CA
El Paso Museum of Art, El Paso, TX
Corcoran Gallery of Art, Washington, DC
The Mexican Museum, San Francisco, CA
University of Texas, El Paso, TX
San Jose Museum of Art, San Jose, CA
Carnegie Art Museum, Oxnard, CA
National Hispanic Cultural Center, Albuquerque, NM
Los Angeles County Museum of Art, Los Angeles, CA

SOLO EXHIBITIONS

2006
Gronk: The Ainadamar Opera Paintings, Patricia Correia Gallery, Los Angeles, CA.

2005
Gronk's BrainFlame, digital animation, produced in collaboration with Hue Walker, Steven La Ponsie, and the Digital Pueblo Project at the University of New Mexico, Albuquerque. Exhibited at DomeFest, Digital Dome, Lodestar Astronomy Center, Albuquerque, NM; Museum of Contemporary Art | Denver's *Film Biennial BLOW OUT 2005*, Starz Film Center, Denver, CO; SIGGRAPH 2005 Animation Festival, Los Angeles, CA.

Urban Narrative: Works by Gronk, Gallery 727, Los Angeles, CA.
Ainadamar: Gronk's Designs for the Opera, National Hispanic Cultural Center, Albuquerque, NM.

2004
Gronk Returns: A Site Specific Painting, Carnegie Art Museum, Oxnard, CA.

2003
Codex: Gronk, A Pictorial Manuscript, Price-Dewey Galleries, Santa Fe, NM.
Gronk's Tormenta—A Method, Carnegie Art Museum, Oxnard, CA.

2002
The Glass Kingdom, installation, Museum of Glass: International Center for Contemporary Art, Tacoma, WA.

1998–99
Gronk x 3: Murals, Prints, Projects, San Jose Museum of Art, San Jose, CA.

1998
The Act of Painting: Gronk!, installation and performance, Memorial Art Gallery, University of Rochester, Rochester, NY.

1997
Gronk, Fine Arts Gallery, California State University, Los Angeles.

1995
Ironweave, installation, Elvehjem Museum of Art, University of Wisconsin, Madison.
Gronk: Past & Present, CU Art Museum, University of Colorado, Boulder.

1994
Gronk in the Galleries, San Francisco Museum of Modern Art, San Francisco, CA.

1993
¡Gronk! A Living Survey, 1973–1993, The Mexican Museum, San Francisco, CA. Traveled to the Los Angeles County Museum of Art, Los Angeles, CA; Tucson Museum of Art, Tucson, AZ; El Paso Museum of Art, El Paso, TX.

1992

Hotel Tormenta, Galerie Claude Samuel, Paris, France.

Fascinating Slippers/Pantunflas Fascinantes, San Jose Museum of Art, San Jose, CA; Daniel Saxon Gallery, Los Angeles, CA.

1991

50 Drawings, Daniel Saxon Gallery, Los Angeles, CA.

1990

Hotel Zombie, Laguna Art Museum Satellite, Costa Mesa, CA.

Hotel Senator, Daniel Saxon Gallery, Los Angeles, CA.

Coming Home Again, Vincent Price Gallery, East Los Angeles College, Los Angeles, CA.

1989

Grand Hotel, Saxon-Lee Gallery, Los Angeles, CA.

Gronk: Paintings, Ianneti-Lanzone Gallery, San Francisco, CA.

King Zombie, Deson-Saunders Gallery, Chicago, IL; William Traver Gallery, Seattle, WA (1990).

1988

She's Back, Saxon-Lee Gallery, Los Angeles, CA.

1987

Bone of Contention, Saxon-Lee Gallery, Los Angeles, CA.

1986

The Rescue Party, Saxon-Lee Gallery, Los Angeles, CA.

1985

The Titanic and Other Tragedies at Sea, Galería Ocaso, Los Angeles, CA.

1984

Gronk, Molly Barnes Gallery, Los Angeles, CA.

SELECTED GROUP EXHIBITIONS

2001

Chicano Visions: American Painters on the Verge, traveling exhibition, 2001–2007. Venues included the San Antonio Museum of Art, San Antonio, TX; National Museum of American Art, Smithsonian Institution, Washington, DC; National Hispanic Cultural Center, Albuquerque, NM; Museum of Contemporary Art San Diego, La Jolla, CA; Weisman Art Museum, Minneapolis, MN; Mexican Fine Arts Museum, Chicago, IL; El Paso Museum of Art, El Paso, TX; Indiana State Museum, Indianapolis, IN.

2000

La Luz, National Hispanic Cultural Center, Albuquerque, NM.

1997

Four Directions, collaborative installation with composer Joseph Julián González, Elvehjem Museum of Art, University of Wisconsin, Madison.

1996

American Kaleidoscope, National Museum of American Art, Smithsonian Institution, Washington, DC.

1995

The Mythic Present of Enrique Chagoya, Patssi Valdez, and Gronk, Fisher Gallery, University of Southern California, Los Angeles.

1993

The Chicano Aesthetic/Four Artists: A Dialogue, Georgia State University Art Gallery, Atlanta.

Chicano/Chicana: Visceral Images, The Works Gallery South, Costa Mesa, CA.

Sin Frontera: Chicano Arts from the Border States of the U.S., Cornerhouse, Manchester, England.

Revelaciones/Revelations: Hispanic Art of Evanescence, Herbert F. Johnson Museum of Art, Cornell University, Ithaca, NY.

The Fifth Element: Recent Acquisitions of Contemporary Chicano Art, The Mexican Museum, San Francisco, CA.

1992

The Chicano Códices: Encountering Art of the Americas, The Mexican Museum, San Francisco, CA.

1991

Myth and Magic in the Americas: The Eighties, Museum of Contemporary Art, Monterrey, Mexico.

Chicano & Latino: Parallels & Divergence, Daniel Saxon Gallery, Los Angeles, CA. Traveled to Kimberly Gallery, Washington, DC, and El Paso Museum of Art, El Paso, TX.

Of Nature and the Human Spirit, Part II, Daniel Saxon Gallery, Los Angeles, CA.

1990

Chicano Art: Resistance and Affirmation, 1965–1985, Wight Art Gallery, University of California, Los Angeles. Traveled to Denver Art Museum, Denver, CO; Albuquerque Museum, Albuquerque, NM (1991); San Francisco Museum of Modern Art, San Francisco, CA (1991); Fresno Art Museum, Fresno, CA (1991); Tucson Museum of Art, Tucson, AZ (1992); National Museum

of American Art, Smithsonian Institution, Washington, DC (1992); El Paso Museum of Art, El Paso, TX (1992); Bronx Museum of the Arts, Bronx, NY (1993); San Antonio Museum of Art, San Antonio, TX (1993).

1989

Le démon des anges: 16 artistes "Chicanos" autour de Los Angeles, Centre d'Art Santa Mònica, Barcelona, Spain; Centre de Recherche pour le Développement Culturel, Nantes, France. Traveled to Stockholm, Sweden.

Hispanic Art on Paper, Los Angeles County Museum of Art, Los Angeles, CA.

From the Back Room, Saxon-Lee Gallery, Los Angeles, CA.

Mister Sister, installation, Laguna Art Museum, Laguna Beach, CA.

Three, Galerie Claude Samuel, Paris, France.

1988

Cultural Currents, San Diego Museum of Art, San Diego, CA.

On the Spot, Centro Cultural de la Raza, San Diego, CA.

Two Artists/Recent Works, University of California, San Diego.

Ten Latino Artists, Jack Tilton Gallery, New York, NY.

1987

Hispanic Art in the United States: Thirty Contemporary Painters and Sculptors, Museum of Fine Arts, Houston, TX. Traveled to Corcoran Gallery of Art, Washington, DC; Brooklyn Museum, Brooklyn, NY; Los Angeles County Museum of Art, Los Angeles, CA; Lowe Art Museum, Miami, FL; Museum of New Mexico, Santa Fe.

On the Wall, Santa Barbara Contemporary Arts Forum, Santa Barbara, CA.

L.A. Hot and Cool: The Eighties, MIT List Visual Arts Center, Cambridge, MA. Traveled to Bank of Boston Art Gallery, Boston, MA, as *L.A. Hot and Cool: Pioneers*.

1986

Crossing Borders/Chicano Artists, San Jose Museum of Art, San Jose, CA.

1985

Asco Performance and Videotapes, Los Angeles Contemporary Exhibitions, Los Angeles, CA.

Summer 1985: Nine Artists, Museum of Contemporary Art, Los Angeles, CA.

Off the Street, abandoned print shop at 411 East First Street, Los Angeles Cultural Affairs Department, Los Angeles, CA.

1984

Asco '84, Armory for the Arts, Santa Fe, NM.

1983

A Través de la Frontera, Centro de Estudios Económicos y Sociales del Tercer Mundo, Mexico City, Mexico.

Asco '83, Sesnon Art Gallery, University of California, Santa Cruz.

The Hispanic Heritage of Los Angeles: Art and Architecture, Thorn Hall Gallery, Occidental College, Los Angeles, CA.

1982

Asco '82, Galería de la Raza, San Francisco, CA.

Califas, Fondo del Sol, Washington, DC.

1980

Herrón/Gronk: Illegal Landscape, Exploratorium Gallery, California State University, Los Angeles.

Latinos de Tres Mundos, Los Angeles City College, Los Angeles, CA.

1979

Gronk/Patssi, West Colorado Gallery, Pasadena, CA.

1978

Faces of Christ, Malone Art Gallery, Loyola Marymount University, Los Angeles, CA.

Hollywood, Hollywood, Cedars-Sinai Hospital Gallery, Los Angeles, CA.

T-Art, West Colorado Gallery, Pasadena, CA.

No Movie, Los Angeles Contemporary Exhibitions, Los Angeles, CA.

Dreva/Gronk 1968–78: Ten Years of Art/Life, Los Angeles Contemporary Exhibitions, Los Angeles, CA.

Valentines, Lyndon House Galleries, Athens, GA.

Hecho en Latinoamérica, Museo de Arte Moderno, Mexico City, Mexico.

1977

No Movie, University of California, Santa Barbara.

Public Works, Exploratorium Gallery, California State University, Los Angeles.

Schizophrenibeneficial, Mechicano Gallery, Los Angeles, CA.

1976

New Works, Galería de Artes Nuevos, Buenos Aires, Argentina.

Artists Have No Rules, Manawatu Art Gallery, Manawatu, New Zealand.

Ancient Roots/New Visions, Raices Antiguas/Visiones Nuevas, Los Angeles Municipal Art Gallery, Los Angeles, CA.

1975

Chicanismo en El Arte, Los Angeles County Museum of Art, Los Angeles, CA.

Chicano Art, Office of Governor Edmund G. Brown Jr., Sacramento, CA.

Ascozilla, Fine Arts Gallery, California State University, Los Angeles.

Asco/Los Four, The Point Gallery, Santa Monica, CA.

The Four in Longo, Long Beach Museum of Art, Long Beach, CA.

SELECTED PERFORMANCES

1999

Y2 Gronk. Museum of Contemporary Art, Los Angeles, CA.

1997

Tormenta Cantata, composed by Joseph Julián González for string quartet, soprano, and amplified paintbrush. Performed by Gronk, the Kronos Quartet, and Yvonne Regalado at the University of Wisconsin, Madison; Villa Montalvo, Saratoga, CA; University of California, Los Angeles; Theater Artaud, San Francisco, CA. Performed by Gronk, members of the New Mexico Symphony Orchestra, and Rebecca Geneva Biorn at the National Hispanic Cultural Center, Albuquerque, NM (2000).

1987

Ismania by Harry Gamboa Jr. Los Angeles Contemporary Exhibitions, Los Angeles, CA.

1985

Morning Becomes Electricity by Gronk and James Bucalo. Museum of Contemporary Art, Los Angeles, CA.

Jetter's Jinx by Harry Gamboa Jr., directed by Gronk. Los Angeles Theatre Center, Los Angeles, CA. Performed in 1986 at the University of California, Irvine and the Saxon-Lee Gallery, Los Angeles, CA.

Striptease by Gronk and Adam Leventhal. Los Angeles Contemporary Exhibitions, Los Angeles, CA.

1984

Asco '84 by Asco. Armory for the Arts, Santa Fe, NM. Performed in 1985 at Los Angeles Contemporary Exhibitions, Los Angeles, CA.

Orphans of Modernism, radio play by Harry Gamboa Jr. Broadcast in two parts on KPFK-FM, Los Angeles, CA.

1983

Asco '83. MARS (Movimiento Artístico del Río Salado) Gallery, Phoenix, AZ; Sesnon Art Gallery, University of California, Santa Cruz.

1982

Asco '82. Galería de la Raza, San Francisco, CA.

1980

Gronk/Herrón: Illegal Landscape by Gronk and Willie Herrón III. Exploratorium Gallery, California State University, Los Angeles.

Pinguino by Harry Gamboa Jr., in collaboration with Gronk and Willie Herrón III, performed by Gronk and Herrón. Videotaped on 3/4-inch color videocassette before Agnès Varda.

1978

No Movie by Asco. Los Angeles Contemporary Exhibitions, Los Angeles, CA.

Pseudoturquoisers, written and directed by Harry Gamboa Jr., performed by Gronk. Exploratorium Gallery, California State University, Los Angeles.

SET DESIGN

2005

Ainadamar (The Fountain of Tears), music by Osvaldo Golijov, libretto by David Henry Hwang, directed by Peter Sellars. Santa Fe Opera, Santa Fe, NM; traveled to the Lincoln Center, New York, NY (2006).

1998

L'Histoire du soldat (Story of a Soldier) by Igor Stravinsky, directed by Peter Sellars. Los Angeles Philharmonic, Music Center, Performing Arts Center of Los Angeles County, CA. Traveled to Palmero, Italy; Paris, France; Madrid, Spain; Vienna, Austria (1998–2000).

Los Biombos/The Screens by Gloria Alvarez, directed by Peter Sellars. Cornerstone Theatre Company, Los Angeles, CA.

1997

Mexican Medea by Cherríe Moraga, music by John Santos. York Theatre, San Francisco, CA.

1995

Welcome to the Moon by John Patrick Shanley, directed by Kathy Scambiatterra. McCadden Theater, Los Angeles, CA.

Journey to Córdoba, music by Lee Holdridge, libretto by Richard Sparks, directed by José Luis Valenzuela. Los Angeles Opera, Music Center, Performing Arts Center of Los Angeles County, CA.

1993

Carpa Clash by Culture Clash, directed by José Luis Valenzuela. Mark Taper Forum, Los Angeles, CA.

1991

Bowl of Beings by Culture Clash, directed by José Luis Valenzuela. Los Angeles Theatre Center, Los Angeles, CA; broadcast on PBS in the Guest Performances series.

Canton Jazz Club, music by Nathan Wang and Joel Iwataki, directed by Tim Dang, book by Dom Magwili. East West Players, Los Angeles, CA.

Hedda Gabler by Henrik Ibsen. East West Players, Los Angeles, CA.

1990

Come Back Little Sheba by William Inge, directed by Tom Atha. East West Players, Los Angeles, CA.

The Chairman's Wife by Wakako Yamauchi, directed by Nobu McCarthy. East West Players, Los Angeles, CA.

The Mission by Culture Clash, directed by José Luis Valenzuela. Los Angeles Theatre Center, Los Angeles, CA.

August 29 by Violeta Calles (pseudonym for the Latino Theatre Lab, whose participants created the play collectively), directed by José Luis Valenzuela. Los Angeles Theatre Center, Los Angeles, CA.

1989

Paris Jazz Festival, Paris, France.

Stone Wedding by Milcha Sanchez-Scott, directed by José Luis Valenzuela. Los Angeles Theatre Center, Los Angeles, CA.

1981

The Ugly Sung Opera: A Homily on the Banality of Spiritual Transcendence, directed by Michael Intriere, music by Nervous Gender. Traction Gallery, Los Angeles, CA.

Gronk, *Lunar Grapefruit*, 2005. Paint and pencil on canvas, 78 x 120 inches.

Reproduced by permission of the artist.

BIBLIOGRAPHY

ARTICLES, CHAPTERS, AND BOOKS

"VII Glugio Gronk Nicandro." *Journal: A Contemporary Art Magazine*, Winter 1987, 27.

Aehl, John. "A Stroke of Genius: Artist Gronk, Kronos Paint a Piece of Music." Review of multimedia concert performance of *La Tormenta Cantata*, composed by Joseph Julián González, painted by Gronk, Wisconsin Union Theater, Madison. *Wisconsin State Journal*, February 22, 1998, 1F.

Agajanian Quinn, Joan. "Snapshots." Review of opening of *17 Artistas Mexicanas Contemporaneas*, Fisher Gallery, University of Southern California, Los Angeles, and review of opening of *Hispanic Art in the United States*, Los Angeles County Museum of Art. *Los Angeles Herald Examiner*, February 5, 1989, E3.

Allen, Steven Robert. "Gronk! Gronk!" Review of *Albuquerque Contemporary 2004: 15th Annual Regional Juried Exhibition*, curated by Gronk, Albuquerque Museum. *Weekly Alibi* 13, no. 32 (August 5–11, 2004).

"Almost Live Art." Review of *Morning Becomes Electricity*, Museum of Contemporary Art, Los Angeles. *High Performance* 8, no. 2 (issue 30, 1985): 18–19.

"Artists' Works Compensate UCLA." *San Jose Mercury News*, May 5, 1994, 3B, morning final edition.

Ayers, Robert. "Artists Take Center Stage at the Opera with Innovative Set and Costume Design." *ARTNews*, Summer 2005.

Baker, Kenneth. "Gronk's at His Best in Miniature Doodles." Review of *Gronk: Paintings*, Iannetti-Lanzone Gallery, San Francisco. *San Francisco Chronicle*, June 21, 1989, E3.

———. "Harlequin Fantasies and a Visionary Chicano Art Show." Review of *The Fifth Element: Recent Acquisitions of Contemporary Chicano Art*, The Mexican Museum, San Francisco. *San Francisco Chronicle*, January 2, 1993, C3, final edition.

———. "New Perspective on Chicano Artist." Review of *¡Gronk! A Living Survey, 1973–1993*, The Mexican Museum, San Francisco. *San Francisco Chronicle*, August 21, 1993.

———. "Nine Artists on the Loose in Los Angeles." Review of *Summer 1985: Nine Artists*, Museum of Contemporary Art, Los Angeles. *San Francisco Chronicle*, July 18, 1985, 64.

Beck, David L. "Art for Eyes and Ears from Gronk." Preview of *La Tormenta Cantata*, composed by Joseph Julián González, painted by Gronk. *San Jose Mercury News*, September 18, 1996, 3E, morning final edition.

Benavidez, Max. "How Do *You* Spell Gronk?" *Los Angeles Times*, June 21, 1992, C4.

———. "Latino Dada: Savage Satire from Harry Gamboa, Jr." *L.A. Weekly*, May 16–22, 1986, 43.

———. "The World According to Gronk." *L.A. Weekly*, August 13–19, 1982, 30.

Benavidez, Max, and Kate Vozoff. "The Wall: Image and Boundary, Chicano Art in the 1970s." In *Mexican Art of the 1970s: Images of Displacement*, edited by Leonard Folgarait, 45–54. Nashville, TN: Vanderbilt University, 1984.

Blanco, Gil. "Art on the Walls: A Vehicle for Positive Change." *Latin Quarter* 1, no. 2 (October 1974): 26–30.

Bonsey, Catherine. "Gronkus Maximus." Review of *She's Back*, Saxon-Lee Gallery, Los Angeles. *Diana Zlotnick's Newsletter on the Arts* (Los Angeles) 13, no. 3 (1988).

Burkhart, Dorothy. "The Political and the Personal Meet in Latino Art." Reviews of *Reserved for Export: Ten Contemporary Mexican Photographers* and *Crossing Borders/Chicano Artists*, San Jose Museum of Art. *San Jose Mercury News*, August 1, 1986, 1D.

Burnham, Linda Frye. "Asco, Camus, Daffy Duck and Devil Girls from East L.A." *L.A. Style*, February 1987, 56–58.

———. "Gronk and James Bucalo, *Morning Becomes Electricity*." Review of *Morning Becomes Electricity*, Museum of Contemporary Art, Los Angeles. *Artforum* 24 (February 1986): 110–11.

———. "Life: The Asco Version." Review of *Asco* and *Striptease*, performance by Gronk and Adam Leventhal, Los Angeles Contemporary Exhibitions, Los Angeles. *High Performance* 8, no. 2 (issue 30, 1985): 66–67.

Buuck, David. "Harry Gamboa and the Contemporary Avant-Garde." *Jouvert* (North Carolina State University) 6, no. 3 (Spring 2002). http://social.chass.ncsu.edu/Jouvert/v613/gamboa.htm.

Caballero, Raúl. "Asco, Original Grupo de Artistas del Este de Los Angeles, California." *El Occidental* (Guadalajara, Mexico), March 15, 1985, 1–2.

Cadava, Geraldo. "Asco = Nausea: Chicano Art as Chicano Politics." Senior honors thesis, Dartmouth College, 2000.

Carr, Elston. "Just Another Painter from East L.A." Preview of ¡Gronk! A Living Survey, 1973–1993, Los Angeles County Museum of Art. L.A. Weekly, March 18–24, 1994, 16.

Castro, Tony. "'Oppression in L.A.': Art Without Borders." Los Angeles Contemporary Exhibitions, Los Angeles. Los Angeles Herald Examiner, May 4, 1978, A3.

Chavoya, C. Ondine. "Internal Exiles: The Interventionist Public and Performance Art of Asco." In Space, Site, Intervention: Situating Installation Art, edited by Erika Suderburg, 189–208. Minneapolis: University of Minnesota Press, 2000. Portions of this essay appear in C. Ondine Chavoya, "Orphans of Modernism: The Performance Art of Asco," in Corpus Delecti: Performance Art of the Americas, edited by Coco Fusco. London: Routledge, 2000.

———. "Orphans of Modernism: Chicano Art, Public Representation, and Spatial Practice in Southern California." PhD diss., University of Rochester, 2002.

———. "Pseudographic Cinema: Asco's No-Movies." Performance Research 3, no. 1 (1998): 1–14.

Cheseborough, Steve. "'Disgust': Chicano Artists Find Bizarre Ways to Protest." Review of performance by Gronk and Harry Gamboa Jr., Patriots Square, Phoenix, Arizona. Phoenix Gazette, November 16, 1983.

Christensen, Judith. "Disparate Influences, Shared Attitudes." Review of Cultural Currents, San Diego Museum of Art. Artweek 19, no. 27 (August 6, 1988): 8.

Clifton, Leigh Ann. "Gronk at SJMA." Review of Fascinating Slippers/Pantunflas Fascinantes, San Jose Museum of Art. Artweek 23, no. 13 (April 9, 1992): 21.

Cockcroft, Eva Sperling. "Chicano Identities." Review of Chicano Art: Resistance and Affirmation, 1965–1985 (traveling exhibition). Art in America, June 1992, 84–91.

Conal, Robbie. Review of Gronk, Saxon-Lee Gallery, Los Angeles. L.A. Weekly, May 30–June 5, 1986, 39.

Cruz, Adam. "Latin Lookers." Elle, August 1988, 34–38.

Curtis, Cathy. "The Galleries." Review of She's Back, Saxon-Lee Gallery, Los Angeles. Los Angeles Times, May 27, 1988, 6.

———. "'Hotel Zombie': Walls Offer Guessing Game." Review of Hotel Zombie, Laguna Art Museum Satellite, Costa Mesa, CA. Los Angeles Times, September 25, 1990, F2, Orange County edition.

Dabovich, Melanie. "Art Exhibit Introduces Chicano Life and Culture to Mainstream America." Review of Chicano Visions (traveling exhibition). Associated Press (state and regional), January 31, 2003.

Davalos, Karen Mary. Exhibiting Mestizaje: Mexican (American) Museums in the Diaspora. Albuquerque: University of New Mexico Press, 2001.

de la Cruz, Elena. "Como matar dos pajaros de un solo tiro: La Opera de L.A. encontró una obra a la altura de su diva Suzanna Guzman." Review of Journey to Córdoba, composed by Lee Holdridge, set design by Gronk, Music Center, Performing Arts Center of Los Angeles County. La Opinión (Los Angeles), February 6, 1995, 1D.

de la Pena, Abelardo. "Hispanic Art: From the Heart." Santa Monica News, February 3–16, 1989, 1.

de la Torre, Einar, and Jamex de la Torre. "Grotesque Super Beauty: An Interview with the Artists." Interview by Gronk. In Einar and Jamex de la Torre: Intersecting Time and Place, edited by Mary Ribesky, 1–7. Tacoma, WA: Museum of Glass: International Center for Contemporary Art, 2005.

Diggs, Agnes. "Skirball Center Symposium Features Mural Artists." Announcement for Modern Art: Murals as History symposium. Skirball Center, Los Angeles. Los Angeles Times, March 24, 1999, B3.

Donnelly, Kathleen. "Mural of the Moment." Preview of Fascinating Slippers/Pantunflas Fascinantes, San Jose Museum of Art. San Jose Mercury News, March 22, 1992, Arts & Books, 3.

Drew, Nancy. "L.A.'s Space Age." In LACE: 10 yrs. Documented, edited by Karen Moss. Los Angeles: Los Angeles Contemporary Exhibitions, 1988.

Dubin, Zan. "Artist Won't Be Confined to Gallery." Preview of Jetter's Jinx by Harry Gamboa Jr., directed by Gronk, Saxon-Lee Gallery, Los Angeles. Los Angeles Times, June 6, 1986, 6:2.

"East L.A.'s ASCO." Belvedere Citizen (Los Angeles), August 1, 1984.

El Playano (literary journal of Loyola Marymount University, Los Angeles), Spring 1972 and Spring 1973 (illustrations by Gronk).

Flaco, Eduardo. "Chicanismo en El Arte." Review of Chicanismo en el Arte, Los Angeles County Museum of Art. Artweek 6, no. 20 (May 17, 1975): 3.

Fox, Howard N. "Tremors in Paradise, 1960–1980." In Made in California: Art, Image, and Identity, 1900–2000, edited by Stephanie Barron, Sheri Bernstein, and Ilene Susan Fort, 193–234. Berkeley: University of California Press, 2000.

Fox, Larry. "Weekend's Best." Washington Post, October 4, 1996, N3.

Fox, Maryl Jo. "Stone Wedding." Review of *Stone Wedding* by Milcha Sanchez-Scott, sets by Gronk, Los Angeles Theatre Center. *L.A. Weekly*, December 30–January 5, 1989, 89.

Gamboa, Harry, Jr. "ASCO 83." *Caminos* (San Bernardino, CA) 3, no. 9 (October 1983): 36. Reprinted as "ASCO," *Imagine* (Boston) 3, nos. 1–2 (Summer–Winter 1986): 64–66.

———. "Asco, No Phantoms." *High Performance* 4, no. 2 (Summer 1981): 15.

———. "ASCO's Performance of *Jetter's Jinx*." In program brochure for *Jetter's Jinx* by Harry Gamboa Jr., directed by Gronk, Los Angeles Theatre Center, 1985.

———. "Café en Blanco y Negro." *La Comunidad* (Sunday supplement of *La Opinión*, Los Angeles), April 26, 1981, 3.

———. "Curtains in Three Acts." In *Gronk x 3*. Exhibition catalogue. San Jose, CA: San Jose Museum of Art, 1999.

———. "Fantasias Moviles." *La Comunidad* (Sunday supplement of *La Opinión*, Los Angeles), August 30, 1981, 8.

———. "Gronk and Herron, Muralists." *Neworld* 2, no. 3 (Spring 1976): 28–30.

———. "Harry Gamboa Jr. and Asco." Interview by Steven Durland and Linda Burnham. *High Performance* 9, no. 3 (issue 35, 1986): 51–53.

———. "Interview with Harry Gamboa." By Jeffrey Rangel, Los Angeles, April 1 and 16, 1999. Archives of American Art, Smithsonian Institution, Washington, DC. http://www.aaa.si.edu/collections/oralhistories/transcripts/gamboa99.htm.

———. "Serpents in the City of Angels." *Artweek* 20, no. 37 (November 9, 1989): 24.

———. "Taking People to the Wall in Mesa." *Phoenix Exposure*, January 1984, 8.

———. "Those Were the Days (of the Dead)." In *Chicanos en Mictlán*, edited by Tere Romo, 56–62. San Francisco: The Mexican Museum, 2000.

———. *Urban Exile: The Collected Writings of Harry Gamboa Jr.* Edited by Chon A. Noriega. Minneapolis: University of Minnesota Press, 1998.

Gamboa, Harry, Jr., and Gronk. "Do Art and Politics Mix? Not in Mesa." Interview. *Ariztlan Arts* (Phoenix, AZ) 2, no. 1 (1984): 4.

Gamboa, Harry, Jr., Gronk, Willie Herrón III, and Patssi Valdez. "A True Barrio Art." Interview by Edy. *El Chicano* (Los Angeles), December 7, 1972, 9.

García, Ramón. "Encyclopedia Tormenta." Paper presented at the Carnegie Art Museum, Oxnard, CA, April 3, 2003.

Garza, Oscar. "L.A., S.A. Artists Use Different Strokes." Review of *Hispanic Art in the United States: Thirty Contemporary Painters and Sculptors*, Los Angeles County Museum of Art. *San Antonio Light*, February 12, 1989, K1.

Gaspar de Alba, Alicia. *Chicano Art: Inside/Outside the Master's House.* Austin: University of Texas Press, 1998.

Geer, Suvan. "Ron Rick's Painterly Deceptions." Review of *50 Drawings*, Daniel Saxon Gallery, Los Angeles. *Los Angeles Times*, March 20, 1991, F7.

———. "The Galleries: Wilshire Center." Review of *Grand Hotel*, Saxon-Lee Gallery, Los Angeles. *Los Angeles Times*, February 10, 1989, section IV, 13.

Gelfand, Janelle. "Cincinnati Opera Could Learn from Successful Risk Takers." *Cincinnati Enquirer*, August 7, 2005, 8D.

Goldman, Shifra. "Chicano Art of the Southwest in the Eighties." In *Made in Aztlán*, edited by Phillip Brookman and Guillermo Gómez-Peña, 76–83. San Diego: Centro Cultural de la Raza, 1986. Originally published in Spanish as "Arte Chicano del Suroeste en los Años Ochenta," in *A Través de la Frontera*, edited by Icla Rodriguez and Salvador Leal, 137–49. Mexico City: Centro de Estudios Económicos y Sociales del Tercer Mundo, 1983.

Gómez-Peña, Guillermo. "A New Artistic Continent." In *Made in Aztlán*, edited by Phillip Brookman and Guillermo Gómez-Peña, 86–97. San Diego: Centro Cultural de la Raza, 1986.

González, Luis. "'Luchador Chicano': Conquista de Nuevo." Review of *El Luchador Chicano*, film by Gronk, Juan Garza, and Lalo López. *La Opinión* (Los Angeles), September 15, 1994, 1D.

Gottlieb, Shirle. "Gronk." Review of *Hotel Zombie*, Laguna Art Museum Satellite, Costa Mesa, CA. *Artweek* 22, no. 1 (January 19, 1991): 19.

Greene, I. "Asco." *Radio and Television News,* no. 49 (May 1983): 58–59.

"Gronk: Fascinating Slippers/Pantunflas." Preview of *Fascinating Slippers/Pantunflas Fascinantes*, San Jose Museum of Art. *La Oferta Review* (San Jose, CA), March 14, 1992.

"Gronk Moves in 'Four Directions.'" *Wisconsin State Journal*, December 14, 1997, 6F.

"Gronk Paints 'Fascinating Slippers/Pantunflas.'" Preview of *Fascinating Slippers/Pantunflas Fascinantes*, San Jose Museum of Art. *Alianza News* (San Jose, CA), March 11, 1992, 6.

Gronk. "Gronk." Interview in "Artweek Focus: 17 Painters Speak about Painting." *Artweek* 22, no. 32 (October 3, 1991): 11–15.

———. "Gronk." Interview by Julia Brown and Jacqueline Crist. In *Summer 1985: Nine Artists.* Exhibition catalogue. Los Angeles: Museum of Contemporary Art, 1985.

———. "Gronk." Interview by Steven Durland and Linda Burnham. *High Performance* 9, no. 3 (issue 35, 1986): 57.

———. "Gronk." Interview by Rita González and Jennifer Flores Sternad. Los Angeles, August 31, 2004. UCLA Chicano Studies Research Center Library and Archive, Los Angeles, CA.

———. "Gronk." Interview by Marva Marrow. In *Inside the L.A. Artist,* edited by Marva Marrow, 46. Salt Lake City, UT: Peregrine Smith, 1988.

———. "Gronk: Off-the-Wall Artist." Interview by Harry Gamboa Jr. *Neworld* 6, no. 4 (July/August 1980): 32–45, 42–43.

———. "Gronk y la política del arte." Interview by Edward Goldman. *La Opinión* (Los Angeles), September 22, 1991, E.

———. "Oral History Interview with Gronk." Interview by Jeffrey Rangel, Los Angeles, January 20 and 23, 1997. Archives of American Art, Smithsonian Institution, Washington, DC. http://www.aaa.si.edu/collections/oralhistories/transcripts/gronk97.htm.

———. Letter to the editor. *Los Angeles Times,* July 1, 2001, M2.

———. "Notes from a Gronk Interview in Los Angeles." Interview by Andrew Connors. In *Albuquerque Contemporary 2004: 15th Annual Regional Juried Exhibition.* Exhibition catalogue. Albuquerque, NM: Magnífico Arts, 2004.

———. "Painting Stages/Performing Life: Gronk." Interview by Jennifer Flores Sternad. *Contemporary Theatre Review* 15, no. 3 (2005): 338–47.

———. "Taking Flight." Interview by Matthew Miles Grayson, photography by Wayne Shimabukuro. *Detour,* June 1992, 60–63.

Gronk, and Harry Gamboa Jr. "Interview: Gronk and Gamboa." *Chismearte,* no. 1 (Fall 1976): 30–33. Reprinted as "The No-Movie Interview: Chicano Art Collective, Asco (1972–87)," *Jump Cut,* no. 39 (1994): 91–92. Also reprinted in Gamboa, *Urban Exile,* 27–31.

Gronk, and Willie Herrón. "Gronk and Herron Muralists." Interview by Harry Gamboa Jr. *Neworld* 2, no. 3 (Spring 1976): 28–30. Reprinted in Gamboa, *Urban Exile,* 32–43.

Guzman, Kristen. *Self Help Graphics and Art: Art in the Heart of East Los Angeles.* Edited by Colin Gunckel. Los Angeles: UCLA Chicano Studies Research Center Press, 2005.

Haley, Lindsey. "Gronk y su Inquietante Concepto del Arte." *La Comunidad* (Sunday supplement of *La Opinión,* Los Angeles), May 19, 1985, 2.

———. "'Jetter's Jinx' a Success." Review of *Jetter's Jinx* by Harry Gamboa Jr., directed by Gronk, Los Angeles Theatre Center. *Belvedere Citizen* (Los Angeles), October 16, 1985, 3C.

Hamlin, Jesse. "Gronk If You're Creative." *San Francisco Chronicle,* November 8, 1998, PK15.

Hansen, Al. "One Hand Clapping." *LAICA Journal* (Los Angeles Institute of Contemporary Art), February 1979.

Harbrecht, Gene. "Critic's Choice: Visual Arts." *Orange County Register* (Santa Ana, CA), September 28, 1990, P26.

———. "Gronk's 'Hotel Zombie' Presents a Rabbit Warren of Images." Review of *Hotel Zombie,* Laguna Art Museum Satellite, Costa Mesa, CA. *Orange County Register* (Santa Ana, CA), September 19, 1990, 106.

Herrón, Willie III. "Interview with Willie Herron." By Jeffrey Rangel, Los Angeles, February 5, 2000. Archives of American Art, Smithsonian Institution, Washington, DC. http://www.aaa.si.edu/collections/oralhistories/transcripts/herron00.htm.

Higgins, Bill. "Coming Attractions with Gronk and Friends." Review of reception for *Fascinating Slippers/Pantunflas Fascinantes,* Daniel Saxon Gallery, Los Angeles. *Los Angeles Times,* May 25, 1992, E6.

———. "The Goods: Cheap—Not Cheesy." *Los Angeles Times,* November 25, 1994, E3.

———. "The Gronkster Finally Gets Inside." Review of opening reception for *¡Gronk! A Living Survey, 1973–1993,* Los Angeles County Museum of Art. *Los Angeles Times,* March 18, 1994, E10.

Holland, Bernard. "Haunted by the Deaths of Martyrs, a Century Apart." Review of performance of *Ainadamar* by Osvaldo Golijov, sets by Gronk, Santa Fe Opera, Santa Fe, NM. *New York Times,* August 1, 2005, E5.

Hugo, Joan. "Communication Alternatives," *Artweek* 10, no. 31 (September 29, 1979): 5.

Isé, Claudine. "Considering the Art World Alternatives: LACE and Community Formation in Los Angeles." In *The Sons and Daughters of Los: Culture and Community in L.A.,* edited by David E. James, 85–107. Philadelphia: Temple University Press, 2003.

James, David E. "Hollywood Extras: One Tradition of 'Avant-Garde' Film in Los Angeles." *October* 90 (Fall 1999): 3–24.

Johnson, Reed. "Soul Searching on Spring Street." *Los Angeles Times*, April 19, 2001, E1.

———. "They Were Here First." *Los Angeles Times*, October 16, 2003, F7.

Jones, Amelia. Review of *She's Back*, Saxon-Lee Gallery, Los Angeles. *L.A. Weekly*, June 3–9, 1988, 45.

Kandel, Susan. "L.A. in Review." Review of *Parallels and Divergences/One Heritage, Two Paths*, Daniel Saxon Gallery, Los Angeles. *Arts Magazine*, December 1991, 89–91.

Kennicott, Philip. "'Ainadamar': Agony and Ecstasy in Santa Fe." *Washington Post*, August 15, 2005, C1.

Kim, Howard. "Chicano Art: Is It an Art Form? Or Simply Art by Chicanos?" *Neworld* 6, no. 4 (July 1980): 26–30.

Knaff, Devorah. "Memories Are Made of This." Review of *Journey/Journals* by Elsa Flores and Gronk, The New Gallery, Santa Monica, CA. *Artweek* 25, no. 15 (August 4, 1994): 25.

Knight, Christopher. "The Two Lives of Gronk." Review of *¡Gronk! A Living Survey, 1973–1993*, Los Angeles County Museum of Art. *Los Angeles Times*, March 19, 1994, F1.

Kosiba-Vargas, S. Zaneta. "Harry Gamboa and ASCO: The Emergence and Development of a Chicano Art Group, 1971–1987." PhD diss., University of Michigan, Ann Arbor, 1988.

Kun, Josh. "The New Chicano Movement." *Los Angeles Times Magazine*, January 9, 2005, 1.

Lacayo, Richard. "A Surging New Spirit." *Time*, July 11, 1988, 46–49.

Lambeart, Bob. "Gronk." *Egozine* 3 (January 1980).

Lerner, Jesse. "Urban Exile." Review of Gamboa, *Urban Exile*. *Afterimage* 27, no. 5 (March/April 2000): 14.

Lippard, Lucy R. *Mixed Blessings: New Art in a Multicultural America.* New York: Pantheon Books, 1990.

"Literally Live Movie at 'No Movie' Exhibit." *Civic Center News* (Los Angeles) 7, no. 17 (April 25, 1978).

Littlefield, Kinney. "Power of Urban Healing Seen in Paintings Exhibit, East L.A. Works Present Raw Emotions." Review of *Chicano/Chicana: Visceral Images*, The Works Gallery South, Costa Mesa, CA. *Orange County Register* (Santa Ana, CA), February 12, 1993, 29.

Lovell, Glenn. "What's It All About, Gronk? Artist Hopes You'll Decode His S. J. Museum of Art Mural for Yourself." Review of *Gronk x 3: Murals, Prints, Projects*, San Jose Museum of Art. *San Jose Mercury News*, November 14, 1998, 1E.

Madrid, Joe. "'August 29': Una forma especial de recorder la Moratoria Chicana." Review of *August 29* by Evelina Fernández and Enrique Castillo, performed by the Latino Theater Company, Plaza de la Raza, Los Angeles. *La Opinión* (Los Angeles), September 13, 1995, 3D.

Mangan, Timothy. "Barrio Boys, Booming Skins and Bare Feet: Yes, L.A. Phil." Review of *Story of a Soldier* by Igor Stravinsky, directed by Peter Sellars, sets by Gronk, Dorothy Chandler Pavilion, Los Angeles Philharmonic, Music Center, Performing Arts Center of Los Angeles County. *Orange County Register* (Santa Ana, CA), June 24, 1999, F25.

Margolis, Judith. "Down to the Bone." Review of *Bone of Contention* by Gronk, Saxon-Lee Gallery, Los Angeles. *Artweek* 18, no. 26 (July 25, 1987): 7.

Marks, Ben. "Nightmares of Self-Indulgence." Review of *Grand Hotel* by Gronk, Saxon-Lee Gallery, Los Angeles. *Artweek* 20, no. 8 (February 25, 1989): 4.

Martinez, Ruben. "Gronk If You Like Art." *L.A. Style*, February 1989, 28–29.

McGrew, Gustavo. "Xicanindio Celebrates Eighth Annual Festival." Review of Xicanindio's Dia de los Muertos Festival, Pioneer Park, Mesa, AZ. *Ariztlan* (Phoenix, AZ) 2, no. 1 (1984).

McKenna, Kristine. "Wilshire Center." Review of *Bone of Contention*, Saxon-Lee Gallery, Los Angeles. *Los Angeles Times*, July 10, 1987, 17.

Montano, Nancy Army. "El Arte." *New Mexico*, July 1988, 36–41.

Montini, E. J. "Avant Garde Troupe Performs Bizarre Show for Unwitting Crowd." *Arizona Republic*, no. 9 (November 1984).

Moss, Karen, ed. *LACE: 10 yrs. Documented.* Los Angeles: Los Angeles Contemporary Exhibitions, 1988.

Moure, Nancy Dustin Wall. *California Art: 450 Years of Painting & Other Media.* Los Angeles: Dustin Publications, 1998.

Muchnic, Suzanne. "The Art Galleries: La Cienega Area." Review of *The Rescue Party*, Saxon-Lee Gallery, Los Angeles. *Los Angeles Times*, May 23, 1986, 6.

———. "Outside-In Tour of L.A. in 'Summer '85: 9 Artists.'" Review of *Summer 1985: Nine Artists*, Museum of Contemporary Art, Los Angeles. *Los Angeles Times*, June 22, 1985, 5:1.

Muñoz, Sergio, ed. "Cultura Chicana: Los Angeles." *La Comunidad* (Sunday supplement of *La Opinión*, Los Angeles), January 13, 1980, 1.

Nagel, Juan Carlos. "Humor no muy en serio: La Pelicula 'El Luchador Chicano' es una propuesta filmica

interesante, aunque no necesariamente original." Review of *El Luchador Chicano*, film by Gronk, Juan Garza, and Lalo López, Los Angeles Film Festival. *La Opinión* (Los Angeles), September 14, 1993, 1B.

Noriega, Chon A. "No Introduction." In Harry Gamboa Jr., *Urban Exile*, edited by Chon A. Noriega, 1–22. Minneapolis: University of Minnesota Press, 1998.

———. "Talking Heads, Body Politic: The Plural Self of Chicano Experimental Video." In *Resolutions: Contemporary Video Practices*, edited by Michael Renov and Erika Suderburg, 207–28. Minneapolis: University of Minnesota Press, 1996.

Norklun, Kathi. "Gronk at Galería Ocaso." Review of *The Titanic and Other Tragedies at Sea*. *L.A. Weekly*, April 19–25, 1985, 49.

Ollman, Leah. "Art Review; A Multi-Sided Look at 'Lone Woman.'" Review of *Substantial: New Work by Gronk*, sponsored by the Daniel Saxon Gallery, Feldman Gallery Building, Pacific Design Center, Los Angeles. *Los Angeles Times*, October 2, 1998, F29.

———. "Centro Cultural's 'On the Spot' Applies to Both Viewers, Artists." Review of *On the Spot* by Felipe Ehrenberg, Gronk, Yolanda López, and Esther Parada, Centro Cultural de la Raza, San Diego. *Los Angeles Times*, April 8, 1988, 25B, San Diego County edition.

"The Opera Gets Gronked." *Santa Fe Opera Crescendo* (Santa Fe, NM), Spring 2005, 2.

Orth, Maureen. "The Soaring Spirit of Chicano Art." *New West*, September 11, 1978.

Otto, Susan. "The Short List: *Urban Exile*." Review of Gamboa, *Urban Exile*. *L.A. Weekly*, December 18–24, 1998, 67.

Perez, Mary Anne. "Taking Score of the Voices on the Street." *Los Angeles Times*, February 5, 1995, City Times, 3.

———. "UCLA Accepts Art to Pay for Vandalism." *Los Angeles Times*, May 8, 1994, 10.

Plagens, Peter. Letter to the editor. *Neworld*, no. 5 (1980).

———. "MOCA Mix, The Good, the Bad and the Unplugged." Review of *Summer 1985: Nine Artists*, Museum of Contemporary Art, Los Angeles. *L.A. Weekly*, August 9–15, 1985, 65.

Richard, Paul. "The Brilliant Assault at the Corcoran, the Stunning Colors of Hispanic Art." Review of *Hispanic Art in the United States: Thirty Contemporary Painters and Sculptors*, Corcoran Gallery of Art, Washington, DC. *Washington Post*, October 10, 1987, B1.

Rodriguez, Richard T. "Urban Exile." Review of Gamboa, *Urban Exile*. *Theatre Journal* 52, no. 1 (March 2000): 140–41.

Romero, Raúl V. "Chicanarte: A Major Exposition of California Arts." *Neworld* 2, no. 1 (Fall 1975): 21–24.

Romo, Tere. "Points of Convergence: The Iconography of the Chicano Poster." In *Just Another Poster? Chicano Graphic Arts in California/¿Solo un Cartel Mas? Artes Graficas Chicanas en California*, edited by Chon A. Noriega, 91–115. Santa Barbara: University of California, University Art Museum, 2001.

Rubin, Jane. "Gronk." Review of *Grand Hotel*, Saxon-Lee Gallery, Los Angeles. *Artcoast* 1, no. 2 (May/June 1989): 81–82.

Rubio, Jeff. "'Stone Wedding' a Marriage of Extremes." Review of *Stone Wedding* by Milcha Sanchez-Scott, sets by Gronk, Los Angeles Theatre Center. *Orange County Register* (Santa Ana, CA), December 16, 1988, 25, evening edition.

Saldivar, Reina Alejandra Prado. "Más Production of Art for the Masses: Serigraphs of Self-Help Graphic Arts, Inc." In *Latinos in Museums: A Heritage Reclaimed*, edited by Antonio Ríos-Bustamante and Christine Marin, 119–30. Malabar, FL: Krieger, 1998.

Salzman, Linda Sher. "Sanity Saved, Humanity Lost." Review of *Hotel Senator*, Daniel Saxon Gallery, Los Angeles. *Artweek* 21, no. 31 (September 27, 1990): 16.

Saville, Jonathan. "Original Thirteen." *San Diego Reader* 17, no. 31 (August 11, 1988).

Saxon, Daniel. *The Daniel Saxon Art Report* (Los Angeles) 2, no. 2 (November 1990).

Selz, Peter. *The Art of Engagement: Visual Politics in California and Beyond*. Berkeley: University of California Press and San Jose: San Jose Museum of Art, 2006.

Serwer, Jacquelyn Days. "Gronk." In *American Kaleidoscope: Themes and Perspectives in Recent Art*, edited by Janet Wilson and Lee Fleming, 28–35, 150–51. Washington, DC: Smithsonian Institution, National Museum of American Art, 1996.

Snow, Shauna. "An Irrepressible Sense of Improvisation Keeps Gronk Grinning." *Los Angeles Times*, April 1, 1990, 103.

Sullivan, Meg. "No Reservations at Gronk Hotels." Review of *Hotel Senator*, Daniel Saxon Gallery, Los Angeles. Review of *Hotel Zombie*, Laguna Art Museum Satellite, Costa Mesa, CA. *L.A. Life*, September 14, 1990, 50.

Sussmann, M. Hal. "Hispanic Art." Preview of *Hispanic Art in the United States: Thirty Contemporary Painters and Sculptors*, Museum of Fine Arts, Houston. *Southwest Art* 16, no. 12 (May 1987): 83–86.

Takahama, Valerie. "Gronk's Palette Holds Whimsy, Humor—and a Tone of Rebellion." Review of *Hotel Zombie*, Laguna Art Museum Satellite, Costa Mesa, CA.

Orange County Register (Santa Ana, CA), September 19, 1990, Show, 101.

Temko, Susannah. "Nine Artists for 1985." Review of *Summer 1985: Nine Artists*, Museum of Contemporary Art, Los Angeles. *Downtown News*, March 1, 1985, 17.

Valdez, Patssi. "Interview with Patssi Valdez." By Jeffrey Rangel, Los Angeles, May 26, 1999. Archives of American Art, Smithsonian Institution, Washington, DC. http://www.aaa.si.edu/collections/oralhistories/transcripts/valdez99.htm.

Van Kirk, Kristina. "L.A. Chicano Art." *Flash Art*, no. 141 (Summer 1988): 116–17.

Venant, Elizabeth. "On-the-Wall Latino Art at LACMA." Review of *Hispanic Art in the United States: Thirty Contemporary Painters and Sculptors*, Los Angeles County Museum of Art. *Los Angeles Times*, February 4, 1989, Calendar, 1.

Walton, Kelly. "All about Art." *City Life* (Phoenix, AZ), November 23, 1983, 34.

Weimers, Leigh. "Gronk Will Have a Brief Brush with Visibility." *San Jose Mercury News*, March 9, 1992, 1C.

———. "How about an Organization for Holiday Parking?" *San Jose Mercury News*, October 14, 1992, 1G.

Weisman, Alan. "Born in East L.A." *Los Angeles Times Magazine* 4, no. 12 (1988): 10.

Wilder, Matthew. "Los Angeles Critics' Picks: Gronk." Review of *Urban Narrative: Works by Gronk*, Gallery 727, Los Angeles. *ArtForum*, April 1, 2005. http://www.artforum.com.

Willette, J. S. M. "@COLA: 1997–98 at the LA Municipal Art Gallery." *Artweek* 29, no. 7 (July/August 1998): 29.

Wilson, William. "An Art that Cuts Close to the Bone." Review of *Hispanic Art in the United States: Thirty Contemporary Painters and Sculptors*, Los Angeles County Museum of Art. *Los Angeles Times*, February 5, 1989, C8.

———. "Browsing in the 'Summer 1985' Boutique." Review of *Summer 1985: Nine Artists*, Museum of Contemporary Art, Los Angeles. *Los Angeles Times*, August 18, 1985, 97.

———. "'Off the Street' Exhibit: The End Is Here." Review of *Off the Street*, Los Angeles Cultural Affairs Dept., Los Angeles. *Los Angeles Times*, May 13, 1985, 6:1.

———. "Trio of California Artists Mix It Up in 'The Mythic Present.'" Review of *The Mythic Present of Enrique Chagoya, Patssi Valadez and Gronk*, Fisher Gallery, University of Southern California, Los Angeles. *Los Angeles Times*, December 9, 1995, F1.

———. "Two L.A. Artists Display a Modernist Connection." Review of *Gronk*, Fine Arts Gallery, California State University, Los Angeles. *Los Angeles Times*, January 21, 1997, F11.

Wood, Daniel B. "'Hispanic' Art Goes Mainstream." Review of *Hispanic Art in the United States: Thirty Contemporary Painters and Sculptors*, Los Angeles County Museum of Art. *Christian Science Monitor*, February 17, 1989, 11.

Woodard, Josef. "A Cultural Foot Soldier Returns." Review of *Story of a Soldier* by Igor Stravinsky, directed by Peter Sellars, sets by Gronk, Los Angeles Philharmonic, Dorothy Chandler Pavilion, Music Center, Performing Arts Center of Los Angeles County. *Los Angeles Times*, January 17, 1999, 76.

Yankes, Bill. "Latino Art Exhibition a Colorful Milestone; Artist Chides Museum." Review of *Hispanic Art in the United States: Thirty Contemporary Painters and Sculptors*, Los Angeles County Museum of Art. *Los Angeles Times*, March 23, 1989, 1. Published in Spanish as "Exhibición multicolor es hito en arte Latino; Pintor critica Museo," *Los Angeles Times*, March 23, 1989, Nuestro Tiempo, 1.

EXHIBITION CATALOGUES

Albuquerque Contemporary 2004: 15th Annual Regional Juried Exhibition. Curated by Gronk. Albuquerque: Magnífico Arts, 2004.

American Kaleidoscope. Curated by Jacquelyn Days Serwer. Washington, DC: Smithsonian Institution, National Museum of American Art, 1996.

Ancient Roots/New Visions: Contemporary Hispanic Art of the United States. Syracuse, NY: Everson Museum of Art, 1979.

Ceremony of Memory: New Expressions in Spirituality among Contemporary Hispanic Artists. Curated by Amalia Mesa-Bains. Santa Fe, NM: Center for Contemporary Arts of Santa Fe, 1988.

Chicanarte. Curated by Comité Chicanarte. Los Angeles: Los Angeles Municipal Art Gallery, 1975.

Chicanismo en el arte. Los Angeles: Los Angeles County Museum of Art, Leo S. Bing Center, 1975.

Chicano and Latino: Parallels and Divergence/One Heritage, Two Paths. With a foreword by Max Benavidez. Los Angeles: Daniel Saxon Gallery; Washington, DC: Kimberly Gallery, 1991.

Chicano Art. Sacramento, CA: Office of Governor Edmund G. Brown Jr., 1975.

Chicano Art: Resistance and Affirmation, 1965–1985. Edited by Richard Griswold del Castillo, Teresa McKenna,

and Yvonne Yarbro-Bejarano. Los Angeles: University of California, Wight Art Gallery, 1990.

Chicano Expressions: A New View in American Art. Curated by Inverna Lockpez, Kay Turner, Judith Baca, and Tomás Ybarra-Frausto. New York: INTAR Latin American Gallery, 1986.

Chicano Visions: American Painters on the Verge. Curated by René Yañez. Boston: Little, Brown, 2002.

Chicanos en Mictlán. Curated by Tere Romo. San Francisco: The Mexican Museum, 2000.

Collaboration Show: The Day of Collage. Curated by Carl F. Berg. Includes essay by Michael Anderson. Los Angeles: Spring Street Gallery, 1996.

East of the River. Curated by Chon A. Noriega. Santa Monica, CA: Santa Monica Museum of Art, 2000.

Fallout Fashion. A production of L.A. Artists for Survival. Performance and exhibition. Produced by Joyce Dallal, directed by Gera Golden. Exploratorium Gallery, California State University, Los Angeles, 1983.

Fascinating Slippers/Pantunflas Fascinantes. Curated by Holly Barnet-Sánchez. Includes interview with Gronk by René Yañez. San Jose, CA: San Jose Museum of Art, 1992.

Gronk: Grand Hotel. Includes essay by Peter Frank. Los Angeles: Saxon Lee Gallery, 1989.

Gronk: Hotel Senator. Includes essay by Max Benavidez. Los Angeles: Daniel Saxon Gallery, 1990.

¡Gronk! A Living Survey 1973–1993. Curated by René Yañez. Includes essay by Max Benavidez. San Francisco: The Mexican Museum, 1993.

Gronk x 3: Murals, Prints, Projects. Curated by Cathy Kimball. San Jose, CA: San Jose Museum of Art, 1999.

Hispanic Art in the United States: Thirty Contemporary Painters and Sculptors. Curated by John Beardsley and Jane Livingston. Includes essay by Octavio Paz. Houston: Museum of Fine Arts; New York: Abbeville Press, 1987.

Images of Hope/Imagenes de Esperanza. Curated by Martha Abeytia-Canalez, Christine Balderas-Vasquez, and Miguel Angel Reyes. Santa Monica, CA: Santa Monica Museum of Art, 1991.

L.A. Hot and Cool: The Eighties. Curated by Dana Friis-Hansen. Cambridge, MA: MIT List Visual Arts Center, 1988.

Le démon des anges: 16 artistes "Chicanos" autour de Los Angeles. Curated by Pascal Letellier. Nantes, France: Centre de Recherche pour le Développement Culturel; Barcelona, Spain: Generalitat de Catalunya, Departament de Cultura, 1989.

Made in Aztlán. Curated by Phillip Brookman. Edited by Phillip Brookman and Guillermo Gómez-Peña. San Diego: Centro Cultural de la Raza, 1986.

Revelaciones/Revelations: Hispanic Art of Evanescence. Curated by Chon A. Noriega and José Piedra. Ithaca, NY: Cornell University, Hispanic American Studies Program, 1993.

Summer 1985: Nine Artists. Curated by Julia Brown. Los Angeles: Museum of Contemporary Art, 1985.

ARCHIVAL HOLDINGS

Califas: Chicano Art and Culture in California. Archival collection, including videorecording. California Ethnic and Multicultural Archives, Library, University of California, Santa Barbara.

CARA: Chicano Arts: Resistance and Affirmation, 1985–1994 Papers. Special collections, Chicano Studies Research Center, University of California, Los Angeles.

The Fire of Life: The Robert Legorreta/Cyclona Collection, 1962–2002. Special collections, Chicano Studies Research Center, University of California, Los Angeles.

Gamboa, Harry, Jr., Papers, 1968–1995. Special collections, Green Library, Stanford University.

Revelaciones/Revelations: Hispanic Art of Evanescence. Department of Special Collections and University Archives, Stanford University.

Sánchez-Tranquilino, Marcos, and Holly Barnet-Sánchez, Papers Relating to the CARA Exhibition. Department of Special Collections and University Archives, Stanford University.

Ybarra-Frausto, Tomás, Papers. Archives of American Art, Smithsonian Institution, Washington, DC.

FILM, VIDEO, AND DVD

2003 Tormenta Lecture Series: Dr. Ramón García April 3, 2003. Videocassette. Oxnard, CA: WestEnd Productions, 2003.

Califas: Chicano Art and Culture in California. Videocassette. 1989.

Daru, Nicolas. *Gronk x 3.* Videocassette. Juramentado Production, 2000.

Gamboa, Harry, Jr. *Baby Kake* and *Blanx.* In *Harry Gamboa Jr.: 1980s Video Art,* Chicano Cinema and Media Arts Series, vol. 2. DVD. Los Angeles: UCLA Chicano Studies Research Center, 2004. Originally produced in 1984 on videocassette.

Garza, Juan Carlos, and Ray Santisteban. *Latino Artists: Pushing the Boundaries.* Videocassette. Princeton, NJ: Films for the Humanities and Sciences, 1995. Originally produced by KLRN, San Antonio, TX.

Gronk! A Work in Progress. Videocassette. Madison: Wisconsin Public Television, 1993.

Kingdom of Glass. Videocassette. 2002.

La Ponsie, Steven. *No Movie: A Journey Through the Archives of a Man Named Gronk.* DVD. Los Angeles, Doto Productions, 2007.

Museum of Glass: Inaugural Installations. DVD. Tacoma, WA: Museum of Glass, International Center for Contemporary Art, 2002.

Oregel, Roberto. *Gronk's Tormenta: A Method.* DVD. Los Angeles: University of California, 2004.

Oregel, Roberto, and Gronk. *Gronk's Journal.* Videocassette. Los Angeles, 2003.

Tartan, James. *Murals of Aztlán: The Street Painters of East Los Angeles.* In *Early Chicano Art Documentaries,* Chicano Cinema and Media Arts Series, vol. 1. DVD. Los Angeles: UCLA Chicano Studies Research Center, 2004.

Varda, Agnès. *Mur murs.* Videocassette. Produced by Ciné-Tamaris, Paris. Roland Collection of Films and Videos on Art, 1980.

Velez, Edin, and Chon A. Noriega. *Revelaciones/Revelations: The Hispanic Art of Evanescence.* New York: Cinema Guild, 1994.

Gronk, *The Garden*, 2005. Mixed media on canvas, 78 x 120 inches.

Reproduced by permission of the artist.

INDEX

Jarry, Alfred, 54

Kronos Quartet, x, 70

Labyrinth of Solitude (Paz), 68
La Duke, Patti, 16
La Ponsie, Steve, 90
League of United Latin American Citizens (LULAC), 22
Legorreta, Robert "Cyclona," ix–x, 17, *19,* 19–20, *21*
Les BonBons, 51, 53, 54, 55, 56
Lincoln Center, 12
LodeStar Dome Theater, 90
Los Angeles: and avant-garde, 39; as backdrop, 44–45;
 effect on Chicano artists, 25–26; in Gronk's art, 88–90;
 precursors to Chicano movement in, 22; public art in,
 24; social conflicts in, ix; as source for art, 11–12
Los Angeles Contemporary Exhibitions (LACE), 10, 57
Los Angeles County Museum of Art (LACMA), 37–38
Los Angeles Museum of Contemporary Art (MOCA), 85
Los Angeles Theatre Centre, 47
Los Illegals, 36–37

mail art, 52, 54, 58; by Gronk, x, 10, 11, 56, 86; by Dreva,
 51, 54; No Movies, 44–46
Martínez, Daniel J., xi–xii, 47
Mexican identity, 68
Mexican Museum (San Francisco), 85
Montes, Roberto Gil de, 24
Mundo Meza, ix–x, 19–20, 36, 59
murals: post-Chicano, 28; in post-Revolutionary Mexico,
 23, 24. *See also* Chicano muralism; Gronk's murals

National Endowment of the Arts, 60
New York Dolls, 52
No Movie (Aztlán) Awards, 46–47, *47*
No Movie project, x, 5, 8, 48, 53, *86,* 86; *The Boo Report,*
 85, *87*
Nomi, Klaus, 52
Noriega, Chon A., 9
Norte, Marisela, 15, 47, 90, 98n18

Orozco, José Clemente, 24, 31
Otis Art Institute, 51
Ozu, Yasujiro, 12, 17, 63–67, 76, 78, 102n13

Plagens, Peter, 39
Plato's cave, 68–69
Pollack, Jackson, 69
post-Chicano art, 28–29
punk culture, x, 11, 48, 57, 60

rasquachismo, 26
Reed, Lou, 52
Regeneración (magazine), 36
Rivera, Diego, 24
Rojas, James, 44, 85

Salazar, Rubén, 27
Sandoval, Humberto, 42, *43,* 44, 47, 48, *49*
Sandoval, Teddy, 52, *53*
Santa Fe Opera, 1, 12
Saxon, Daniel, 61, 84, 85
Saxon-Lee Gallery, 61
Score Bar, *60,* 60
Self Help Graphics, 37, 42, 44, 61
Sellars, Peter, x, 1, 85
Senator Hotel, 75, 78, 82, 83
sexual identity, 54, 64, 65, 69, 70
Sharp, Willoughby, 51
Sherman, Cindy, 45
Silver Dollar Cafe, 27, 28
Siqueiros, David Alfaro, 24, 31, 99n5
Street Meeting (Siqueiros), 24
Suburban Death Camp, 49

Tomata DuPlenty, *59,* 59–60, *60*
Tormenta, 31, 72; and gender identity, 2, 7; in Gronk's
 later career, 84; invention of, 63–64; as metaphor, 65
Tormenta in Gronk's works: *Cabin Fever,* 76, *77; Enter
 Tormenta, 66; Post, Library: Muse,* 8, 65; *Puta's Cave,* 65,
 67, 68–69; *She's Scared,* 65; *Slice of Life,* 65, *66; St. Rose
 of Lima,* 65; *Tormenta Cantata I, 69; Tormenta Cantata*
 (with Joseph Julián González), 69, 70; *Tormenta Suite
 in 12 Movements,* 65; untitled mural in Ithaca, *xii*

Upshaw, Dawn, 1, *96*
Urban Exile: The Collected Writings of Harry Gamboa Jr.
 (Gamboa), 9

Valadez, John, 23, *47*
Valdez, Patssi, 8, 19, *21,* 36–37, *47,* 63. *See also* Asco
Vietnam War, 20–21, 22–23, 26, 41, 42
Villareal, Daniel, 47

Walker, Hue, 90
The Wall That Cracked Open (Herrón), 28
Women's Building, 57

Xirgu, Margarita, 1, 94